simply creative
faux finishes
WITH GARY LORD

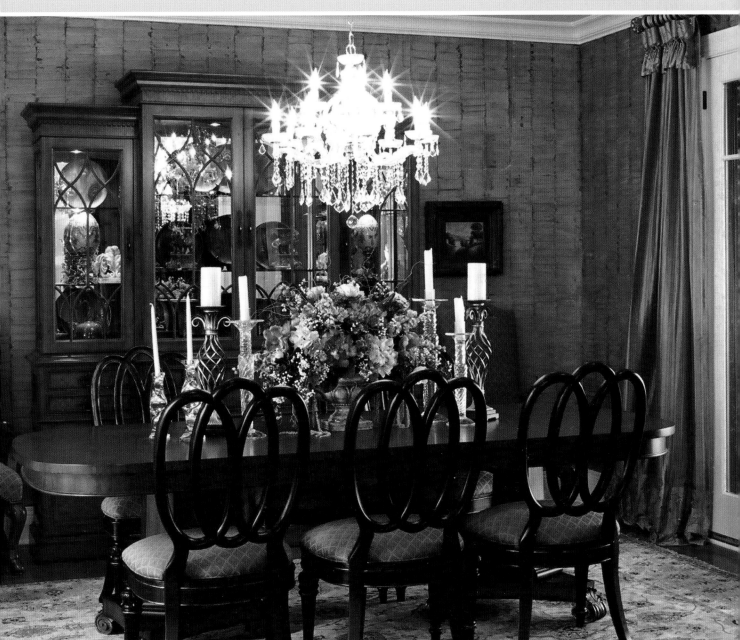

30 Cutting-Edge Techniques for Walls, Floors & Ceilings

NORTH LIGHT BOOKS
CINCINNATI, OHIO
www.artistsnetwork.com

Published by North Light Books, an imprint of F+W Media, Inc., 4700 East Galbraith Road, Cincinnati, Ohio, 45236. (800) 289-0963. First edition.

Other fine North Light Books are available from your local bookstore, art supply store, online supplier or visit our website at www.fwmedia.com.

14 13 12 11 10 5 4 3 2 1

Distributed In Canada By Fraser Direct
100 Armstrong Avenue
Georgetown, ON, Canada L7G 5S4
Tel: (905) 877-4411

Distributed in the U.K. and Europe by David & Charles
Brunel House, Newton Abbot, Devon, TQ12 4PU, England
Tel: (+44) 1626 323200, Fax: (+44) 1626 323319
Email: postmaster@davidandcharles.co.uk

Distributed in Australia by Capricorn Link
P. O. Box 704, S. Windsor NSW, 2756 Australia
Tel: (02) 4577-3555

Library of Congress Cataloging-in-Publication Data
Lord, Gary.
 Simply creative faux finishes with Gary Lord : 30 cutting-edge techniques for walls, floors, and ceilings / Gary Lord. - - 1st ed.
 p. cm.
 Includes index.
 ISBN 978-1-60061-694-5 (alk. paper)
 1. House painting. 2. Texture painting. 3. Finishes and finishing. I. Title.
 TT323.L684 2010
 698'.1- -dc22
 2009046165

Edited by Kathy Kipp
Designed by Clare Finney
Photography by Christine Polomsky, Adam Hand and Richard Deliantoni
Photo styling by Lauren E. Emmerling
Production coordinated by Mark Griffin

Grateful thanks to the following photographers for permission to use their photos in this book: Robin Victor Goetz, Ron Kolb, Buck McCann, Sharon L. Creagh at Creagh Photography, Jamie Antonioli Photography, Gale Kirkpatrick at Imaginations Photography, The Greg Wilson Group, Randall Perry Photography, Eric Marcus Photography.

>> METRIC CONVERSION CHART

To convert	to	multiply by
Inches	Centimeters	2.54
Centimeters	Inches	0.4
Feet	Centimeters	30.5
Centimeters	Feet	0.03
Yards	Meters	0.9
Meters	Yards	1.1

About the Author

Gary Lord is recognized internationally as an artist, teacher, author and television personality. He owns and operates Gary Lord Wall Options and Associates, Inc., (www.WallOptions.com) which executes all of his commercial and residential decorative finishing contacts. Wall Options won first place in three Painting and Decorating Contractors of America national competitions and was named best faux finisher in the nation in 2002, 2003, 2004, 2005 and 2006 by Painting and Wallcovering Contractor. In 2007 Gary was named to *Who's Who in the Painting Industry for Decorative Painting* by the American Painting Contractor, and in 2009 was honored with Strathmore's *Who's Who.*

Gary also operates Prismatic Painting Studio (www.prismaticpainting.com) which allows him to teach his extensive faux finishing skills to others, nationally and internationally.

Gary has appeared on HGTV's *Decorating with Style* and *The Carol Duvall Show*, the PBS show *Paint! Paint! Paint!* and The Discovery Channel's *Christopher Lowell Show.* Gary writes numerous articles on decorative painting for *Faux Effects World, The Artist's Magazine, The Faux Finisher, Artistic Stenciler, The Decorative Painter, Profiles in Faux, Paint Pro, American Painting Contractor* and *Architectural Living*, among others. This is Gary's fifth North Light book; his previous books include *Great Paint Finishes for a Gorgeous Home, Marvelous Murals You Can Paint, It's Faux Easy*, and *Mural Painting Secrets For Success.*

Visit Gary at www.ItsFauxEasy.com for more information on how-to videos, faux-finishing tools and products, and sample kits.

DEDICATION

Life is a very short process in which we need to learn what is really important. I am blessed to be able to make a living at something I love and am happy that others wish to share that with me. But I am really blessed by my wonderful wife Marianne and my great children Ben, Corrie and Jared, for it is their love and support that I enjoy every day.

ACKNOWLEDGMENTS

In my professional career, I wish to thank the many clients, interior designers, architects, students and each of you who enable me to make a living in one of the most rewarding ways I can think of.

The finished projects in this book reflect many creative and talented artists. Thank you to my fellow artisans who continue to help me grow in this field and whose work is instrumental in this book: Kris Hampton, Jeff Sutherland, Joe Taylor, Ben Lord, Debbie Rye, Jan Gommeringer, Cindy Downard, Teresa Kaehler and Mindy Giglio.

Thank you to Jennifer Dumoulin, June Surber, Henry Vittitoe and Jenny Lynn Wynne whose wonderful sense of interior design and creativity made many of the projects in this book happen.

A special thanks to my clients who allowed their beautiful homes to be photographed for this book: Mrs. & Mrs. Dan Buchanan, Cutter Construction, DeStefano Builders, Hensley Homes, and Tanner Construction.

Thank you to my wonderful editor at North Light Books, Kathy Kipp, designer Clare Finney, and photographers Christine Polomsky, Richard Deliantoni and Adam Hand. Thanks also to Robin Victor Goetz and Ron Kolb.

>> Contents

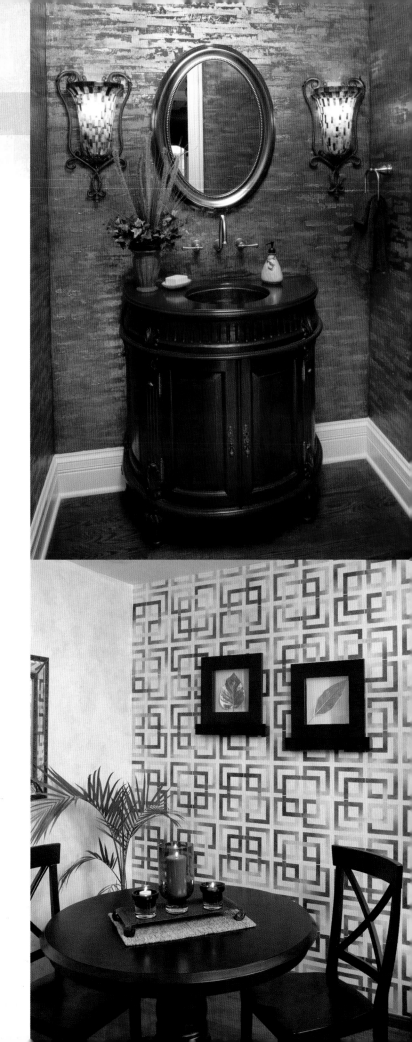

>> Introduction

THE IDEA FOR THIS BOOK resulted from the success of my earlier book titled *It's Faux Easy with Gary Lord*. In that book I was able to share 30 different decorative painting finishes that could be easily executed by beginning DIYers or by professional decorative painters at any stage of their career. It has been since 2004 that I compiled those finishes for publication. Many of the finishes in that book I still do today. But there are now so many new things that were not even thought of at that time and the years since.

One of the great joys (and sometimes frustrations) of the field of decorative painting is that it is always evolving and changing into something new and different. Colors, textures, stencil designs, tools, products, and application techniques are constantly moving forward. This allows us as artists to continue to be creative in an endless variety of ways. The pursuit of that next elusive breathtaking finish with a new twist to it is what I find most enjoyable about being an artist. So it is in this book I will share some of those new ideas with you. My goal is to be forward thinking and anticipate where the design market will be heading in the future and offer you projects that will take you there.

The designs in *It's Faux Easy* were almost 100 percent mine or my staff's. In this new book I wanted to do something different. My most recently published book titled *Mural Painting Secrets for Success* (2008, North Light Books) was a collection of the mural works of 21 different artists. Each artist offered his or her own unique style and techniques for displaying mural elements. I felt that book was a great way to showcase many people's talents and their individual styles of painting. The work of those artists, plus some of my own work, enabled readers to see a wide variety of techniques not possible by one artist alone.

My publisher and I both felt there was a continuing demand for a new book on decorative painting that showcased the latest techniques and faux finishing products on the market. We decided to invite some of the finest, most creative professionals working in this field to share with you their newest ideas for decorative painting projects that you can do in your own home just by following the easy step-by-step instructions in this book. We also decided to include a DVD of five demos plus a stunning gallery of photos showing additional work by these artists that will inspire and encourage you to try these painting ideas for yourself.

Where did all the artists in this book and DVD come from, you may wonder? After the concept of the book was conceived, I posted invitations on many open forums and websites seeking submissions of new, cutting-edge finishes for the book. I deliberately sought out unpublished artists to supply many of the projects—there is such a wonderful wealth of talent out there that I wanted to showcase the work of some of those up-and-coming artists. We had over a thousand different submissions from all over the country. I wish we could have included everyone but unfortunately that was not possible. The selected submissions went before a committee who, after careful consideration, narrowed it down to what you will see in this book. We are very pleased with the results and hope you will be as well.

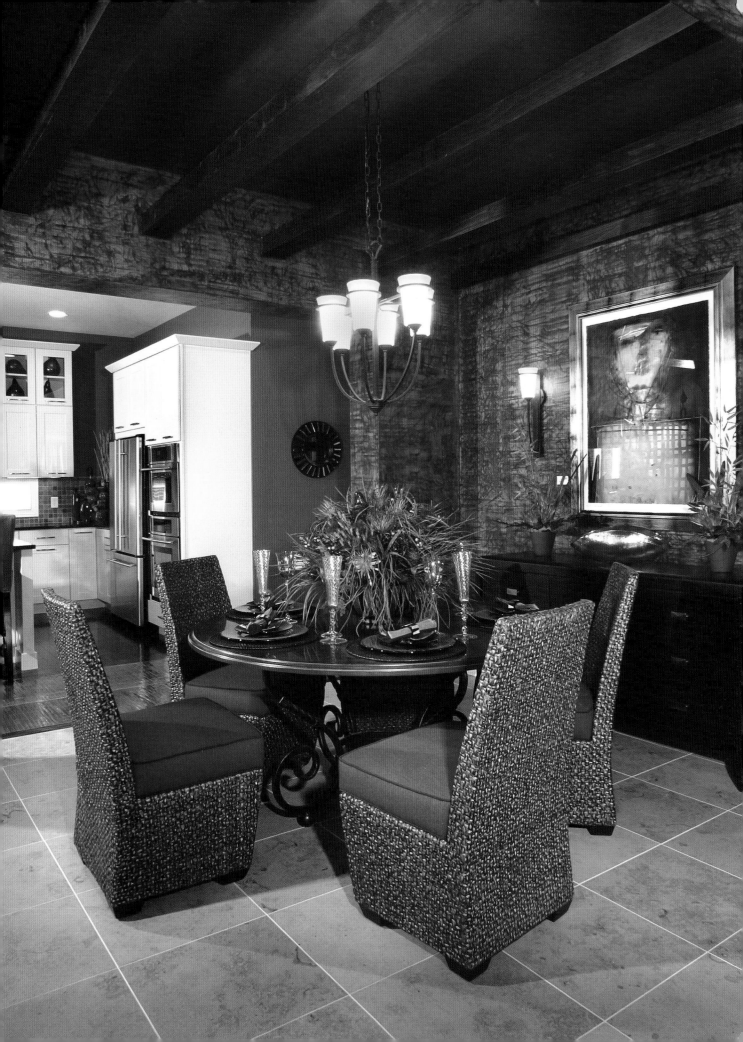

>> Getting Started

THIS SECTION will teach you what you need to know about preparing your surfaces for painting, repairing problem areas, and how to use basic painting tools and techniques. You'll also discover a wide variety of specialized products and tools that artists have developed over the years to help them create many of the spectacular decorative painting finishes featured in this book. Some are texturizing products such as Venetian plaster, one of the most beautiful and popular wall finishes used in homes today. Others are metallic paints and foils that lend a rich sheen to almost any surface. If you decide to try some of the finishes in this book for yourself, take advantage of all the products and tools that are available these days to help ensure your success. You'll find complete product listings in the Resources section in the back of this book.

>> **STAINED WOOD MODELLO FLOOR** Today's faux finishes are no longer limited to walls and ceilings. Now you can paint on any surface you want, including floors (indoor and outdoor), furniture, doors, cabinets, and so much more. The stunning floor treatment shown here can be achieved using familiar products like wood stains combined with new techniques like Modello Designs decorative vinyl patterns. You'll find this floor design demonstrated on pages 106-109.

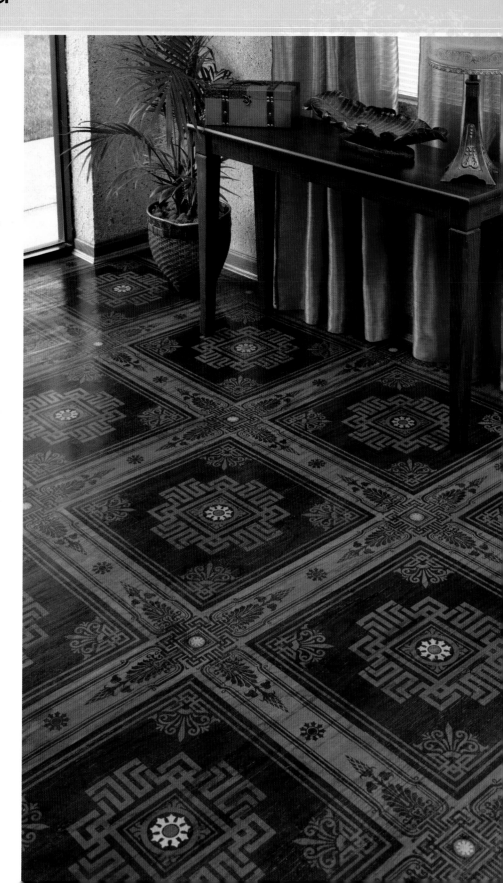

SURFACE INSPECTION

General surface preparation should start with a close inspection of the areas you are painting. You want to look for any nail pops, stress cracks, dings or dents in the walls, previous patch jobs, loose or bad caulking around moldings, flaking or cracking paint, water marks, smoke damage or dirty surfaces. Make sure you do these inspections while the lighting in the room is good, as it is very easy to miss spots in poor lighting. You could also use a halogen lamp and shine it on your surfaces to help find any problem areas. Usually when I am making my inspection, I use small pieces of blue low-tack adhesive tape to mark any areas in need of repair. I also keep this tape by the areas being repaired until the repair work is complete, since it is often hard to see your spackled spots on white walls. Please note that you should not begin repairing the walls until you have completed the room preparation described below.

PROTECT THE FLOORS

Cover the floors with drop cloths. Use butyl rubber-backed drop cloths so paint can't soak through them. For hardwood floors or wall-to-wall carpet, I cover the baseboards using a tape dispenser and 6- to 12-inch (15cm to 31cm) kraft paper that extends beyond the baseboard to cover the edge of the floor. This saves me a tremendous amount of cleanup in the long run. Even though I put drop cloths over the entire floor, they tend to pull away from the wall, allowing the floor to be exposed to the risk of paint spatters. The paper shield helps protect the floors from paint spatters even if the drop cloth shifts.

PROTECT TRIM & CEILINGS

If I am doing a basecoat, I don't mask out the trim and ceiling areas. I just carefully cut into them with my cut brush. But if I am applying a decorative paint finish, which can be messy, I protect these areas using 2-inch (5cm) blue tape on the trim and, for the ceilings, either 2-inch (5cm) blue tape or 6-inch (15cm) kraft paper applied with a tape gun and 1-inch (2.5cm) blue tape. I then use a 4-inch (10cm) Whizz roller and roll my basecoat right against the tape. This is much faster than cutting the trim in by hand with a brush.

PROTECT THE FURNITURE

I try to move all small pieces of furniture and pictures out of the room. I throw 9 x 12-foot (3m x 4m) sheets of plastic over all of the furniture remaining in the room. This may sound like a lot of work, but I have found that if you paint often enough, you will spill paint at some point. (For any of my clients who are reading this, I did not spill paint on your job.) However, it is better to be safe than sorry. In my career I have spilled paint dozens of times. But because of my good prep work, I have never had to buy a new carpet or piece of furniture.

SURFACE REPAIR

Once you prepare the room, you can then attend to the areas that need repair. If the walls are extremely dirty or greasy, wash them first. You can use a product like Soilax or TSP (tri-sodium phosphate) to clean the surfaces. Make sure you clean the walls from the floor up to the ceiling. When you clean this way, you avoid streaking the walls with cleaning solution. If you have bare drywall, lightly dust the walls before you prime them to make sure your paint will bond properly to the drywall board.

REPAIR CRACKING PAINT

Next, I scrape off any loose or cracking paint and then use spackling compound and a putty knife to fill any surface irregularities. Most compounds shrink a little, so leave more on the surface to account for this possible shrinkage. Once the areas are dry, sand them with medium to fine sandpaper until smooth. Sometimes it's easier to feel the texture with your hands than to see it with your eyes. You can spot-prime these areas if there are only a few, but if there are a lot, it's easier just to prime the whole wall.

REPAIR CAULKING

If the caulking is bad, remove any loose areas and re-caulk with a good tube of paintable acrylic caulking. It is worth buying the better caulking product because it lasts longer than the inexpensive brands.

Surface Preparation

There are a variety of needs for different surface preparations. The following instructions are generalizations only, and each area may vary. If you are ever in doubt as to what to do to get an area ready, just make your surface as smooth as possible and clean off any dirt, grease or wax contaminants before painting.

At the beginning of each demonstration in this book, the artist will list the type of paint basecoat and color. I switched over to a water-based system about 14 years ago, mostly for my health, the safety of my employees and clients, as well as ever-increasing environmental regulations. I can truly say I am happier, and feel I am a better artist with greater products to choose from. So, all prep work in this book is geared toward water-based products and techniques.

OVER OIL-BASED PAINT

First, a tip for you: An easy way to tell if your surface is painted with oil is to take a cotton ball and put denatured or isopropyl alcohol on it. In an obscure area, rub it onto your paint. If the paint is removed or gets soft and gummy, it is a water-based paint. If it stays hard and firm, it is an oil-based paint. If it is an oil-based paint, you should do a light sanding on the surface with a fine to medium sandpaper. Then dust off the surface and apply a water-based paint that will adhere to an oil-based paint surface. There are many of these paints on the market, so just ask your paint dealer. Some of these will be primer coat paints only, like Zinsser's B-I-N, Shieldz, KILZ from Masterchem, and XIM. These all need a water-based finish coat on top if you use a specific color underneath your technique. You can also get water-based paints that are a combination bonding primer and finish coat, such as Faux Effects SetCoat or Porter Paints Advantage 900. Once you have converted your oil paint to a water-based paint, you can safely do any of the projects in this book.

OVER LATEX

If you are working over any latex-based paint, you need to make sure the paint is clean of any dirt, grease, wax or other contaminant. If the sheen of the existing paint is a semi-gloss or lower sheen, you can usually put latex straight onto latex with no additional prep work needed. If the sheen of the paint is a high gloss, you may need to do a light sanding and use a tack cloth over the surface prior to painting.

OVER LACQUER

You can paint any latex over lacquer after you have lightly sanded the surface and used a tack cloth to remove any dust residue.

OVER WALLPAPER

Another tip for you: All paint stores and wallpaper manufacturers will tell you to remove all wallpaper and its paste before doing any painting. That is the best way, especially if your walls are a smooth finish. But I do break the rules when it makes sense. For example, if my clients want to have a dimensional texture applied to their walls and are concerned about the hassle and expense of removing it later, I can save them money by going over the existing wallpaper with a textured finish, if the wallpaper is secure and in sound shape. I make sure the seams and edges of the paper are not loose and are fairly flush. I apply a coat of primer such as an oil-based Shieldz or Bull's Eye 1-2-3 from Zinsser that will act as a stain blocker and primer in one coat. I can apply my dimensional texture right over the existing primed wallpaper. This not only saves the time and expense of removing the paper, but if I want to remove the texture in the future, I can strip off the wallpaper to do so. It is harder removing a painted paper than one that has not been painted, but it is a lot easier getting rid of my texture this way. I have painted textures dozens of times over wallpaper for more than twenty years and have never once had a failure.

You should warn your client of the potential hazards of the wallpaper releasing or product failures. Have them sign a release to protect you in case of any problems. If you started to remove your wallpaper and the paper is ripping, STOP! You can use a wall primer such as Shieldz by Zinsser right over the ripped-up damaged wall surface. Then do one of your heavier dimensional finishes over the walls and you will save yourself countless hours of work and frustration.

OVER DAMAGED WALLS

If you are doing a smooth decorative painting finish, you need your walls as smooth as possible. Patch any nail pops, dings, dents, cracks, scratches, etc., with drywall mud, then sand the patch smooth to the surface and dust it off. Now use any drywall primer to either spot prime or prime the whole room. If you are doing a dimensional texture, you can go right over most minor flaws. Use common sense as to what may need additional work, the repair needed and the depth of your finished texture.

BASECOATING TECHNIQUES

When basecoating your walls with a water-based paint, use a 2½-inch (6.4cm) sash brush or Whizz roller to cut in around the edges of the room and around the moldings. If you are working by yourself, you can cut and roll the walls at the same time. If you are working with another person, one can cut in while the other rolls the paint on.

Use a 9-inch (23cm) roller frame with a ½-inch (1.3cm) nap lambskin roller cover to apply the paint. The lambskin covers are more expensive but they hold a lot of paint, spatter very little and clean up very quickly. Try to roll right into the wet cut lines as closely as you can on the edges. You can even turn the roller sideways at the ceiling and baseboards. This avoids the difference you may notice with brush strokes versus roller marks. Also, there is sometimes a minor color difference between paint that has been brushed on versus rolled on, and this technique will help eliminate that problem. I almost always apply two solid basecoats before doing a decorative finish. Make sure the paint has dried thoroughly between coats and before you start your decorative finish.

GLAZE COATING TECHNIQUES

There are many ways to apply your glazes in decorative paint finishes, from using brushes and paint rollers of all sizes, as well as rags and cheesecloth, to spraying and other techniques. If using a paint roller, I normally use a ⅜-inch (1.0cm) or ½-inch (1.3cm) Whizz Premium Gold Stripe roller cover on a 9-inch (23cm) roller frame or 4-inch (10cm) Whizz roller. Each step in the glazing process, from the application to completion, affects the final look. In the demos in this book, the artists will describe many different ways of applying glazes.

One of the most important things in your decorative painting process is consistency. Make sure that the process is the same throughout. If you are using two or more people to do a finish, make sure each person does the same job throughout to help maintain this consistency. For example, the same person who rolls on the glaze should do it everywhere while the other person takes the glaze off with a rag. Pay close attention to your edges and corners and use a 2-inch (5.1cm) chip brush to pounce your glaze in these areas and even it out.

FOIL INSTALLATION

Foils have many possibilities, all depending on how you wish to use them. Here are some general guidelines to follow.

First, always basecoat before foiling. You cannot apply foils over an unpainted surface. Foils can go over any flat, satin or semi-gloss oil- or latex-based paint. Over flat latex, you may need two coats of size for better transfer of the foil and longer working time. Basecoat the surface with satin latex- or oil-based paint in any color, then apply only one coat of size. Try to select a paint color that is close to the dominant foil color. If you want a strong metallic look, use a metallic paint underneath the foil. Basecoats need to be fully dry before applying size.

You must have the *shiny side up* when transferring foil. Crumple and un-crumple the foil. With a firm, even pressure, rub the foil onto the tacky size. Then remove the backing. A small short-bristled nylon scrub brush works well for giving maximum release. To avoid obvious seams, do not press down on the edge. Foils do not usually transfer 100 percent to your surface; you can expect a 70-90 percent transfer. If you want 100 percent coverage, you may need to size, apply the foil, then resize over the foil and apply foil again.

For more information on foiling, instructional packets and videos are available from Prismatic Painting Studios (see the Resources section in the back of the book).

>> Tools, Materials and Products

IN THIS BOOK we are using a wide variety of tools to create different effects. We are also using different paint products from different manufacturers. You can find more information on these products and manufacturers in the Resources section in the back of the book. Almost all of the projects in this book use water-based products, which offer easy clean-up and are environmentally friendly.

WATER-BASED PAINT SYSTEMS

Water-based paints are a lot more user-friendly than oil-based paints because they are almost odorless and dry quickly (usually within 2 hours), allowing for multiple applications in one day. This is especially true when applying the basecoats for your decorative paint technique.

Water-based paints are easy to clean up with soap and water. They are healthier for you to use than solvent-based products because they do not release harmful toxins into the air and enter into your skin while you are using them. There are many parts of the country that are now restricting the use of solvent-based paints.

It is for all of these reasons that the majority of the paints mentioned in this book are water-based. Also note that many of the techniques illustrated in this book could not have been developed without the incredible water-based products made by creative and forward-thinking paint manufacturers.

BASECOATS

Most of the time you should use a low luster or semi-gloss latex or 100 percent acrylic paint as your basecoat. A good quality paint will make a difference in how long your glazes will stay open—100 percent acrylic paints seem to work better as basecoats because they do not have fillers, clay or silica in them which ultimately affect your open time. The sheen of the paint will also affect your open time, as discussed in the next section.

One word of caution: Allow your basecoats to dry twenty-four to forty-eight hours before glazing on them. This will allow the longest open time for your glazes, because the basecoat has dried firmer and the glaze will not bite into it as it would on a softer paint film that is still fresh. You can certainly glaze on a dried film of fresh paint but the glaze sinks in more. It is harder to manipulate, and you may create the dreaded "lap line."

SHEEN

You must choose a degree of paint sheen. Paint that has no sheen is labeled as a "flat" or "matte" finish. Paint that has a slight sheen is called "satin," "low-luster" or "eggshell." Higher sheens are known as "semi-gloss" and "high-gloss." All paints start out as a high-gloss sheen and flattening agents are added to progressively lower the sheen to the desired level. All major paint stores will have a chart to help you determine sheen.

Generally, the higher the paint sheen, the higher the durability and washability of the surface. It is also generally true that the higher the paint sheen, the longer your open time for glazes. Many negative glazing treatments cannot be done on a flat sheen and certainly should not be tried by a novice faux finisher. Once you bcome more experienced, you can do more finishes on a flat-sheened surface. Flat-sheened surfaces do not clean as well as those painted with a higher-sheen paint. The negative side of using higher gloss paint is that it magnifies all surface defects, such as nail pops, bad tape joints, lumps, dents and undulations. Flat paints hide flaws better than higher-sheened paints. For good washability, I recommend using a low-luster, satin or eggshell sheen on your walls. These will not magnify defects as much as a high-gloss sheen but they'll still clean up very well. For additional protection, you can also clear-coat your surface with a clear sealer.

SEALERS

Most water-based glaze finishes, once they are fully cured (thirty days), are washable and are as durable as woodwork trim paint. If you want extra protection on a water-based finish, you can use either oil- or water-based sealers. The sealers come in a variety of sheens—flat, low-luster, semi-gloss and high-gloss. All water-based sealers are like paints in that the higher the sheen, the less flattening agents are in them. The more flattening agents there are, the milkier the paint film. All water-based sealers will create a slight bluish haze over darker colors which is more noticeable with a lower sheen. This bluish haze is often not noticed on mid to light colors. Be careful to use your sealers on warm, dry days. Coolness and higher humidity trap moisture under your sealer and cause even more hazing and irregular sheen problems. I very seldom seal my walls because they are usually durable enough after they cure for thirty days.

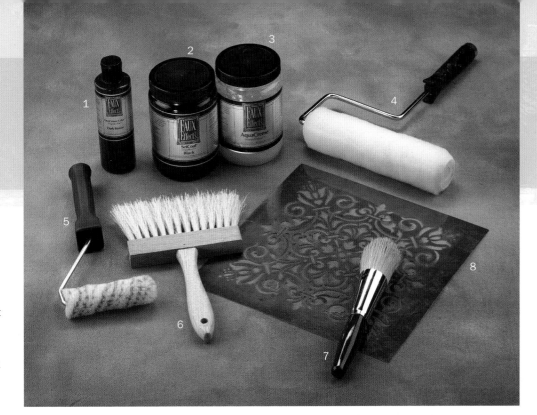

Some of the materials often used by professional decorative painters may include: 1) FauxCrème Color, 2) SetCoat and 3) AquaCreme, all by Faux Effects; 4) a standard paint roller; 5) a Whizz Roller; 6) a large texturing brush; 7) a large stencil brush; and 8) an acetate stencil.

OIL-BASED PRODUCTS

For over twenty years of my career, I used an oil-based glazing recipe of 1 part oil-based paint, 1 part oil glazing medium and 1 part paint thinner. If I needed to extend my open time even more, I would add either boiled linseed oil or kerosene to my mixture. I would then use this mixture in small rooms during the winter months where I couldn't get a lot of ventilation. The client would come home and would almost fall over from the odor. After working in the room for hours I didn't even know it smelled anymore! My clothes would reek from the solvents. When I came home no one wanted to be around me until I changed my clothes! I realized I needed to convert to a water-based paint system to avoid all the health issues involved with an oil-based system.

In the early 1990's I tried many different water-based glazes and did not like any of them. I was used to oils and I could not find a water-based system that allowed the working time and versatility of oil-based paints. Then I came across a water-based product line called Faux Effects (see the Resources section on page 142 for more information). I fell in love with their glazes and their whole line of creative water-based products. They were nontoxic, with a working time that rivaled or surpassed oil-based formulas. They also offered unique finishes in a wide-ranging product line I could never attain with the oil products I had been using for over twenty years. Slowly, over two to three years, I weaned myself off my oil-based crutch and learned more and more about this fantastic line of paints. I truly feel that the Faux Effects line enabled me to work on a more creative level than ever before. And I believe that this manufacturer changed the whole field of decorative paint products for the faux finishing industry. I use a great number of their products, and many other manufacturers' products as well, to create many of my finishes.

GLAZES

In today's marketplace, there are many different manufacturers of water-based glazing mediums. The main purpose of a glazing medium is to extend the working open time of water-based paints and to make the paints more translucent so you can see through one layer of paint to another below. Each manufacturer makes their glazes differently, so you will need to experiment with them to see which you like best. I use a variety of glazes but the one I use most often when mixing my glaze with a latex-based paint is AquaGlaze. I usually use AquaCreme or Faux Crème Clear (a clear glazing medium) when I want a sheer glaze that I can custom color myself with either FauxCrème Color (a pure liquefied 100% acrylic paint) or universal tinting agents.

I mostly work in the Midwest area, and my standard AquaGlaze mixture is 3-4 parts AquaGlaze to 1 part latex-based paint in the color of my choice. You may need to increase or decrease the amount of glazing medium you use in your mixture depending upon where you live. If you are in a cool, humid environment, you will need less glaze in your mix than if you are in a warmer and drier climate. My recipe works well for the Midwest.

I will usually tint AquaCreme or Faux Crème Clear up to the desired color by using FauxCrème Color. When using AquaGlaze, the glazes tend to be a little more opaque than when you use the tinted AquaCreme or Faux Crème Clear. Therefore, I mostly use AquaGlaze on smooth or non-textured wall finishes and AquaCreme or Faux Creme Clear over dimensional textured surfaces.

When I custom-tint AquaCreme or Faux Crème Clear, I measure an exact amount of AquaCreme (say 8 ounces or 24 centiliters) and then I use a disposable metric syringe to measure 2cc of one color and 3cc of another, or whatever the measurements may be. I can always repeat the mixing process in any volume over and over and repeatedly make the same color, just like a paint store mixing up their paints.

A quart of latex-based paint mixed with a gallon (4 liters) of AquaGlaze (which is a 1:4 ratio) will cover approximately 500 square feet (47 square meters) of wall space. A gallon (4 liters) of AquaCreme or Faux Crème Clear will cover approximately 400 square feet (37 square meters) of wall space over a non-dimensional finish. On a textured finish, however, the glaze tends to be pushed out further, which increases the square footage it will cover to approximately 600 square feet (56 square meters) per gallon (4 liters) of AquaCreme or Faux Crème Clear. When you tint AquaCreme or FauxCrème Color, use a small amount of AquaColor or a lesser amount of universal colorant, which is a more concentrated pigment. When you tint AquaCreme or FauxCrème Color, a little bit of color will keep it more sheer and translucent whereas a higher concentration of color will increase the opacity and depth of color.

STORAGE AND LABELING

All paints should be kept in a cool, dry area and never allowed to freeze. Do not store your paints in your garage unless it does not freeze in your part of the country. The rims of your paint cans should be kept clean so the lids will seal properly. Use a felt-tip marker to label all cans of paint with the date, name of paint, paint formula if it's a computer-matched color or you made it yourself, what it was used for (basecoat on walls, trim color, etc.) and in what room it was used. In five years, if you need to touch up your walls for any reason, you will be very happy that you did this.

If you are using a plaster or heavy-bodied material, you can wipe down the inside of the container to the material level.

Then you can spritz a little water on the material, apply a plastic film over the material and seal the lid. This will keep the material from drying out.

BRUSHES

In order to execute the best finish, you need to buy the best brushes you can afford. The better your brushes, the better your results. An inexpensive brush will not last long and will almost always give you an inferior look. If you take good care of your brushes and all the tools mentioned in this book, they will last for many years.

BRUSH SIZE

Your job will go a lot faster if you have a variety of brush sizes. Use the correct size brush for the area. If you are working around a door frame that is very close to the adjacent wall, don't try to smash a 4-inch (10cm) brush into that area. Instead, use a small artist's brush. Don't use a small 1-inch (25mm) brush to cut in your base or glaze coat around the large open areas in a room. Use a 2- to 4-inch (51mm to 10cm) brush.

BRUSH QUALITY

Quality brushes are hand-crafted from a variety of materials. Brushes used for water-based paints are usually made from synthetics like nylon or a polyester blend. Oil-based paint brushes are often made of pig or ox hair. Do not use a latex brush in an oil-based paint because the strong solvents may damage your brush. Likewise, do not use an oil brush in a water-based paint because the water will explode the natural hairs in the brush and ruin its fine quality. Make sure that your brush has a chiseled edge and will hold a fair amount of paint. Even high-quality brushes may shed hairs. It's a good practice to break in all new brushes by flicking the bristles back and forth until all the loose hairs have come out. The price of brushes often indicates the quality. Buy the best brushes you can afford and then experiment with different, less expensive brushes.

Specialty Paints, Tools & Products

The artists in this book used many different products from a wide range of manufacturers to create the spectacular finishes you will see in the demonstrations. Some of these products are available at paint stores and home improvement centers. But many of them are specialty items available through a network of manufacturers and distributors. These are listed in the Resources section in the back of the book.

Following are brief descriptions of each specialty product and what it is used for, and if there is a substitute product available. If you change the products you use from what is recommended in the projects, you may not get the exact end result. However, if you know your paint products well and if there's a possibility to inter-change products, try it. You may come up with something better! Each artist in this book and on the DVD used their personal choice of products. If you do not see them listed here and you have questions about the products used in their demos, please contact the artists at their websites.

AQUACRACKLE CLEAR

AquaCrackle Clear is a clear crackle material that is applied over AquaSize in a two-part system designed to offer consistent results and a variety of crack patterns.

AQUACREME

AquaCreme is a clear, translucent glazing material that offers clarity, increased open time and durability. When used with AquaColor, AquaCreme allows you to execute detailed finishes using translucent layers of color. As a substitute you can use a translucent glazing material from another manufacturer such as Pro Faux, Modern Masters or Adicolor.

AQUAGARD

AquaGard is a furniture quality, acrylic material formulated for use as a clear topcoat to increase the durability of a decorative finish or artwork. It can be used on any surface. Substitute this product with any quality water-based clear sealer.

AQUAGLAZE

AquaGlaze is a water-based, slow drying medium used in combination with a good quality latex paint. Use the color charts at the paint store to tint the chosen latex paint and then combine with the glaze. There are many substitutes for this product available at most paint and hardware stores. Be careful because the open working time of glazes varies greatly. You will get the best open time using a specialty paint manufacturer like Pro Faux, Modern Masters or Adicolor versus a paint manufacturer glaze.

AQUASEAL

AquaSeal (SetCoat Clear) is a product designed to work specifically as an almost totally clear basecoat for decorative finishing work where an extended open time is important.

AQUASIZE

AquaSize is a glue-like material that works as the foundation coat in a two-part crackle system designed to offer consistent results and a variety of crack patterns. Substitute with a similar product in other specialty paint lines.

AQUASTONE

AquaStone is a textured material that contains actual marble dust suspended in an acrylic resin. It holds its shape when troweled on or texturized. It dries to a very hard, durable finish, yet it is very flexible for movement on walls. If you substitute drywall mud, it will not be as durable or flexible as AquaStone. Plus you cannot easily stain over unpainted drywall mud like you can with AquaStone. Substitute products are available from Pro Faux, DuroRock, Adicolor and Modern Masters.

BEHR METALLIC PAINT

Behr Metallic Paint (from Home Depot) creates an alluring look with a rich metallic luster. The metallics have a high concentration of metallic particles for an opaque shimmer.

CAKE DECORATOR

You can create many of the same effects as you can on a cake, but using heavy-bodied paint products instead. Cake decorators are found at any craft store.

CHIP BRUSHES

Chip brushes are indispensable tools of the trade which are used to apply glazes, stipple edges, paint a strié pattern, cross hatch, and more. They're inexpensive and disposable.

DENATURED ALCOHOL

Denatured alcohol is a superior, fast-evaporating product that can remove dry or partially dried water-based paints.

FAUXCREME COLOR

FauxCrème Color is a combination of non-organic color ground in a proprietary water-based resin. FauxCrème Color can be used alone or as a color additive that can be mixed to tint any Faux Effects product. FauxCrème Color is used alone for trompe l'oeil, stencil work, floor cloths and murals. You

can often substitute a high-quality artists' acrylic paint such as FolkArt, Jo Sonja, etc., for FauxCrème Color.

FLUORESCENT PAINTS

Fluorescent paints will glow under black light. There is also an invisible fluorescent paint that appears only under black light. Add the 3D glasses to this and you get a three-dimensional paint effect! 3D is becoming huge as well: Pixar is now making movies in 3D and Crayola is making 3D chalk.

FX THINNER

FX Thinner is used to reduce the color concentration of Stain & Seal. It is also an excellent acrylic-based color thinner for raw wood, concrete or color over staining.

JAPAN SCRAPERS

Japan scrapers (see photo #8 on the facing page) come in a set of four stainless steel scraping blades and can be used to apply or remove materials in a wide variety of ways.

LASER LEVEL

A laser level (available at home centers) can be used to create accurate, level horizontal lines and plumb and straight vertical lines on walls, floors and ceilings. It allows you to follow the laser beam and not have to draw your lines onto the surface.

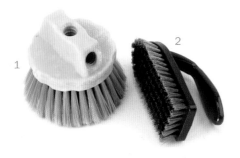

LEON NEON

A Leon Neon (see photo #1 above) is a 5-inch (13cm) round nylon brush used to apply glaze over textured or flat walls. You can use it for swirled, stippled, striated or pounced finishes.

LUSTERSTONE

LusterStone (see photo #6) is a revolutionary architectural coating that produces beautiful reflective stone-like patterns. It is available in over forty different colors. There are a few similar products to LusterStone in the market place, such as Shimmer-Stone by Modern Masters.

MAGIG METALLICS STEEL

Magic Metallics Steel is a paint medium that has real steel particles in it, which will oxidize and rust when aged with Magic Metallics Rapid Rust liquid patina solution. Modern Masters also makes a line of reactive paints.

MAGIC METALLICS RAPID RUST

Magic Metallics Rapid Rust is a liquid patina solution that will rust the Magic Metallics Steel paint when applied over it.

METALGLOW

MetalGlow is a beautiful, lustrous paint that seems to glow from within. When properly applied, it can be used alone or as a basecoat for decorative glazing, stenciling and artistic embellishments. Other brands of water-based metallic paints are available at art and craft stores.

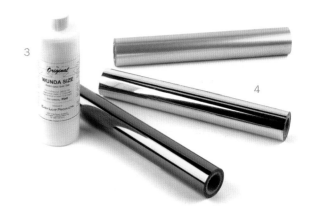

METALLIC FOILS

Metallic foils (see photo #4 above) come in a wide variety of colors and hologram effects. The foils are on clear acetate and will transfer to a size product like Wunda Size for an endless array of beautiful effects.

MODELLO

Modellos are one-time-use decorative patterns made out of adhesive-backed vinyl. Developed by Melanie Royals of Modello Design Group, LLC, modellos are used to transfer decorative designs to any surface, including wood, glass, mirrors, etc.

9-INCH SPONGE ROLLER

This large sponge roller is incised and is used to apply a random natural-sponge pattern onto a surface much faster than using the traditional sponging methods.

PALETTE DECO

Palette Deco is a durable, paste-like, water-based product that can be applied in a variety of ways and does not need a protective topcoat. It comes in clear, black, white, and a variety of metallic colors.

PLASTERTEX

PlasterTex is a specially formulated textured material designed to produce a grained plaster finish. I know of no other substitute for this product.

ROBERT RUBBER

A Robert Rubber (see photo #2) is a scrub brush used to adhere foil to tacky size; also can be used for burnishing.

SETCOAT

SetCoat by Faux Effects is a durable wall, trim and cabinet finish. It is 100 percent acrylic and has superb bonding and sealing qualities that can easily be sanded to a smooth finish. SetCoat allows the most open time for your glazes when using AquaCreme and AquaGlaze. You can substitute any low-sheen acrylic paint for this product, but they may not have the superb bonding properties that SetCoat has. If using SetCoat as a basecoat underneath a treatment, you may also use an eggshell or semi-gloss as a substitute in a 100 percent acrylic product.

SQUEEGEE

A squeegee is normally used for cleaning windows but with a little creativity, this tool can produce a multitude of designs by cutting a repeating pattern of notches into the rubber edge.

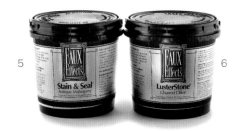

STAIN & SEAL

Stain & Seal (see photo #5 above) is a water-based stain and seal gel which can be used for staining or antiquing and also as a tint for AquaCreme or AquaGlaze. It comes in a variety of wood tones and is rich and deep in color saturation.

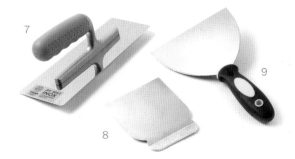

STAINLESS STEEL TROWEL

This is a sturdy trowel (see photo #7 above) with plain, straight, un-notched edges and is used to do any plaster finish and to apply texturing products to stencils and modellos.

6-INCH TAPING KNIFE

A taping knife (see photo #9 above) is used to apply or remove heavy-bodied materials like dry wall mud or Wood Icing.

STENCIL BRUSHES

Stencil brushes have very stiff bristles and are used to pounce or swirl stencil paint or other products into the open areas of acetate stencil patterns.

WHIZZ ROLLER

A Whizz roller is a 4-inch (10cm) roller on a handle which is used to apply glazes, paints or stains.

WOOD ICING

Wood Icing is a heavy-bodied faux finish and furniture refinishing paint product that is sculptable and stains beautifully like wood.

WUNDA SIZE

Wunda Size (see photo #3) is a water-based gold size which is specially formulated for every type of gold or silver leaf work. It is also a perfect size to use for transferring metallic foils.

YES! PASTE

Yes! Paste is an all purpose glue that can be used to hold objects onto horizontal, vertical or overhead surfaces because of its paste consistency.

>> How to Use Faux Finishing Tools and Products

LEARNING HOW to use a few of the tools and products commonly employed by professional faux finishers will make your painting much easier. If you run across an instruction in the demonstrations that you don't understand, come back to these pages. With a little hands-on practice, you'll soon master the techniques the professionals use and you'll have a lot more fun in the process!

CHIP BRUSHES

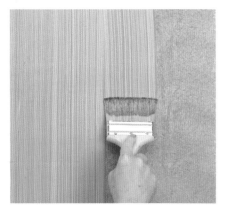

1. Use a 4-inch (10cm) double-wide chip brush to pull a strié pattern in a wet glaze.

2. Use a 2-inch (5cm) chip brush to pounce your glaze evenly against a woodwork trim or ceiling lines throughout the room.

3. A 3-inch (7.6cm) chip brush is great for cross-hatching a design in two colors, such as magenta and lavender as shown here applied on a Woody Yellow background.

WHIZZ ROLLERS

1. Use the Fab roller cover on a Whizz Roller to apply texture to a surface. The longer fibers help to apply a lot of product quickly.

2. Use the Velour roller cover with its shorter nap to apply size. Wash the size out of the cover as soon as possible when you're finished or you'll have a sticky roller.

3. You can use two Whizz Rollers at the same time to apply two different colors of glazes—a faster way to apply glazes if you're working on a large surface area.

SPONGE ROLLER

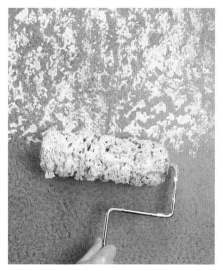

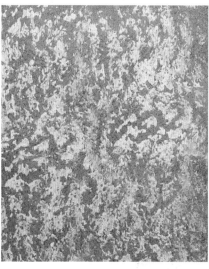

1. This 9-inch (23cm) sponge roller is deeply incised with random low and high places. It uses a lot of product, so place a good amount of paint in a 5-gallon bucket with a 5-gallon grid screen to roll your roller onto, or use a large paint pan.

2. Roll the texture on but don't go over the area you just applied—keep moving to a clean area.

3. This is how the texture looks when applied with a sponge roller. It's so much easier and faster than dabbing it on one spot at a time with a natural sea sponge!

JAPAN SCRAPERS

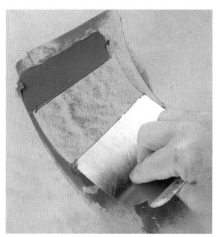

1. Load just the top edge of the Japan scraper with your product.

2. The advantage of a Japan scraper is that the blade is very flexible and allows you to remove the maximum amount of material from the surface.

3. To apply texture, your fingers must be on the side edges of the blade, so the blade can lay almost totally flat to the surface as you apply the material.

STAINLESS STEEL TROWEL

1. Butter the flat blade of the stainless steel trowel with a thin amount of product. Here I'm using an orange color of LusterStone called "Cantaloupe," but this works on any dimensional textured plaster such as Venetian plaster and drywall mud.

2. Hold the blade at a 45° angle…

3. …and scrape off as much product as possible with a firm pressure.

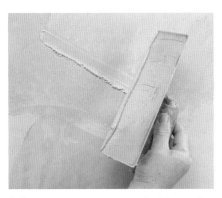

4. As you scrape, you can see that the product gathers on the edge that is touching the surface.

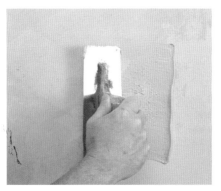

5. With the excess material on your blade, lay the blade flat and apply that material to continue the skim coat process.

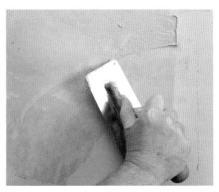

6. Take your blade back up to the 45° degree angle for the removal. The higher the angle of your blade to the surface, the more material you can remove. To add material to the surface, you want your blade almost flat and parallel to the surface.

WUNDA SIZE & METALLIC FOILS

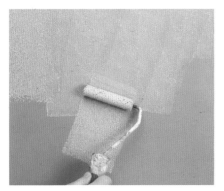

1. Use a Whizz roller with a Velour cover to apply Wunda Size. Let it tack up for a minimum of 15-20 minutes.

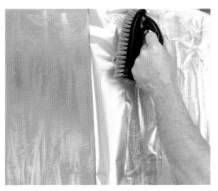

2. Transfer a metallic gold foil using a Robert Rubber.

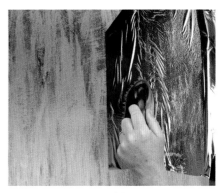

3. Other metallic foil colors you can use are Celadon Green and Bronze.

LUSTERSTONE

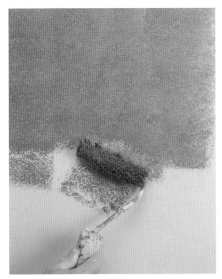

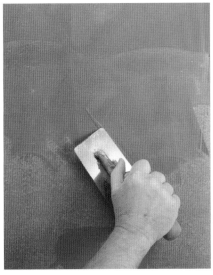

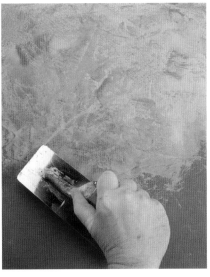

1. Load a Whizz roller (with a Fab cover) with a LusterStone color and apply to your surface. LusterStone's metallic sheen is very subtle—good for a surface where you don't want something as shiny as a metallic paint or foil.

2. Troweling on the LusterStone will show a bit more of the metallic sheen.

3. Backfill with another color of LusterStone for more depth and interest. Here I'm using "Cantaloupe." Use colors that fit your décor.

REACTIVE PAINTS

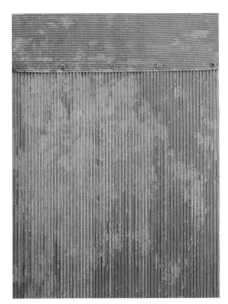

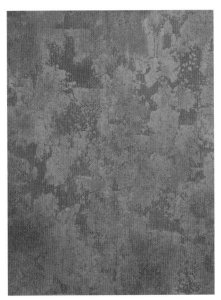

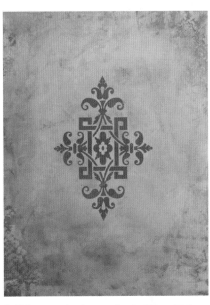

1. Reactive paints are real metal paints that will patina when hit with a reactive agent. This shows a copper finish that's had a patina agent applied to produce the distinctive greenish color of verdigris.

2. This is a real rust finish. An activator was applied over a real steel paint to produce actual rust.

3. This example shows a LusterStone background with a rust modello.

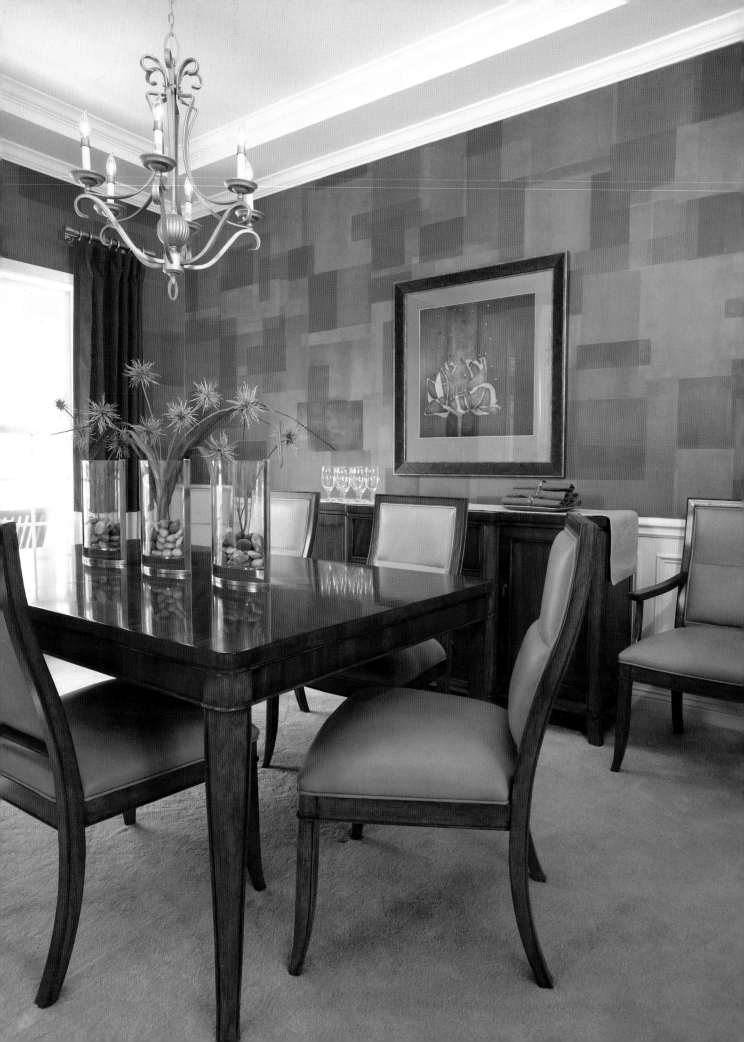

Layered Silk

TAMMY BURGESS

Translucent, layered shapes create a depth that viewers will have to touch before their eyes are convinced it's not wallpaper. This technique gives the illusion of thin sheets of overlapped silk. It's a dramatic effect that is easily achieved by painters of any skill level. Give it a try, using the colors of your choice to match your decor.

MATERIALS

- Basecoat: "Coffee Bean" eggshell latex (Porter Paints) or an equivalent dark brown shade
- 2-inch (51mm) low-tack painter's tape for delicate surfaces
- 7 to 10 sheets of poster-board cut into rectangular shapes of various sizes
- Small level
- 4-inch (10cm) Whizz Roller
- LusterStone: Brown Suede, Mandarin Red, Copper

>> PRO TIPS

1. Rectangle Sizes
Repeating the same 7 to 10 shapes throughout the design helps keep the unity of the project. If the sizes are too varied, the finished design can appear a bit messy and without continuity.

2. Shape Placement
Placing the shapes randomly is extremely important so as to not form any sort of repeating patterns. The first color should cover half of the surface, leaving random openings for the next two colors.

3. Rolling On LusterStone
When your load your Whizz roller with LusterStone, do not overload the roller with product. Roll a thin layer of LusterStone in each rectangle, always going in the same direction with the roller, e.g., top to bottom. This will allow it to dry evenly.

4. Overlapping Shapes
To really make this technique pop, it is important to overlap your rectangular shapes quite a bit. The translucent, overlapped areas will add color and depth to the surface.

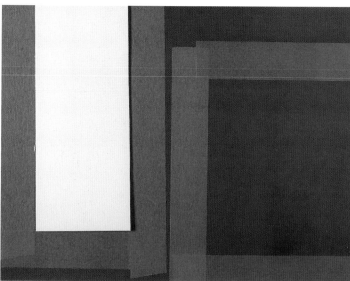

>> **STEP 1:** For the basecoat on your wall, apply two coats of a warm, dark brown latex paint in an eggshell finish. I used "Coffee Bean" by Porter Paints. Let dry completely before going on to the next step.

>> **STEP 2:** Using posterboard, carefully cut out 7 to 10 different sized rectangles. Place a piece of low-tack painter's tape (small tacks could also be used) on the back of a rectangle and press it to the wall. Use a level to make sure the rectangle does not lean in either direction. When it's right, tape around the outside of the rectangle with 2-inch (51mm) low-tack tape (shown at left in the photo above) to form a frame. Remove the posterboard rectangle, leaving just the taped shape (shown at right in the photo). Repeat this step, covering 25 percent of the wall surface in a consistently random fashion.

>> **STEP 3:** Using a 4-inch (10cm) Whizz Roller, apply a layer of Brown Suede LusterStone to a few rectangles at a time, then quickly remove the tape surrounding the still-wet shapes (do not allow the LusterStone to dry before you remove the tape). Continue this process, painting a few shapes at a time and removing the tape, until all the rectangles you taped up in Step 2 are filled in with this color.

>> **STEP 4:** Repeat Steps 2 and 3, still using Brown Suede LusterStone, covering one-half to three-quarters of the wall surface. Make sure to overlap some of the previously painted squares.

>> **STEP 5:** Repeat Steps 2 and 3, using Mandarin Red LusterStone. These new rectangles should be placed randomly across 25 percent of the wall surface area, overlapping parts of both the dark brown basecoat and the first layer of Brown Suede LusterStone rectangles.

>> **STEP 6:** Repeat Steps 2 and 3, taping off rectangles for a final 25 percent coverage to the surface. Roll on Copper LusterStone for these final rectangles.

>> **FINISH:** Continue with the final coverage using the Copper LusterStone. When you finish, the original dark brown basecoat will be completely covered with one or more layers of the LusterStone colors. It's this layering that gives the finish its depth and dimension and creates the look of translucent silk.

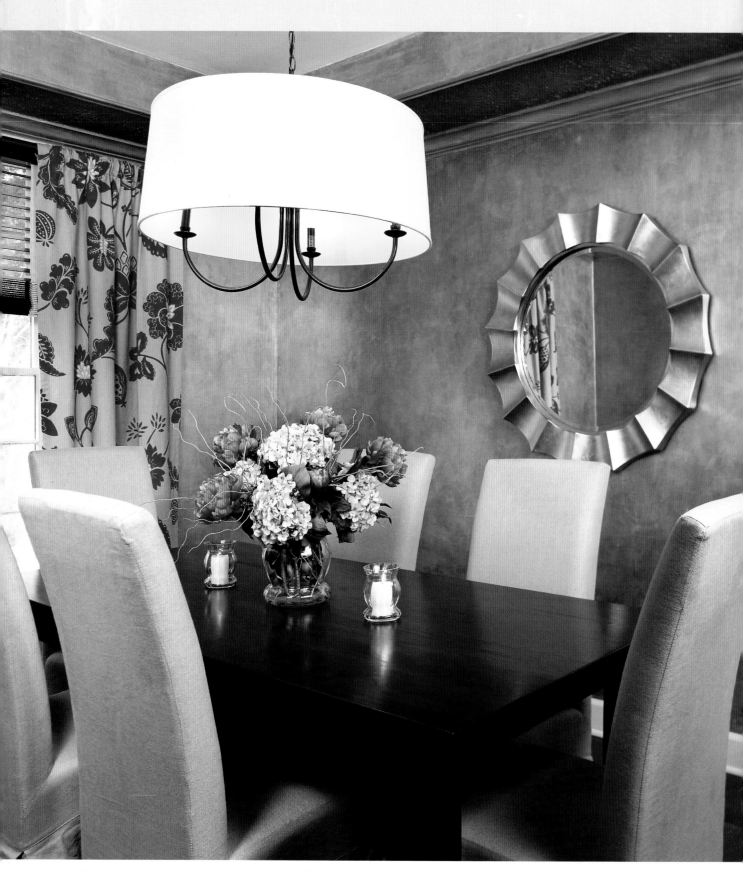

Angela Morton Interior Design.

Silver Patina

GINA RATH

This particular dining room was originally painted a deep red; the homeowner (an interior designer) wanted silver walls that emulate the silver patina finish often seen on high-end furniture and mirrors. Many sample boards later this elegant finish was created and is stunning in this contemporary dining room setting. This unique finish would also be beautiful in a Hollywood style bedroom or would make a significant statement in a tiny powder room.

MATERIALS

- Basecoat: "Krypton" satin latex (Sherwin-Williams) or an equivalent blue-gray color
- Palette Deco: Metallic Silver and Metallic Pearl
- Stain & Seal: Rich Brown and American Walnut
- SoSlow Super Extender
- FauxCrème Color: Black
- Whizz Roller
- Japan scrapers
- Cotton rags

>> PRO TIPS

1. Start with Sample Boards
Before starting any large room project, always do a sample board first so you are comfortable with the products in each layer, then you can adjust any step to suit your taste.

2. Make Adjustments
If you like a more textured finish, simply adjust the thickness of the application of the Metallic Silver Palette Deco. Palette Deco can also be thinned with water if needed. Apply more stain if you want the walls darker. If they are too dark for your liking, don't panic; simply spritz with water and rub with a rag to lighten.

3. New Life for Old Fixtures
Recycle and reclaim. Before tossing out your old brass light fixture, you might try updating it with this technique. Be sure to use a basecoat for metal, then simply follow the same steps. A gloved finger works to apply the Palette Deco to small and curved areas. Caution: the Palette Deco dries quickly and is difficult to remove from fingernails, clothing and carpet, so cover your clothing and floors appropriately. An apron, drop cloths and gloves are your friends!

>> **STEP 1:** Basecoat your wall surface with a blue-gray color. I used Sherwin-Williams satin latex "Krypton." Let dry for at least 24 hours before going on. Using a Japan scraper, apply Metallic Silver in vertical strokes for a really thin coat. You want to see a little texture and the blue-gray wall color behind it—about 85 percent coverage. Let dry.

>> **STEP 2:** Apply a skim coat of the Metallic Silver over the first coat with 100 percent coverage. It should be thin enough that you can still see a bit of the blue-gray wall color behind it. Let dry.

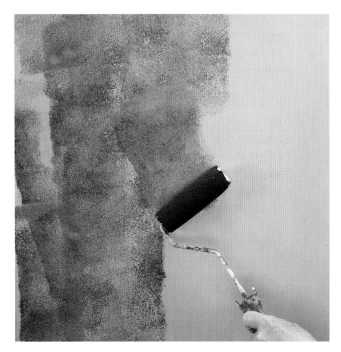

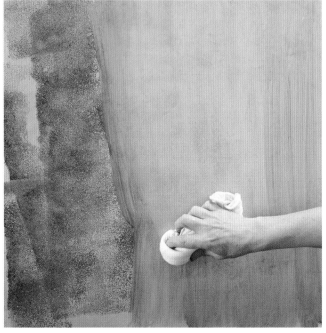

>> **STEP 3:** Mix up a 3 to 1 ratio of Stain & Seal Rich Brown to American Walnut; add a little SoSlow extender, no more than 10 percent. Use a Whizz roller to apply lightly to the wall in small sections, about a 2-foot (61cm) square area. Do not let it dry before going on to the next step.

>> **STEP 4:** Using a clean cotton rag, blend and wipe the Stain & Seal to remove the excess. Let dry.

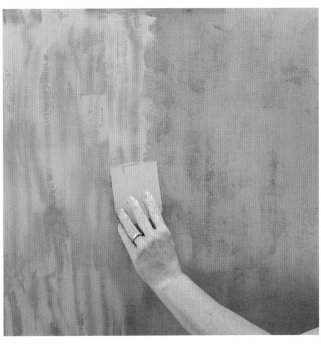

>> **STEP 5:** After the stain is blended and wiped off, step back and take a look. If you like the look of the finish at this point, you can stop here. If you prefer more of the Metallic Silver to show, continue rubbing off the stain until you like the effect.

>> **STEP 6:** Mix Metallic Pearl with a drop of Black FauxCrème Color. Apply to the wall surface using a Japan scraper to get 100 percent coverage. Let dry completely.

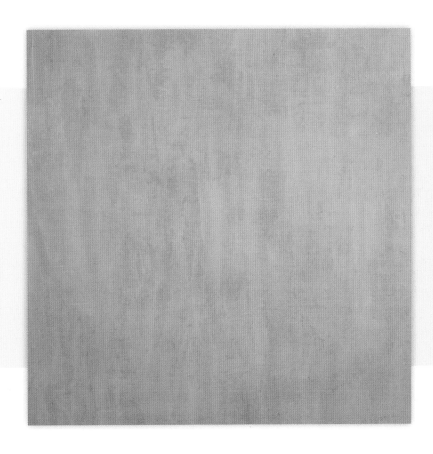

>> **FINISH:** The Metallic Pearl adds a little bit more reflectivity and an aged silver shine without it being too dark. Compare this finish with the one you see in Step 2. A soft patina finish adds warmth and depth while preserving the sheen of old silver.

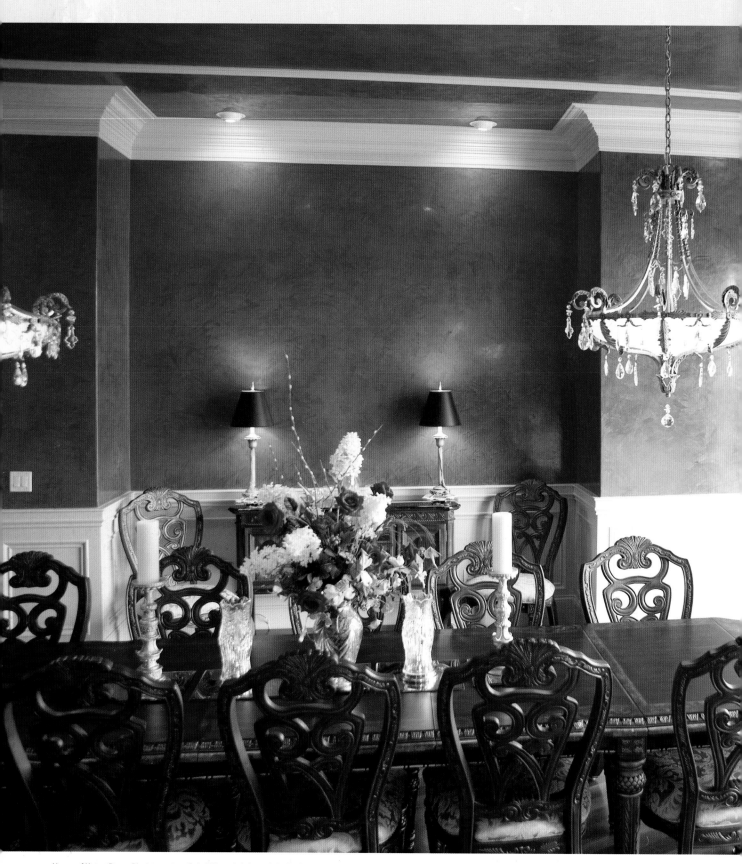

Home of Karen Rowe. Photo courtesy Gale Kirkpatrick / www.imaginationsphotography.com

Veneziano Polished Italian Plaster

RIK LAZENBY

Veneziano plaster is an exquisite finish created with materials that have been imported from a small town near Verona, Italy. This beautiful finish is produced by applying thin layers of primer and finish plaster, thus creating a final product that has depth and a stunning first impression. It is the type of finish that makes the viewer want to touch it. Veneziano Polished Italian Plaster is easily taught but is somewhat labor intensive. However, the end result is fit for royalty.

MATERIALS

- 4-inch (10cm) paint brush
- Plastic pail
- Safra Colors Firmonovo
- Stainless steel beveled trowel
- Metal scraper (spatula)
- Drill with mixing attachment
- Arte Nova Stucco Veneziano Primer
- Arte Nova Stucco Veneziano Finisher (Neutral)
- Arte Color Colorants:
 #4 Bordeaux
 #13 Magenta
 #7 Blue
- Cheesecloth
- Soft cotton rags
- Safra Colors Millennium Wax
- Sparkle Gold Mica Powder

>> PRO TIPS

1. Firmonovo Tips

Firmonovo is clear. I add a small amount of the plaster colorant (Bordeaux) into the diluted mixture. This allows me to better see the mixture as I apply it and to be sure I have 100 percent coverage. I do not prep the wall and ceiling areas with tape until after Step 1 because the Firmonovo will cause the tape to release.

2. Troweling

Use a clean metal scraper (spatula) to dip the Veneziano Primer and Finisher from the bucket and apply it to the stainless steel trowel. This places the plaster on the trowel properly. The metal scraper is also used to keep the trowel clean. A dirty trowel will scratch the primer and finish layers.

3. Burnishing

When burnishing, be sure that your trowel is clean and the beveled edges are free of nicks, as this will cause scratches in the surface of the plaster. Also, quite often, sections of the wall become ready for burnishing before you can apply the finish plaster to the entire wall. It's helpful to have a second person available to burnish these sections as they are ready, so that you can continue to apply the finish coat.

>> **STEP 1:** Using a 4-inch (10cm) paint brush, apply a thin 100% coverage of Firmonovo to the wall area. The Firmonovo should be diluted 200% with water. This 200% dilution is recommended for applying over a nonporous surface such as primed gypsum board. Firmonovo adds strength to the substrate and helps the plaster bond with the substrate. Let it dry thoroughly before proceeding. (See Pro Tip #1.)

>> **STEP 2:** Load a small amount of Veneziano Primer onto the stainless steel trowel and apply the primer to the wall in short, choppy strokes in various directions. Keeping the blade of the trowel at a 45° angle, pull the primer as far as possible across the wall. The end result should be a surface that is as smooth as possible, so pull the primer tightly. Allow the Veneziano Primer to dry for 24 hours.

>> **STEP 3:** Tint the Veneziano Finisher with colorants (I used Arte Color Bordeaux, Magenta and Blue) and mix with an electric drill and mixing attachment. Load a trowel with a small amount of finish plaster and apply it to the wall. Keeping the blade of the trowel at a 45° angle, pull the plaster across the surface in different directions as far as it will go before reloading. This first layer of Veneziano Finisher should be smooth with a minimum of high areas in the plaster. Let dry.

>> **STEP 4:** Begin the second and final layer. Load the trowel with a small amount of the tinted Veneziano Finisher and apply it to the wall. Use the same choppy technique, pulling the plaster in different directions. Smooth any high areas of plaster as you work across the wall. When the second layer of Veneziano Finisher is almost dry, it must be burnished.

>> **STEP 5:** The second layer of the Veneziano Finish plaster should be burnished shortly before it dries. Depending upon the thickness of application, the humidity and temperature, the plaster is usually ready to burnish between five and twenty minutes from the time it is applied. When burnishing, first lightly run the beveled edge of the trowel across the wall to close off the plaster.

With minimal pressure, begin to burnish. Laying the beveled edge of the trowel against the wall at a 30° angle, begin to run the blade against the section that you are burnishing. This motion feels as though you are trying to push the plaster across the wall. You will eventually burnish the entire surface of the plaster by pushing or pulling the trowel in all four directions: right to left, left to right, top to bottom and bottom to top. Every time that you change the direction of the trowel, you can add more pressure to the trowel as you move it across the wall. This will intensify the shine. The more you burnish, the deeper the shine.

To finish the burnishing process, use a soft cloth and rub the burnished section of the wall with a circular motion. This brings out the shine and ensures that all areas are burnished, including the low spots in the plaster. (See Pro Tip #3.)

>> **FINISH:** The burnished Veneziano plaster must be totally dry before waxing. Millennium wax with gold mica powder is applied using cheesecloth to small sections of the plaster. The wax should be applied in a thin coat and immediately removed with a soft, clean cloth. I apply the wax by softly rubbing it onto the surface of the plaster in a circular motion. The wax is then removed with a soft, clean cloth by rubbing in a circular motion. The wax will intensify the shine of the plaster and the gold mica powder will remain in the low areas of the plaster.

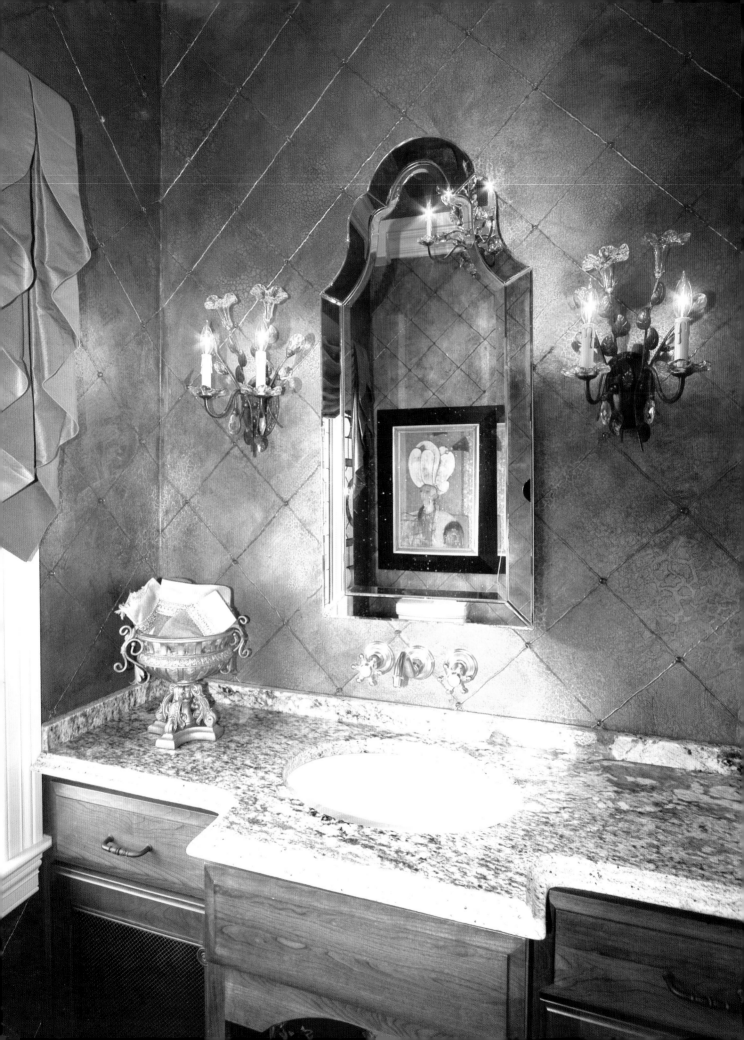

Crackle Foil

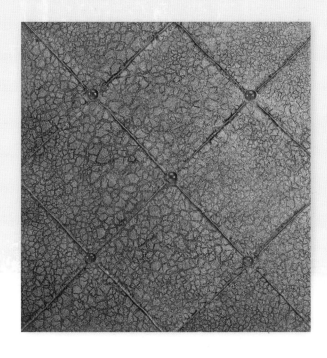

GARY LORD

If you want a decorative paint treatment that has a lot of *Wow!* factor to it, this is the one. This finish combines many of the most popular design elements found today in the decorative painting field. It has a combination of metallic sheen and texture with the use of metallic foils and a crackle texture. On top of that, it has a raised stencil motif accented by three-dimensional beading. This is a very unique look that can be altered to fit any décor by changing the stencil, the colors of the foil and the stain color.

MATERIALS

- Level or laser level
- Pencil and yardstick
- Low-tack painter's tape
- Palette Deco white acrylic
- Cake decorator with star tip
- SetCoat: Metallic Bronze
- Wunda Size
- Metallic Foils in Bronze, Celadon Green and Antique Gold
- Robert Rubber

- AquaSize
- AquaCrackle Clear
- Chip brush
- Whizz Roller
- Stain & Seal: Antique Mahogany
- FX Thinner
- Flat-backed glass beads from any craft store
- Yes! Paste

>> PRO TIPS

1. Making a Diamond-shaped Pattern

To lay out your diamond pattern, start your design on the main focal wall in your room. Measure the height of your wall to help you decide on the size of your diamond shapes. A standard 8-foot (2.44m) high wall is 96 inches (244cm). So one easy height for your diamonds would be 12 inches (30.5cm) because it divides evenly into 96 inches (244cm). If the height of one diamond pattern is 12 inches (30.5cm), you will have 8 full diamonds in a vertical row. To lay out the pattern, find the center of the width of the wall and use a level or a laser level to create a vertical plumb line down the center axis of the wall. Starting at the ceiling, measure down and place a dot at every 12 inches (30.5cm) on this line. You will have 7 dots when you're finished. Now to the right and left of this main vertical line, measure over 12 inches (30.5cm) and repeat, placing 7 dots along those vertical lines. Continue in this same manner placing all the dots on the wall, then use a pencil to connect the dots on their diagonal access points to create the diamond shapes.

2. When to Basecoat the Surface

Mistakes will happen when you're drawing up your lines on the wall due to mathematical errors. Don't be concerned about that—basecoat the surface after all the lines are drawn up and the raised line beading is done.

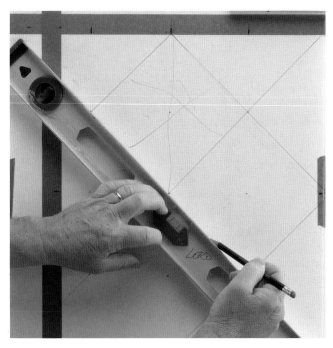

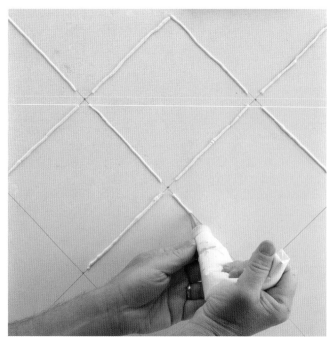

>> STEP 1: Apply a strip of low-tack painter's tape on the wall at the top to show you where your center point of the wall is. Also use a piece of tape at the bottom of the wall to show the center point there as well. Connect these dots with a plumb line or a laser level beam. Now use your template to draw the dots on the surface. Use a pencil, not a marker, when doing the dots or lines so the basecoat will cover them over later.

>> STEP 2: Fill a cake decorator with white Palette Deco acrylic and squeeze out a small amount in a push-and-pull technique to create raised lines. Leave blank spots where the lines intersect to create a flat area for your glass beads to sit flush on later. Allow these raised lines to dry completely, usually overnight.

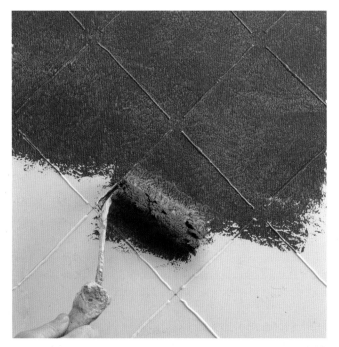

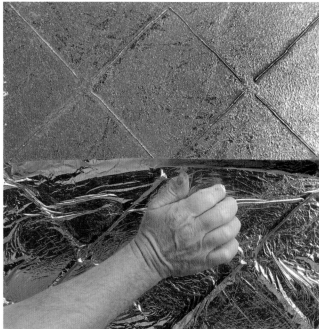

>> STEP 3: Using SetCoat Metallic Bronze, apply a basecoat with a Whizz Roller covering everything, including the raised bead lines. Let dry. We put the basecoat on now because it hides any errors or extra pencil lines and dots, or any problems with the cake decorator. One coat is all you need.

>> STEP 4: Roll on two coats of Wunda Size over the entire surface and let it tack up, preferably overnight. Crumple, then un-crumple, a sheet of Antique Gold foil and place it shiny side up over the tacky surface. Use a Robert Rubber to rub over the gold foil, aiming for about 30 percent coverage (use your hand to press over the raised lines). Do the same with Celadon Green foil, filling in another 30 percent coverage.

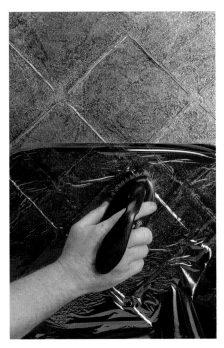

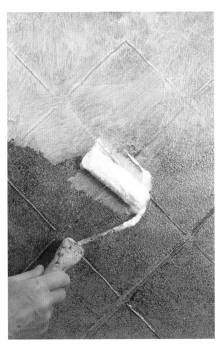

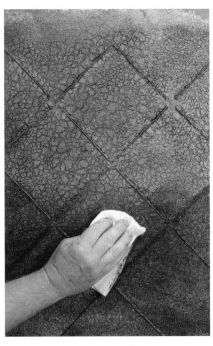

>> STEP 5: Fill in the remaining 30 percent of coverage by transferring the Bronze foil using a Robert Rubber for the field, and your fingernails for the raised bead lines. After the Bronze foil is applied, roll on one coat of Aqua-Size in a random crosshatch motion covering 100 percent of the surface with a medium density of material. Allow it to tack up.

>> STEP 6: Now roll on a medium coat of Aqua Crackle Clear. Work in a small 8-inch (20cm) square section at a time, rolling in crosshatch motions, with light pressure. Do NOT go over sections you've already rolled on or the crackle medium will lift. Allow it to crack fully, at least 2-8 hours.

>> STEP 7: Mix a glaze of Stain & Seal Antique Mahogany cut with 10 percent FX Thinner. Test for depth of color and adjust as needed. Roll or brush on the glaze, then pat off with a rag or cheesecloth. The glaze sinks into the cracks of the crackle.

>> FINISH: To finish, apply glass beads in the color of your choice at the intersections of the raised lines, using a small dollop of Yes! Paste or a hot glue gun on the back flat side of the bead.

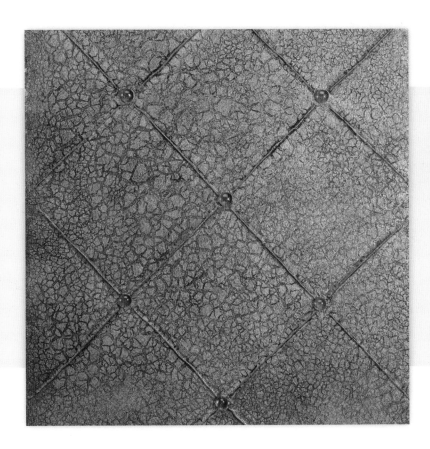

Abstract Collage

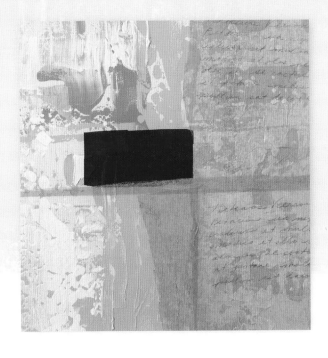

KIM METHENY & SUE WEIR

The inspiration for this finish came from a client's desire to incorporate her contemporary style with memories of her childhood in Italy. The paint was troweled onto the wall, which created a look of texture and defined areas of color. A recipe handwritten in Italian and transferred onto tissue paper, along with unexpected bits of red and blue tissue paper, brought in pops of color while complementing her kitchen style. This idea can easily be customized by changing out the recipe we used with a special saying, poem or letter.

MATERIALS

- Basecoat: Neutral White SetCoat or equivalent off-white 100% acrylic paint
- FauxCrème Color: Dark Brown
- AquaGlaze
- Benjamin Moore latex: Richmond Gold, Santorini Blue and Hot Spring Stone
- Sherwin-Williams Extra White ready mix color, and Macadamia

- 9-inch (23cm) taping trowel
- Colored tissue paper (including natural for the recipe)
- no. 2 pencil
- Mod Podge glue
- Chip brushes
- Cheesecloth

>> PRO TIPS

1. Color Tips
Start with darker colors and place them randomly around your wall. These are your accent colors and will peek out from under the lighter colors and create depth. Pick one to two lighter colors for overall effect and use colors that are in line with your decor.

2. Trowel Tips
The angle in which you hold your trowel will dictate how much coverage and what pattern you will achieve, as does the pressure you apply. Pushing hard at a 45° angle will give you a smooth look and a lot of coverage. Lightly skipping over the surface at a 20-30° angle will give you more texture and less coverage. Test your technique on a board to see what effect you like best.

3. Blending Tips
There is no reason to wait for the paint to dry as you move through the steps. This will help blend the colors as much or as little as you want. It is difficult to make a mistake with this finish. If you would like more or less of a color—just apply more of that color or cover the color you do not want with one that you like better. This allows you to have a lot of control.

>> **STEP 1:** Basecoat the walls with two coats of Neutral White SetCoat or any off-white, 100 percent acrylic paint. Let dry. Then, using a taping trowel, scoop up a small amount of Richmond Gold latex paint on the trowel and apply to the wall. Hold the blade at a 45° angle and pull the trowel in a downward motion. Apply the gold color in random areas, reloading the trowel as needed. Try to balance your placement, keeping in mind that you will be layering many colors. It will look spotty at this point.

>> **STEP 2:** Next, load the taping trowel with Santorini Blue latex paint. Again, hold the blade at a 45° angle and pull the trowel in a downward motion. Watch your placement and balance the colors against each other.

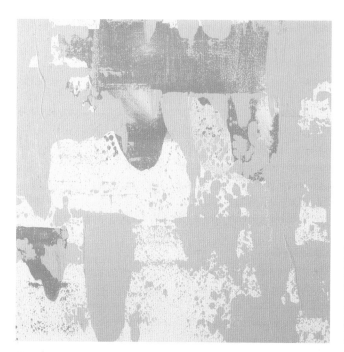

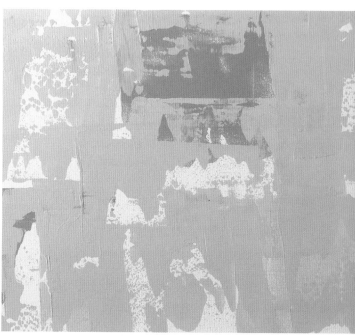

>> **STEP 3:** Repeat the application, this time with Hot Spring Stone latex paint, increasing the coverage and starting to fill in larger areas of color but still leaving the blue and gold peeking out from underneath.

>> **STEP 4:** Use the Macadamia latex paint in the same manner, again filling in larger areas of paint but allowing the previous colors to come through.

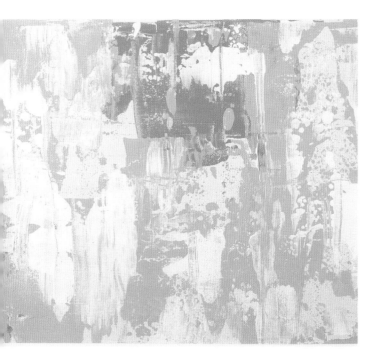

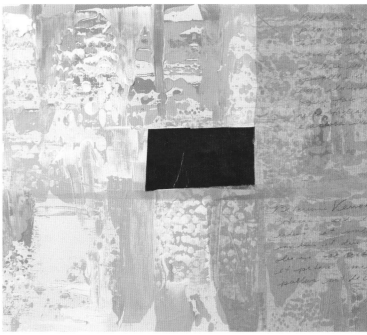

>> **STEP 5:** Apply the Extra White paint in the same way, randomly filling in areas to your liking.

>> **STEP 6:** Using colored tissue paper, cut out the burgundy rectangles and the long, blue streaks. The recipe collage pieces use sewing pattern paper or natural color tissue with the recipe written on it in pencil. Apply these pieces using a paint brush dipped in Mod Podge and cover the top of the tissue as well with the Mod Podge. This creates a barrier for the final step which is a finishing glaze.

>> **FINISH:** The finishing glaze consists of 2 cups of AquaGlaze, 1 tablespoon of Dark Brown Faux-Crème Color, thinned with about a fourth of a cup of water. Apply the glaze with a chip brush and smooth the surface with a piece of cheesecloth.

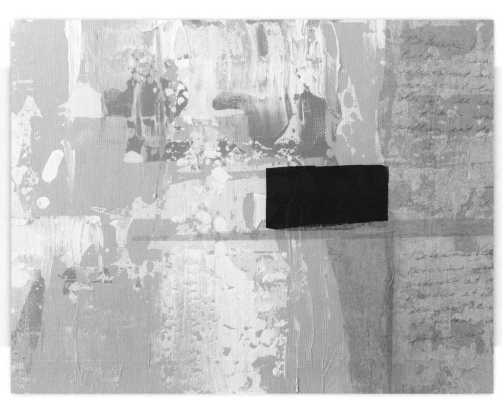

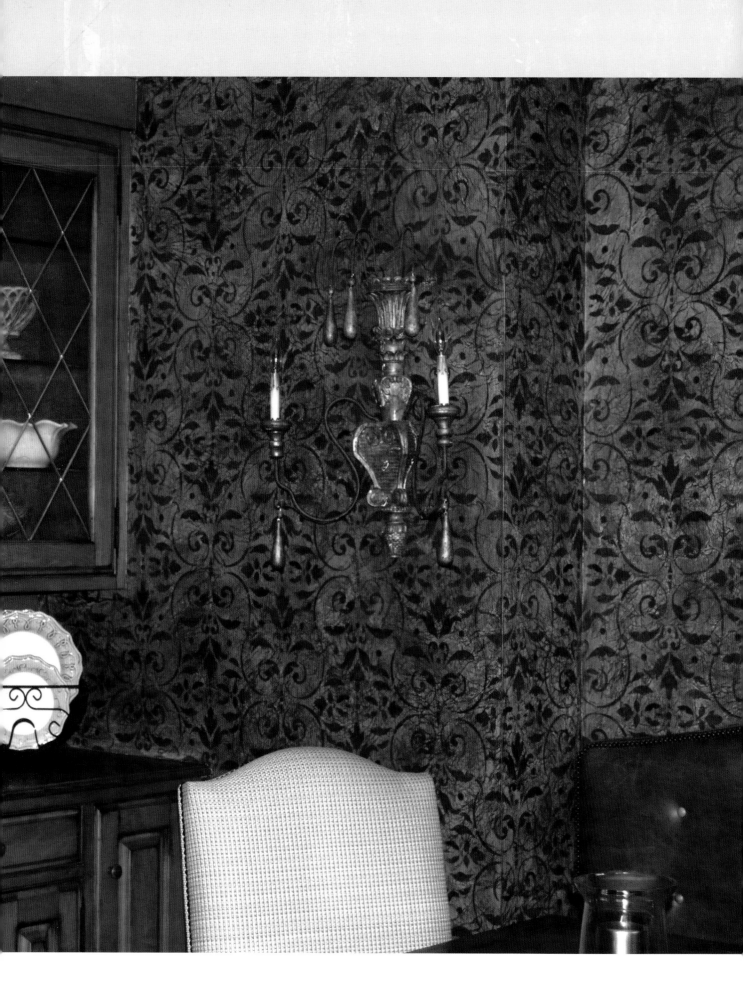

Pompeian Ornament Tavern Finish

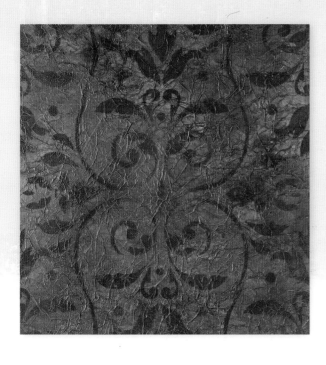

CYNTHIA DAVIS

This dramatic, textural finish is brought to life with Wallovers™ Pompeian Ornament Stencil. Wallovers stencils are designed to repeat into a beautiful, allover pattern using easy registration marks that allow you to connect the pattern like a puzzle. Bold or subtle, you can create a pattern that looks like you had the finest custom wallpaper designed just for your home. The design shown here complements the natural wood finishes and gives the room a warm and rustic feel reminiscent of an old inn or tavern.

MATERIALS

- White tissue paper in 24 x 36 inch (61 x 91cm) sheets
- Benjamin Moore Aquavelvet eggshell latex, "Baby Turtle," or an equivalent olive green color
- Stain & Seal: Rich Brown and Antique Mahogany
- LusterStone: Charred Olive and Copper

- Cotton rags
- Foam roller
- Elmer's white glue
- Wallovers™ Pompeian Ornament stencil and Topper™
- Wallovers™ Allover Stencil Brush
- X-acto knife
- no. 6 round artist's brush

>> PRO TIPS

1. When to Basecoat Your Walls

Do not basecoat the walls with the olive green color until after the tissue paper has been applied.

2. To Tear or Not to Tear the Tissue Paper

Some artists like to tear the tissue paper to avoid seeing geometric shapes behind the finish. I never tear the paper with this process. Once the paper is basecoated you'll never see the lines.

3. Trimming the Tissue Paper

When the walls are complete, use an X-acto knife to softly score the edges where the walls meet the trim to release any tape without tearing the paper finish.

4. Make Sample Boards

Always create a sample board and make notes as to the amounts and variation of colors you applied in every step. If you want to do this finish again later, you won't have to rely on your memory for the details.

>> **STEP 1:** You can begin the tissue paper step over any primed wall. Since you will be applying your basecoat color *over* the tissue finish, you can really go over any existing flat or eggshell water-based finish. Either prime the walls with water-based primer or clean and prepare the existing walls so they are ready for the tissue application.

Using white tissue paper (you can purchase it by the ream from any paper website), tightly ball up the tissue like a snowball. Release it back into its original form so it is a large piece with crinkles.

Create the glue mixture by mixing Elmer's white glue and water until it has the consistency of milk. Using a foam roller, roll an area a little larger than the full tissue sheet you are applying. Gently press the tissue paper flat against the wall, smoothing it over with your hand and allowing the creases to remain. Here's where you can choose how you want your wall to look. Large creases in the paper will show up as a more pronounced texture while flatter creases will make the walls appear more crackled and leathery. Roll another light layer of glue over the tissue-papered area, pressing hard so there are no bubbles. Apply another piece of tissue, slightly overlapping the last, in the same manner. Tear the tissue whenever it is too large for the space. Continue the same way until the wall is complete.

>> **STEP 2:** The amount of time it will take for the tissued walls to dry will depend on the weather and the temperature in the room. I make sure to let it dry at least overnight before applying the basecoat.

Apply 2 coats of "Baby Turtle" eggshell latex (Benjamin Moore Aquavelvet) or an equivalent olive green color.

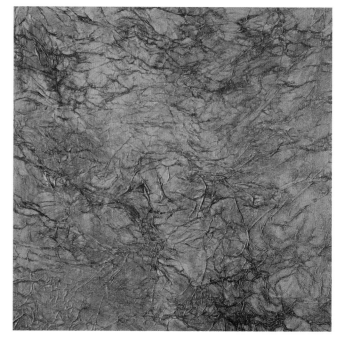

>> **STEP 3:** The process in this step may seem like a lot to do in one step. I prefer to do as few passes around the room as possible so I apply all these colors at once. You will need the following items during this step: LusterStone Charred Olive, LusterStone Copper, Stain & Seal Antique Cherry, Stain & Seal Rich Brown.

Make 4 containers, each containing some of the above products. Using a rag, apply some of each product on the wall, moving from one to the other and blending them as you go. You do not need to worry about dry lines because the products remain pretty wet as you move. Also, imperfections and dark areas become more interesting after the stencil is applied. You will be surprised at how dark spots and dry lines turn into your favorite parts of the wall. Complete the entire room applying these 4 colors with a rag.

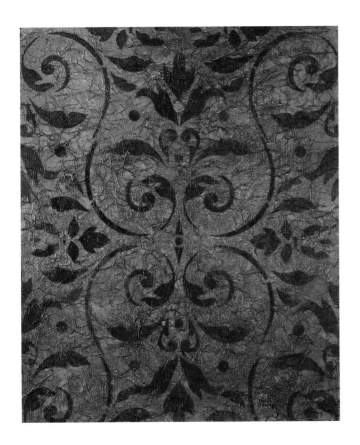

>> STEP 4: Using the Wallovers Pompeian Stencil and the Wallovers Allover Stencil Brush, apply the stencil using Stain & Seal Antique Mahogany. Stain & Seal goes very far so a quart will do more than a very large room. Put some Stain & Seal on a paper plate and just touch the brush to it lightly. Offload any excess paint onto a paper towel and begin painting the stencil in a soft pouncing method.

To begin your allover design, find the least conspicuous area of the room, possibly in a corner or behind a door, to start your stenciling. This way, if you complete the room and the pattern does not match up, it will not be very noticeable. Using the stencil registration marks on the outer part of the stencils, move the stencil to the right and then down, connecting it by registering it to the marks. This will create your "allover" design. When the main portion of the design is complete you can use the Wallovers Pompeian "Topper" to complete the missing area of the design up by the ceiling line. Just peel off the sticky back adhesive on the Topper, use the registration marks to line it up to the design already painted on the wall and begin to stencil the missing area. Complete this around the entire perimeter of the room.

You can stencil very evenly with a solid design for a more bold and contrasted look, or let the brush dry out as you go, creating soft, faded areas for a more antique look. Remember, you still have the opportunity to set your design back in the next step, so make sure not to stencil too lightly.

>> FINISH: Once the stencil is complete, you can give it a more handpainted look by connecting some of the breaks in the stencil with an artist's brush. Then you may want to add some sheen as well as soften the contrast of the design. Using a rag, apply LusterStone Charred Olive softly over areas that you want to set back. You can also use any of the other colors you had applied in Step 3 to set the design back, keeping in mind the end result of the color you want to achieve.

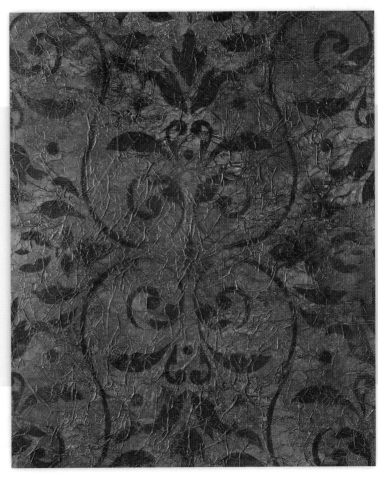

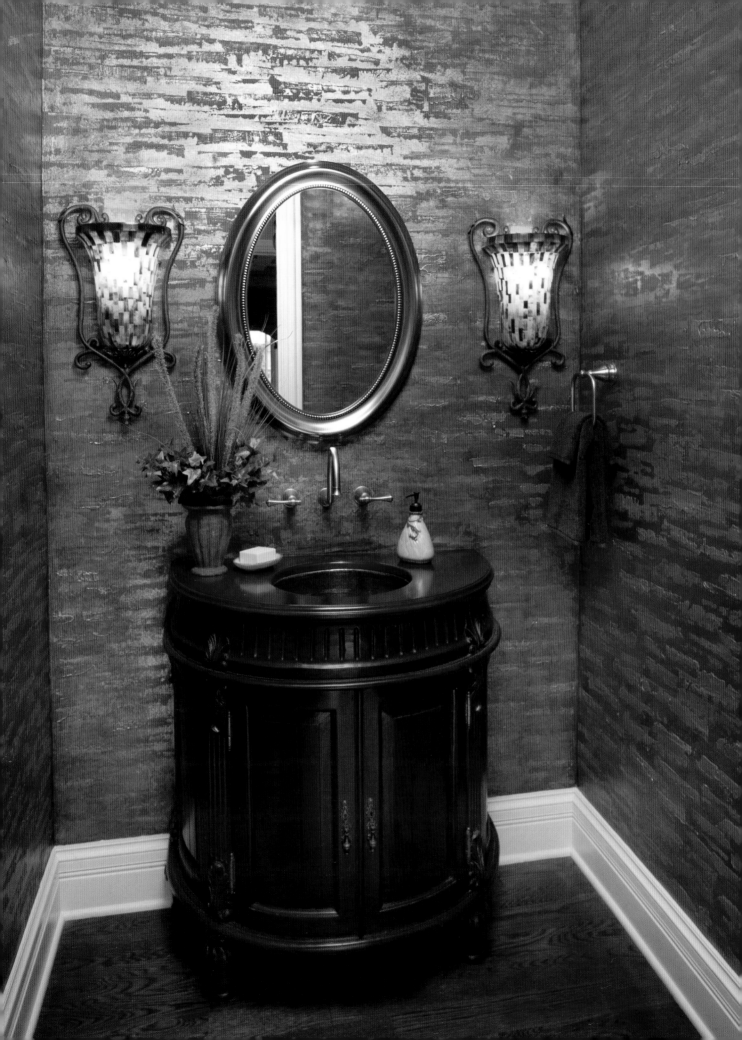

Rustic Bark

GARY LORD

This finish was created by my colleague Joe Taylor during one of my company's "play days" where we brainstorm and invent new techniques. The version you see here is a slight adaptation of that finish. This one was created specifically for a client's powder bath room. What I would like to see you do with the finishes in this book are the same as I did for this technique: keep the main concept the same but tweak the colors or pattern to go with your particular project.

MATERIALS

- Basecoat: Woody Yellow SetCoat
- Wunda Size
- 4-inch (10cm) Whizz Roller
- Metallic Foils: Antique Gold, Bronze
- Robert Rubber
- 6-inch (15cm) taping knife

- Wood Icing
- Wooden craft sticks
- Stain & Seal: Antique Mahogany
- 2-inch (5cm) chip brush
- Leon Neon brush
- Cotton rags
- MetalGlow: Pewter Gold

>> PRO TIPS

1. Tips on Applying Metallic Foils

When transferring a sheet of metallic foil to your surface after size has been applied and allowed to tack up, using the heel of your hand, start out with light pressure and work to a medium pressure, peeling back the foil to make sure the amount of transfer is what you want. If you want less coverage, press lightly; if you want more coverage, press a little harder. Or you can use a Robert Rubber, starting with light pressure and adjusting accordingly.

2. Avoid Seams

To avoid seams in your overlap areas, do not press all the way to the edge of your metallic foil with a Robert Rubber. Be wary of rubbing the finished transferred foil with the Robert Rubber because it will mar the surface.

3. Give Size Time to Tack Up

I find it works very well to apply two coats of Wunda Size and allow it to dry and tack up overnight, then transfer the foil the next day for a better release. For more detailed information on metallic foils and how to install them, visit my website at www.prismaticpainting.com/worksheet.lasso.

>> **STEP 1:** Apply a basecoat of Woody Yellow SetCoat. Let dry. Apply one coat of Wunda Size and let it tack up, usually within 10-15 minutes. Crumple up a piece of Antique Gold Metallic Foil, then un-crumple it and place it shiny side up loosely on the still-tacky Wunda Size. Use the heel of the palm of your hand (or a Robert Rubber) to press the foil until about 50 percent of the surface is covered with the gold foil

>> **STEP 2:** Pull a small part of the foil away from the surface to see if you've got about 50 percent coverage (you should still be able to see the yellow basecoat here and there through the foil). If not, replace the foil and continue pressing on it with firmer pressure. If you want to get more transfer than you're getting with your hand, use the Robert Rubber. Maximum transfer is achieved by using the Robert Rubber with fairly hard pressure.

>> **STEP 3:** Place the Bronze Metallic Foil, shiny side up, on the surface and using the Robert Rubber, firmly press down the Bronze foil to fill in as much negative space as possible.

>> **STEP 4:** Using a 6-inch (15cm) taping knife, apply Wood Icing in a horizontal choppy pattern. Load the blade of the taping knife as shown on page 72 ("Faux Bamboo" project) using wooden craft sticks. Let the Wood Icing dry completely before going on.

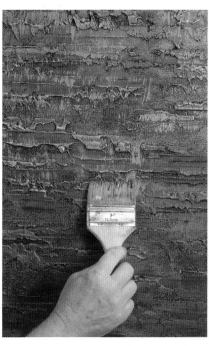

>> STEP 5: Apply the Stain & Seal Antique Mahogany with a Leon Neon brush, working the color into the texture of the Wood Icing.

>> STEP 6: With a cotton rag, wipe off any excess Stain & Seal before it dries.

>> STEP 7: Pick up some MetalGlow Pewter Gold on a chip brush and "tip" the high ridges and points of the texture.

>> FINISH: Don't worry if your finish doesn't turn out to look exactly like this. The goal is to make the finish attractive. Seldom, if ever, does my sample match the finished wall exactly. You just want it close.

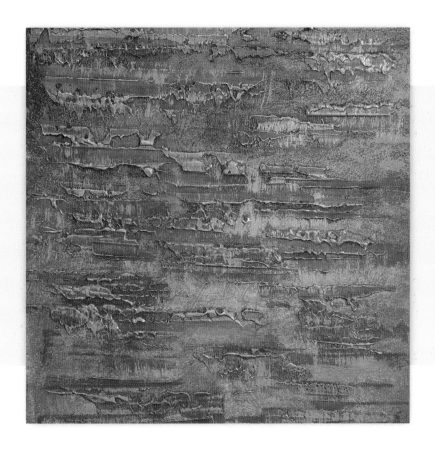

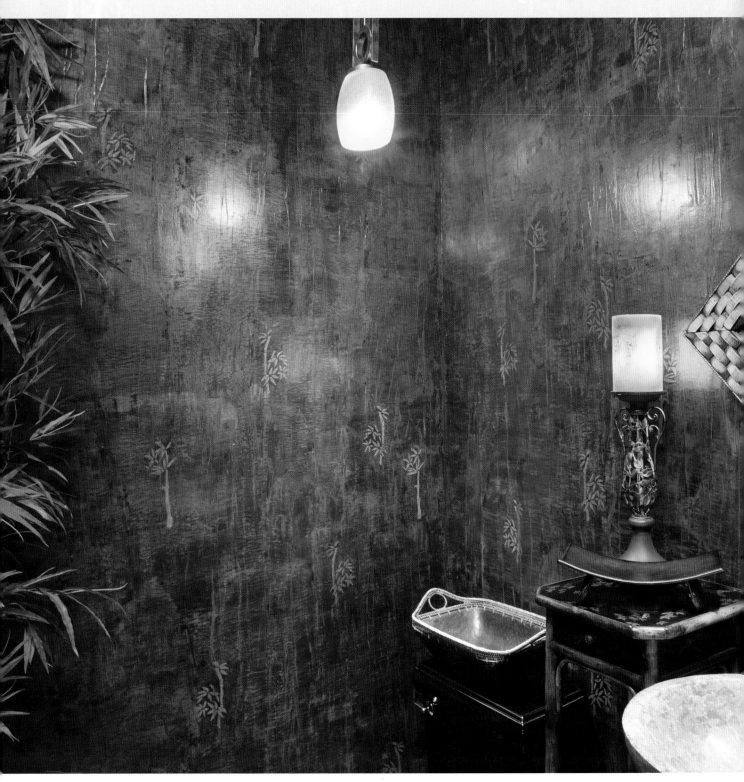

Photo courtesy The Greg Wilson Group.

Bamboo Noire

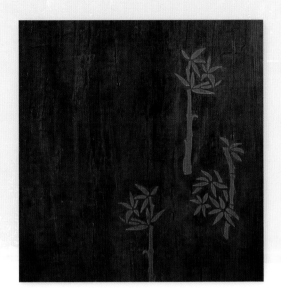

DONNA PHELPS

Bamboo Noire is a rich and elegant finish that's a perfect fit for one of today's most popular design trends—contemporary tropics. With the look of rare black bamboo and the smooth and shiny texture favored in modern stylings, Bamboo Noire is a great way to create sophisticated drama in a casually chic environment.

MATERIALS

- Basecoat: SetCoat Black
- Venetian Gem Black Onyx
- LusterStone: Antique Parchment
- SoSlow Super Extender
- Stain & Seal: Rich Brown
- Varnish Plus gloss sealer
- Low-tack painter's tape
- 2 low nap or seamless foam paint roller covers
- Several small polystyrene trowels cut into various widths
- Stainless steel trowel
- Foam brush
- Toweling
- Badger brush or other softening brush
- Natural Accents Stencil #SB-278 Small Bamboo (2 branches)

>> PRO TIPS

1. Extending the Open Time
The addition of SoSlow Super Extender will extend the open (working) time of the Venetian Gem and Luster-Stone, making it easier to manipulate these products during application.

2. Using Two Sets of Stencils
Two sets of stencils will provide you with a left and right facing version of each stencil and will give you more design options when stenciling an overall pattern.

3. Stencil Placement Tips
To plan your stencil placement, stencil a right and left facing image of the two stencil patterns on paper, then photocopy each in multiples. Using a low-tack tape at the top of each photocopy, place them around the room in various positions and groupings so that you can visualize the spacing and balance of your overall design. As you work around the room and arrive at each pre-positioned photocopy, just lift the bottom of the copy and slide your actual stencil into position. Gently remove the taped photocopies, taking care to not damage your finish underneath, and you're off to the races with no funky placements to haunt you later!

>> **STEP 1:** Basecoat your surface with 2 coats of SetCoat Black, allowing it to dry at least 2 hours between coats and at least 24 hours before applying the first layer of the faux finish (the black basecoat can be seen on the right side of the photo). For best results, be sure to use a low nap or seamless foam roller cover.

Add 5 percent SoSlow Super Extender with Venetian Gem Black Onyx and mix well. Using the various sizes of small polystyrene trowels, apply this mixture in a vertically pulled manner (as shown on the left side of the photo). Do this by picking up some of the Venetian Gem Black Onyx and Extender mix on one end of a small poly trowel. Apply that end to your surface and pull down as you offload the material. Alternate the different sizes of the small polystyrene trowels and vary your pressure and the angle at which you hold the trowel to the surface to create the look of bamboo with raised vertical striations and variations in width and texture that will enhance your final finish. Allow to dry completely.

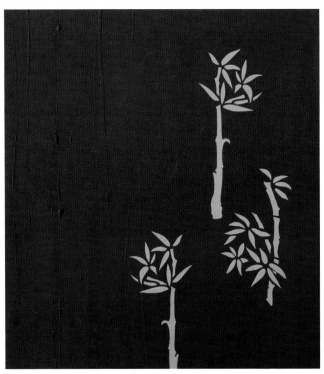

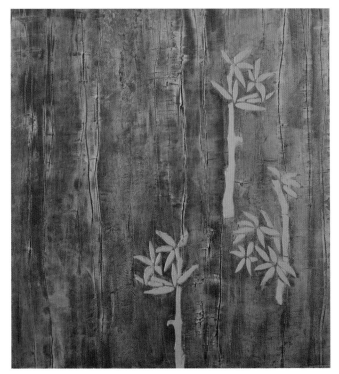

>> **STEP 2:** Determine the placement of the bamboo stencils (see Pro Tip #3). After plotting the overall design, position the first stencil and gently adhere it to the surface. Use a small polystyrene trowel to apply the LusterStone Antique Parchment through the stencil, being careful to not overload the stencil with material. Once you have completed the stenciling of that image, anchor it at the top with one hand and gently lift the bottom straight up and away, being careful to not let the stencil slide or drop back in to the wet image. Wipe any residue from the back of the stencil after each use and continue around the room in the same manner. Allow to dry completely before going on to the next step.

>> **STEP 3:** Add 5 percent SoSlow Super Extender with LusterStone Antique Parchment and mix well. Apply a tight skim coat of this mixture using a stainless steel trowel. Do this by loading a small amount to one edge of the trowel, then place that edge against the surface. Move the trowel across the surface at an almost flat angle, offloading the material. After each application stroke, skim off the excess by dragging the edge of your trowel blade along the same line. Use a small polystyrene trowel to remove the halo effect from around the stenciling. Finish each section by running the edge of the trowel vertically down the surface to burnish the highs. Allow to dry completely.

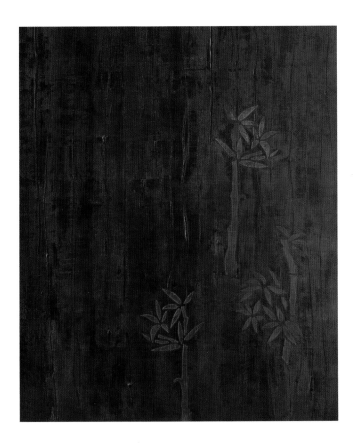

>> **STEP 4:** Glaze the surface with a mixture of the following: Stain & Seal Rich Brown + 10 percent extender + 10 percent water. Use a foam brush to apply the mix following the vertical lines of the finish. Remove the excess by stippling with a slightly damp towel. Soften and remove application marks using a badger brush or other softening brush. Allow to dry completely.

>> **FINISH:** Spray or roll a finish coat of Varnish Plus gloss sealer. Strive for an evenly applied, moderately wet coat to allow the product to self-level. If rolling on, use a low-nap or seamless foam roller. Allow to dry completely. Repeat if desired and again allow to dry completely.

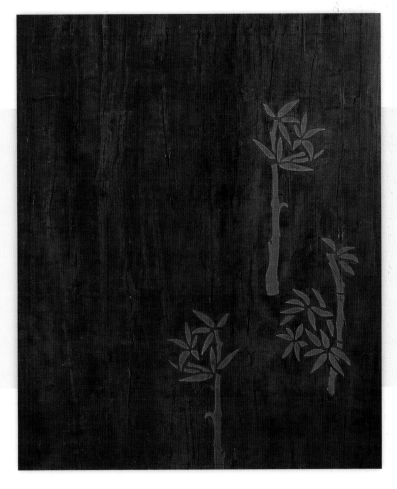

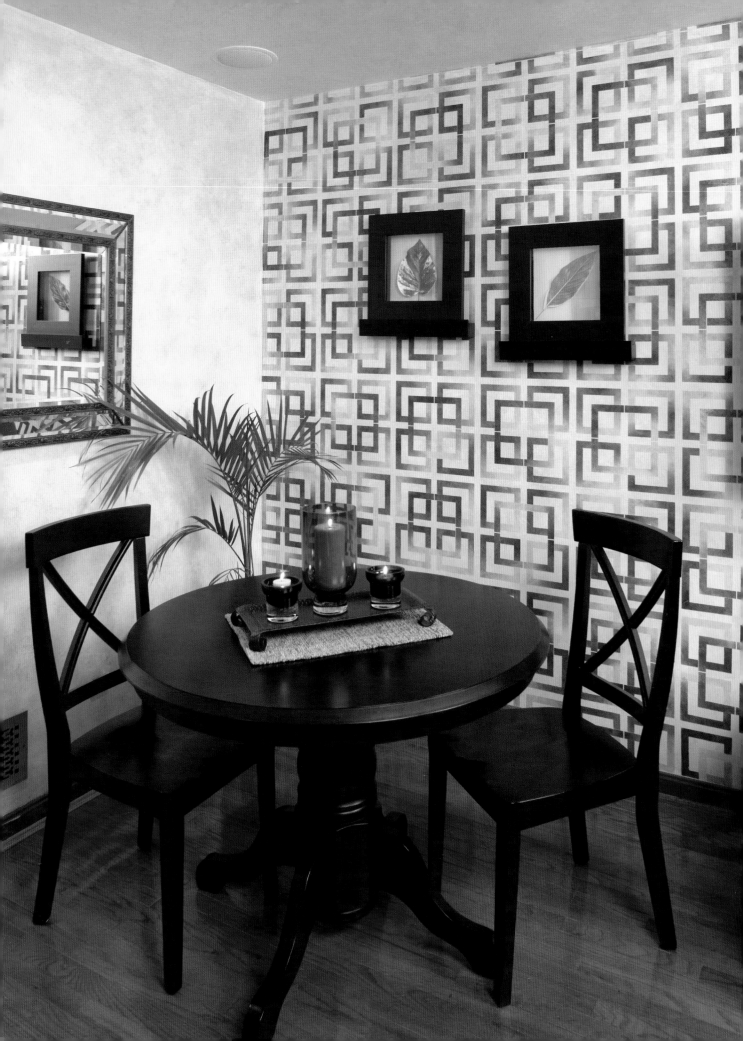

Hip to Be Square

MINDY GIGLIO

This technique uses a basic rag finish and a stencil in a way that gives it a more urban, sophisticated appeal. Neutrals combine for a dramatic look that remains simple and pleasing. Luster-Stone is used to add texture and shimmer, yet allows walls to stay clean and fresh looking. The rag technique was used all around the room, while the stencil was added on one wall for drama and a focal point. This technique is neutral in a sense that any color can be brought into the room as an accent color.

MATERIALS

- Basecoat: SetCoat White
- "Decodence" two-part overlay stencil and Topper™ from Wallovers™ (Wallovers. com)
- Stencil brushes (3)
- LusterStone: Snowflake White, Antique Parchment, Champagne Mist, Espresso, Ebony Frost Black
- SoSlow Super Extender

- 2-inch (51mm) low-tack tape
- Whizz Rollers (3)
- Chip brushes (2)
- Stainless steel trowel or Japan scraper
- Cotton rags
- Buckets in various sizes for thinning LusterStone
- Plastic one-gallon grids (3)
- Dropcloths

>> PRO TIPS

1. Preparing for Stenciling

Prepare the room as you would for any painting job, taping off trim and putting down canvas dropcloths. Decide where you want to start your first stencil overlay, taking into consideration the design repeat and the shape of your walls. I started in the center top and worked around the wall on both sides to allow the stenciled areas time to dry. For example, I stenciled left of center, then moved to the right, then back to the left, etc. so I didn't have any downtime waiting for the LusterStone to dry.

2. Keep Your Stencils Clean

You will be reusing the same stencils over and over as you work so set up a stencil cleaning station. Cover a table with plastic and have a bucket of water with a green scrubby sponge and some dry rags handy. After each repeat, clean your stencil using the water and sponge, then dry it with a clean rag. If you clean the stencil every time, the LusterStone comes off easily and your stencil stays quite clean. If you wait and use the stencil a few times before cleaning it, the LusterStone builds up and dries on the stencil, making it much more difficult to clean—and to use.

3. Blend Any Lap Lines

Once your rag finish has dried, you can go back over areas with a lightly loaded Snowflake White roller to blend any lap lines.

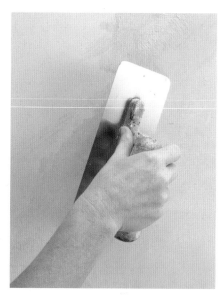

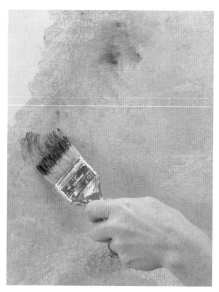

>> **STEP 1:** Basecoat the walls with SetCoat White and let dry. Apply a skimcoat of Snowflake White LusterStone. Thin the LusterStone with water until it has a yogurt-like consistency. Apply the LusterStone to the edge of a stainless steel trowel and pull a tight skimcoat across the surface. Hold the trowel at about a 45° angle to ensure that you get a tight skim and are not leaving too much product on the wall. Lap lines are okay in this step. Let dry.

>> **STEP 2:** In different buckets, thin LusterStone Snowflake White, Champagne Mist, Antique Parchment and Espresso, using water and some extender for a yogurt-like consistency. Start rolling on Snowflake White randomly over the area. Using new rollers, do the same with Antique Parchment and then Champagne Mist. Use a chip brush to add a touch of Espresso LusterStone here and there. Using the roller from the Champagne Mist, lightly roll over the entire area to blend.

>> **STEP 3:** While the colors are still wet, using light pressure and moving quickly, pat the surface with a loosely bunched-up rag while twisting your hand to create movement across the area. Blend the colors, but allow individual colors to still show. You can increase the pressure of your hand to blend more. Feather out your wet edges to avoid lap lines, changing to clean rags often. Let dry. If needed, go over with the Snowflake White roller to blend out any remaining lap lines (see Pro Tip #3).

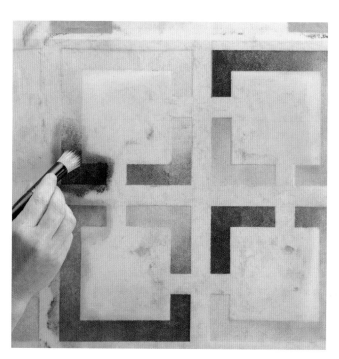

>> **STEP 4:** Tape the first stencil overlay to the wall and work on one square at a time. Randomly tap on each of the five LusterStone colors, fading them in and out of each other. Use one stencil brush for the Ebony Frost Black, one for the Espresso, and one for the three light colors. Blot your brushes on a rag to clean as needed.

>> **STEP 5:** Continue this until you have completed the entire first overlay. Make sure you keep your LusterStone thinned by adding more to your palette. It tends to thicken up from the stencil brushes absorbing the liquid.

>> **STEP 6:** The second overlay is for the large center square that over-laps the four smaller squares. Place the second overlay precisely using the register marks and tape into place.

>> **STEP 7:** Tap on the five colors of LusterStone to the second overlay the same as you did for the first one in Step 4. Keep your color pattern random. Step back and check your color pattern to make sure it is pleasing to your eye.

>> **FINISH:** Do you see how the large center square fits neatly into the openings on the four smaller squares? Be sure to plan your colors before you start the center square so that the same colors are not overlapping each other. This helps the design to pop, almost as if it were three dimensional.

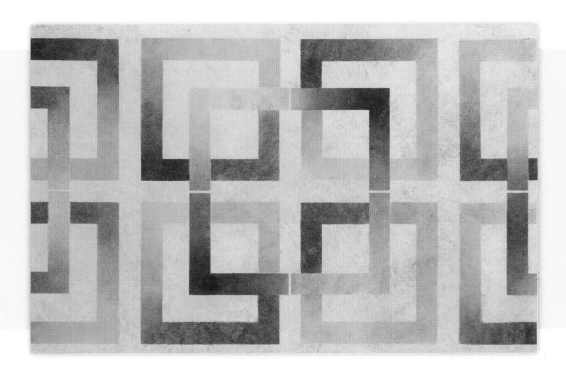

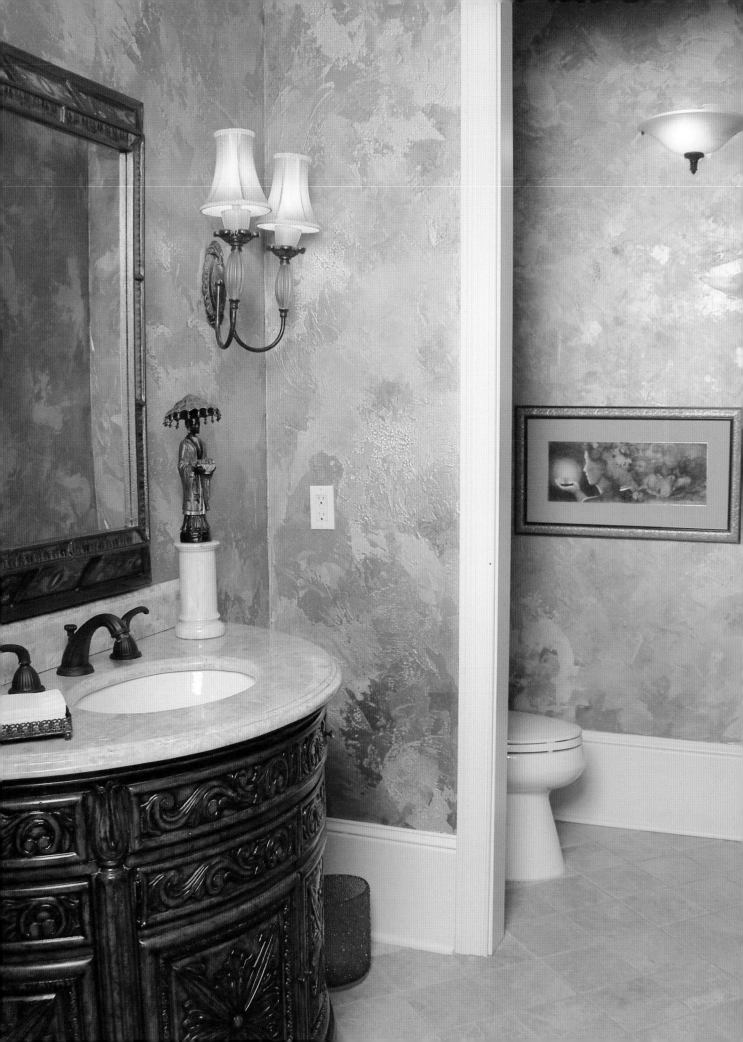

Golden Grotto

SUE HON

This technique started out as a simple metallic gold finish and grew from there. A mirror over the vanity had beautiful colors and I wanted to introduce them in a subtle way. Variegated gold leafing came to mind. My love of textures led me to layering different plasters that had their own characteristics. I wanted the plaster to crack like a porcelain crackle and I achieved that look by stippling the size on instead of rolling or brushing it on and then allowing the size to set up. The gold glaze pulled it all together with a hint of shimmer.

MATERIALS

- Basecoat: SetCoat Chamois and Brown
- MetalGlow: Eldorado Gold and Old Bronze
- Mona Lisa Gold Leaf Size
- Mona Lisa Variegated Gold Leaf in red, green, and solid gold
- Mona Lisa Gold Leaf Sealer
- StucoLux Marmorino (untinted)
- SoSlow Super Extender
- ColorSeal
- Venetian Gem Ultra Polishing Tint Base (untinted)
- AquaCrackle Size
- Olde World Crackle Pull Off: White
- Stain & Seal: Metallic Gold and Bronze
- Cheesecloth or soft cotton rags
- Standard paint roller
- 6-inch (15cm) Whizz Roller
- Chip brushes
- Stainless steel trowel

>> PRO TIPS

1. Prepare the Walls

Tape off all woodwork, trim and ceiling. Fill all nail holes and patch any larger holes. If your wall patch is bigger than the size of a quarter, while the patching material is still wet, roll an old, dry 4- to 6-inch (10-15cm) roller head over it to match the wall texture. The patches do not need to be perfect; the plaster layers will hide them.

2. Metallic Gold Basecoat

The basecoat can be any flat or eggshell latex paint tinted to a metallic gold. All the metallic paints used for this project can be your personal color choice. Metallic paints generally need two to three coats for a good finish. Any brand of metallic paint can be used but be sure to use the brand's extender to keep the metallic paint from drying too quickly.

3. Applying Crackle Size

Apply the crackle size later in the day so you can leave it overnight and still maintain small, even cracks after applying the plaster.

>> **STEP 1:** Basecoat your wall surface with SetCoat in Chamois and Brown. Let dry. Roll on a metallic gold finish using MetalGlow Eldorado Gold. Let dry.

>> **STEP 2:** Apply random patches of the gold leaf size with a 6-inch (15cm) roller or a brush, making the patches a little bigger than the size of the leaf itself. Let the size set up until it's tacky to the touch. Gently apply the variegated gold leaf onto the size, alternating the different colors (above you can see variegated red on the left, variegated green on the right, and solid gold at the top). Using a soft cotton rag, wipe over the leaf to secure it to the size. Apply a thin coat of the gold leaf sealer to the leaf only. Let dry.

>> **STEP 3:** Apply a small amount of StucoLux Marmorino onto the blade of your stainless steel trowel. With light pressure, quickly drag the edge of the blade across the surface in a random pattern, covering 50 percent of the surface. Leave open areas for the next two plasters but cover some of the edges of the leaf. Let dry. Small cracks may form if you apply the Marmorino too thickly, but that is acceptable for this finish.

>> **STEP 4:** Mix 1 quart (.95 liter) of MetalGlow Old Bronze with ¼-cup (58 ml) SoSlow Extender and roll it over the entire surface, patting back with a soft cotton rag or cheesecloth to soften any roller marks. When it's dry, roll a coat of ColorSeal or any water-based sealer over the entire wall surface. Let dry completely.

>> **STEP 5:** Using the same technique as in Step 3, apply a small amount of the Venetian Gem Ultra Polishing plaster to your trowel and lightly drag it across the wall, covering more of the open areas as well as some of the first plaster and the edges of the leaf. This layer should cover approximately 65 percent of the surface.

>> **STEP 6:** With a chip brush, apply the AquaCrackle Size. Do not brush the size on; instead, use the chip brush to stipple the size on the areas where you want heavy crackles. This should not be a heavy, thick coat of size or your plaster will slide and fissure cracks will be the result. Stipple some thin areas and some medium areas and let it set up for several hours.

Apply an even amount of the Olde World Crackle Pull-off to the trowel and glide over the crackle size, going for 80-90 percent coverage and blending to disguise the edges of the leaf and allowing all the layers to show. If you cover too much area with the Pull-off plaster, use a paper towel to pop off the excess. Allow to dry overnight.

>> **FINISH:** The final glaze is a mixture of Stain & Seal Metallic Gold and Bronze plus SoSlow Extender to make a dirty gold color. Or use any brown-gold metallic color mixed with the manufacturer's extender. Roll over the entire surface and pat out the roller marks with a soft cotton rag or cheesecloth.

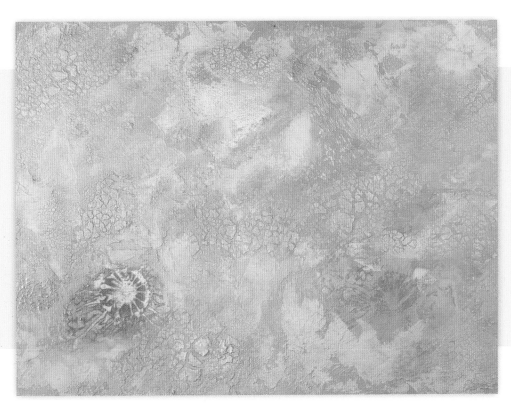

Red Tissue LusterStone

GARY LORD

This is a beautiful finish that is easy and fun to do. The combination of the shimmer of the LusterStone with the texture of the tissue paper makes for a very dynamic treatment. It looks great in almost any room in your home and can be applied to walls or ceilings.

MATERIALS

- Tissue Paper
- AquaSeal
- "Maple Sugar" eggshell latex (Porter Paints) or an equivalent light tan color
- LusterStone: Mandarin Red

- Cotton Rags
- Whizz Roller or 9-inch (23cm) regular roller
- 9-inch (23cm) squeegee
- Stain & Seal: Antique Cherry
- FX Thinner

>> PRO TIPS

1. Adhering the Tissue Paper

Substitutes for AquaSeal would include wallpaper paste, Elmer's Glue diluted 50 percent with water, or the base paint color of your finish. If you use the base paint color as your adhesive, you can also roll that base color right on top of the tissue paper at the same time you install it. However, this means the tissue is permanently adhered to the wall.

2. Buy It by the Ream

If you're doing a large job like walls or a ceiling, it's much cheaper to buy a ream of tissue paper from a paper manufacturer than to buy small packets of it at a gift wrap store.

3. Tissuing Next to Trim Molding

When applying tissue to a wall, place the straight edge of the tissue right next to, but not onto, the trim molding. Keep it away from the molding about 1/16 inch (1.6mm). If the tissue overlaps onto the taped-out molding or ceiling line, you will have to cut it with a razor blade to remove the tape safely and not tear the tissue paper into your wall treatment.

>> **STEP 1:** First, crumple and un-crumple one or two pieces of 24 x 36-inch (61 x 91cm) tissue paper and set it aside. Roll AquaSeal on your wall in the area where you want to apply the tissue paper. While it's wet, press on the tissue paper, gathering it together with your hands to form creases and crumples in the tissue paper. Tack the corners down lightly with your fingertips.

>> **STEP 2:** Use your fingers to crumple and press the tissue together, not outward, to get more creases and therefore more texture.

>> **STEP 3:** Once the tissue paper is up, roll on AquaSeal to press the tissue into place but don't smooth it out—leave the creases as they are. Repeat as often as needed to cover the entire space. Let dry.

>> **STEP 4:** Basecoat the tissued surface with Maple Sugar or other light tan eggshell latex paint. Let dry.

>> STEP 5: With a dry rag, apply the Mandarin Red LusterStone using circular motions. In your transition areas, start outside and work up into the areas already painted, reducing the pressure and amount of paint as you "walk" into the transition area. Keep working the paint for a consistent coverage. Let dry.

>> STEP 6: Dilute Antique Cherry Stain & Seal with 15-20 percent FX Thinner and apply to your surface with a Whizz roller. Don't let the stain dry before going on to Step 7.

>> STEP 7: With a 9-inch (23cm) squeegee, remove some stain and create a horizontal pattern by pulling downward using short choppy motions.

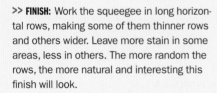

>> FINISH: Work the squeegee in long horizontal rows, making some of them thinner rows and others wider. Leave more stain in some areas, less in others. The more random the rows, the more natural and interesting this finish will look.

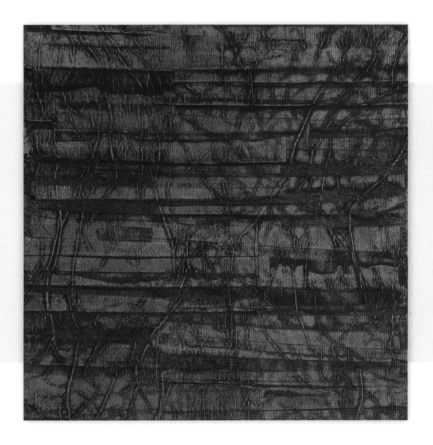

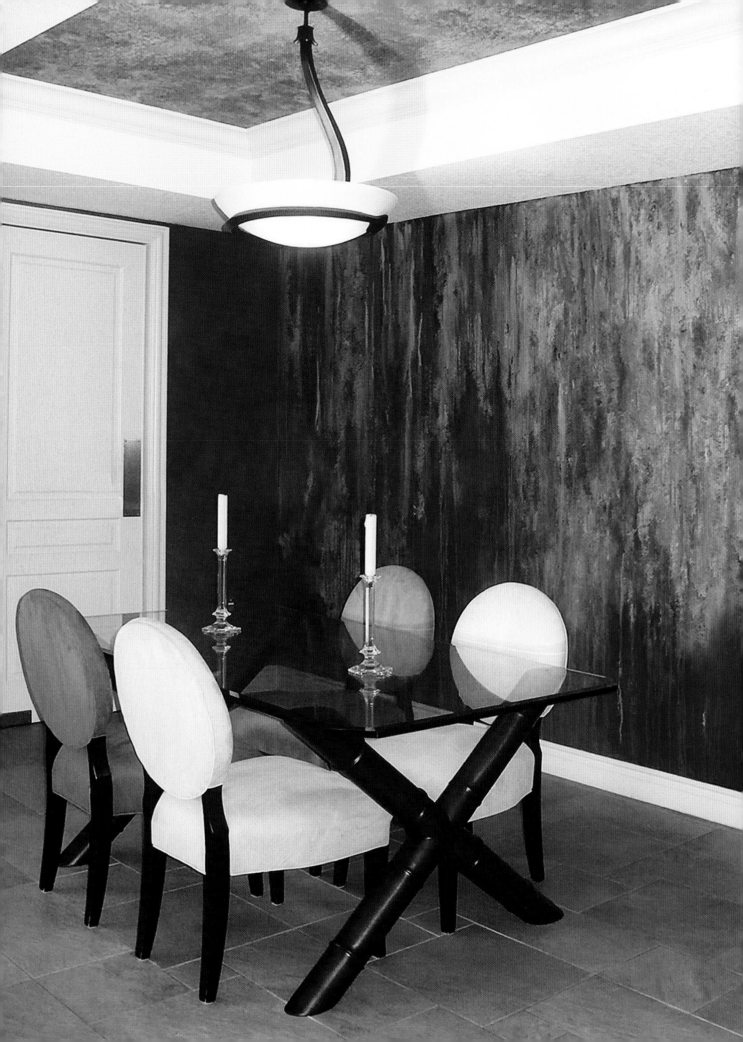

Vibrant Verdigris

ZEBO LUDVICEK

In gardens around the world, one of the greatest attractions of copper vessels, statues and fountains is the beautiful green patina they develop. This patina is known as verdigris, from the French *vert de Grece* (green of Greece). Why not bring this lovely patina indoors? Enhance any space while creating a rich, sophisticated and timeless look. My Vibrant Verdigris technique uses metallic paint and glazes to achieve the natural sheen of copper.

MATERIALS

- Basecoat: SetCoat Leather Red and Metallic Copper, or equivalent 100% acrylic colors
- AquaCreme
- FauxCrème Colors: Metallic Copper, Metallic Bronze and Brown
- Designer Rust
- Finishing Solutions Aqua Verdigris in Dark Green, Blue-Green and Light Green
- Finishing Solutions Aqua-Gard
- 2-inch (51mm) low-tack tape

- 2-inch (51mm) nylon-poly trim brush
- 2-inch (51mm) chip brush
- 3/8-inch (10mm) low nap roller
- 3-inch (76mm) foam brushes
- 1½-inch (38mm) stippler brush
- Natural bristle (e.g., badger) blending brush
- Burnishing tool
- Paper towels
- Plastic bags
- Cheesecloth
- Natural sea sponge
- Spray bottle of water

>> PRO TIPS

1. Painting Tips
The lighter the basecoat color, the more you will notice roll marks when applying the metallic paint over it. Do not over-roll metallic paint, which will remove the paint.

2. Glazing Tips
When applying glaze, try to be consistently inconsistent! Avoid patterns. Maintain a wet edge. Work only in small sections so the glaze remains workable throughout the process. Keep moving! Using bubble wrap instead of a wet paper towel to remove metallic glaze will give you more texture. If you see brush marks in the wet glaze after using a soft badger brush, you are pushing too hard.

3. Verdigris Tips
The logical buildup of oxidation is on the top edges. These pigmentations are washed downwards, some settling on the bottom edge and some not. Vary the length of drips. Be sure to make it appear these colors ran naturally and reveal enough metal and rust underneath to make it realistic. Do not use cloth to cover the floor or furniture. Paint will soak into the cloth and stain whatever is underneath.

Home of Jerry and Christine Schoeb.

>> **STEP 1:** Basecoat your wall with 2 thin coats of SetCoat Leather Red (shown at left in photo above) or an equivalent color of 100 percent acrylic paint. Allow to dry completely between coats, at least four hours. Then apply 2 thin coats of SetCoat Metallic Copper (shown at right in photo above), covering the entire surface. Let dry for 24 hours.

>> **STEP 2:** Mix three different glazes in three separate containers, using a ratio of 75 percent AquaCreme with 25 percent FauxCrème Color in Copper, Bronze, and a 50/50 mixture of Copper and Bronze. Apply each glaze mixture with random strokes. Work from light to dark, first applying the Copper glaze, then the 50/50 mixture, and finally small areas of the Bronze glaze. Soften the still-wet glaze with a badger brush. Let dry overnight.

>> **STEP 3:** To prepare the basecoat for the rust areas, pick up a little FauxCrème Color in Brown on a damp sea sponge. Press sponge lightly against the wall to create texture and pattern. Do not press too hard as this will cause the paint to run. Allow some areas of the Metallic Copper SetCoat to show through. Soften with a damp cheesecloth.

>> **STEP 4:** With a chip brush, apply a heavy coat of Designer Rust on top of the areas sponged with Brown. While still wet, pounce rust areas with a stippler brush to create peaks and valleys. Soften some edges with damp cheesecloth. When the Rust is partially dry, dab rust areas with a damp sponge to lift off chunks of rust. Let dry. Brush on one coat of Designer Glaze on top of rust areas with a chip brush. Remove excess glaze with a damp cheesecloth, streaking the glaze in a vertical ceiling-to-floor stroke, imitating the natural flow of pigmentation down the wall. Let dry.

>> STEP 5: Apply Finishing Solutions Aqua Verdigris in Dark Green and Blue-Green colors randomly over the surface. Shape a bunched-up plastic bag into a ball in your fist, dip the bag into one of the colors and blot off the excess paint on a paper towel. Dab lightly, creating random patterns with the folds. Reload the bag as needed. Overlap and blend each color as you move across the surface. Blot areas of the Verdigris material with a damp sea sponge. When dry, dab Finishing Solutions Aqua Verdigris in Light Green over the Dark Green and Blue-Green material to produce a natural oxidized finish. Allow to dry.

>> STEP 6: To create verdigris trails of multicolor accents, build up pigment from the top down. With a chip brush, randomly lay down thick blobs of Finishing Solutions Aqua Verdigris in Dark Green and Blue-Green along the top edge of the surface. Holding a spray bottle almost directly on top of the paint blobs, spray water onto the paint and allow it to drip down the wall. When dry, repeat the same process using Aqua Verdigris in Light Green over the Dark Green and Blue-Green colors.

>> FINISH: With a damp cheesecloth, mottle on a mixture of 75 percent AquaCreme with 25 percent FauxCrème Color in Brown. Cover 100 percent of the surface to antique as desired. For more durability and added UV protection, topcoat with Finishing Solutions AquaGard using a foam roller.

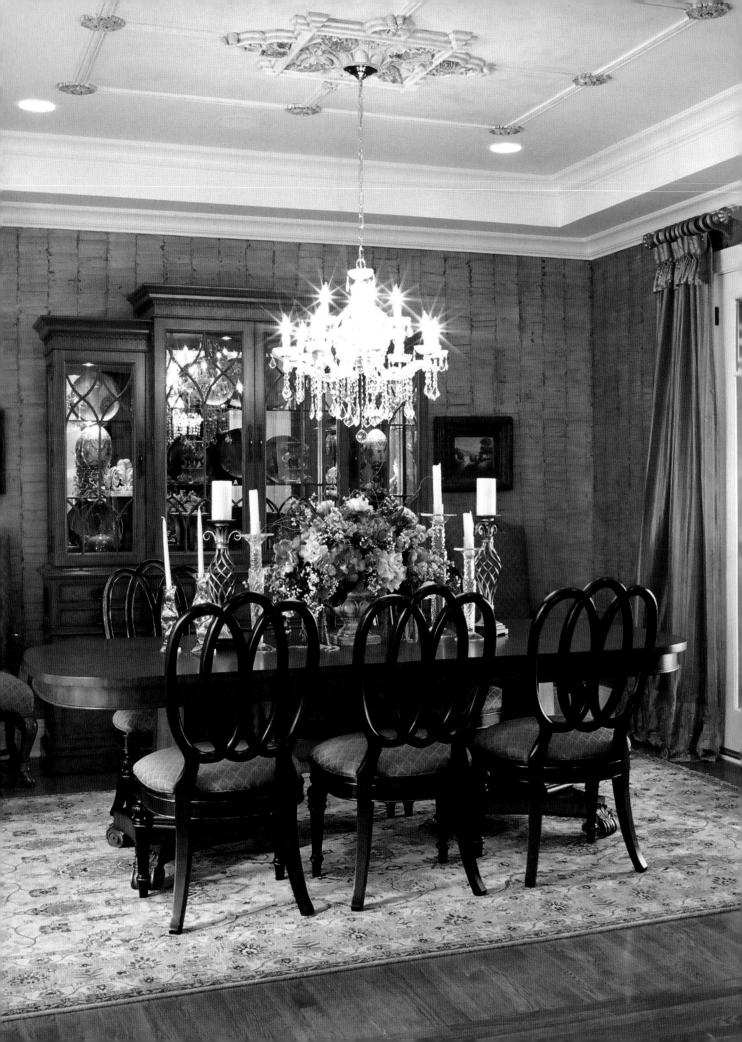

Faux Bamboo

GARY LORD

This handmade wallpaper creates a distinctive look and can be accessorized to become Asian, urban or modern in its design theme. You can choose to apply kraft paper for the wallpaper ground. Or you can choose to paint your ground to look like kraft paper. Or you can mix things even more and paint it an accent color underneath for a more urban loft feeling.

MATERIALS

- 60-lb. weight kraft paper
- Wood Icing
- 4-inch (10cm) or 6-inch (15cm) taping blade (plastic or metal)
- Stain & Seal: Rich Brown and Antique Cherry
- Leon Neon or chip brushes
- Rags
- FX Thinner (optional)
- SoSlow Extender (optional)

>> PRO TIPS

1. Taping Blades
All taping blades have a natural bow of the blade. You want the bow to work *away* from the surface so the two corners don't gouge the wall. To see which way the blade bows, look down the edge against a white surface.

2. Using Wood Icing
The reason I like Wood Icing for this particular project is because of its ability to take stains like real wood does, which helps create the illusion of bamboo slats.

3. Laser Levels for Straight Lines
When applying the design in rows onto your wall, using a laser level beam is a great way to keep your lines straight.

4. Pre-Hang Your Kraft Paper
I find the most successful way to do this finish is to pre-hang your kraft paper onto your wall just as you would do to apply any other wall covering. The weight of the Wood Icing is too heavy to hang in full 8-foot (2.4m) length strips without the risk of damage to your finish. Another option is to make small panels and install them in a pleasing pattern that is manageable to hang.

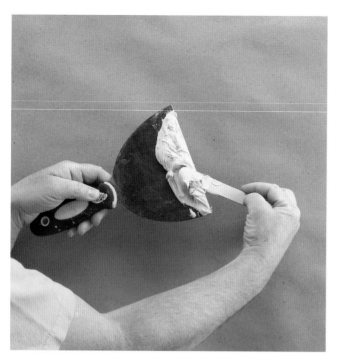

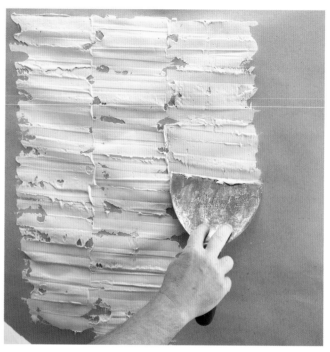

>> **STEP 1:** Using the Wood Icing straight from the container, apply a liberal amount to one side of your taping blade along the edge.

>> **STEP 2:** With firm pressure to start, off-load the material onto the brown kraft paper by using a short dragging/pulling motion with the blade. At the end of the short stroke, lightly decrease the pressure while rocking the blade up ever so slightly. The blade does not need to leave the surface at this point.

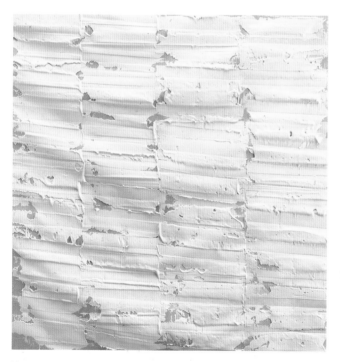

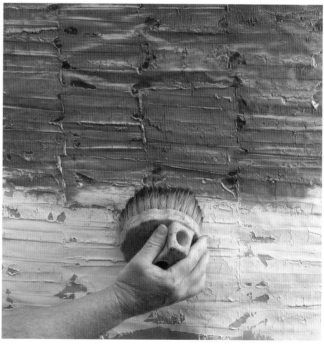

>> **STEP 3:** Continue this motion until the blade has very little material left on it. Reload the blade and continue this process in a vertical direction. Periodically you want to leave slight gaps in the material that expose the raw kraft paper below. Continue this until the row is complete and then start the next row. Allow to dry.

>> **STEP 4:** Using the Stain & Seal colors of your choice, stain the Wood Icing. I'm using Rich Brown here. If you want a lighter stain, mist the surface with water first. You can also use FX Thinner to dilute your Stain & Seal. For more open time you can add an extender. Use chip brushes or a Leon Neon to apply the stains.

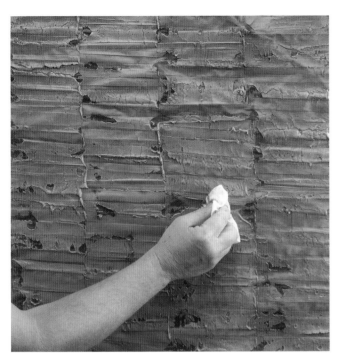

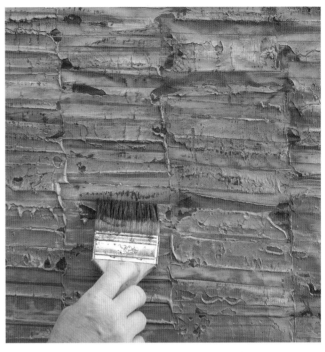

>> **STEP 5:** Wipe back the stain with a rag (a slightly damp rag will remove even more stain) to your desired shade.

>> **STEP 6:** Pick up some Stain & Seal in Antique Cherry color on a chip brush and wisp the color across the surface with a drybrush technique to create slight highlights.

>> **STEP 7:** The dark spaces you can see here and there between the rows of faux bamboo are where the Rich Brown Stain & Seal has stained the kraft paper ground. Keep this in mind when you choose your stain colors.

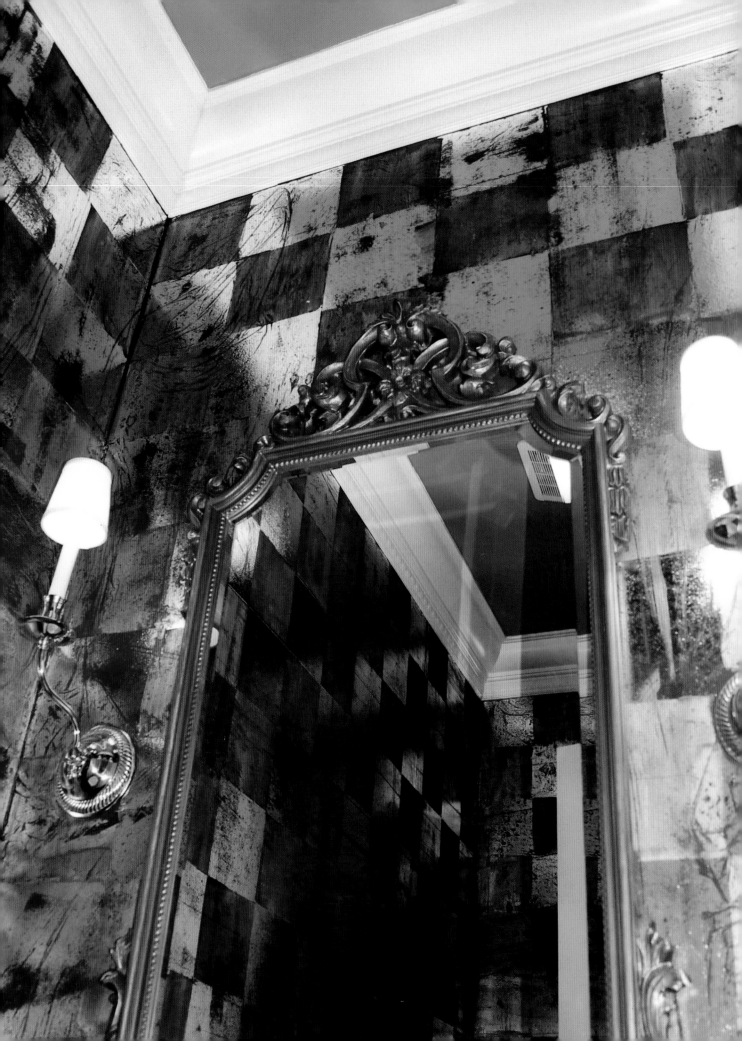

Reflective Checkerboard

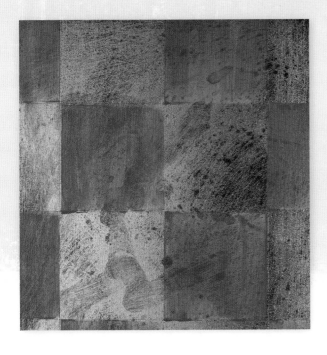

DEBBIE HAYES

This finish was created for the powder room in an artist's home. She works in brightly colored fused glass and pure silver. We designed the powder room walls to complement the brilliant hues of the paintings hanging just outside in the hallway. The highly reflective silver foil overlaid with a dark neutral brown, juxtaposed with the almost electric turquoise-colored ceiling, generates a graduated reflection that looks almost like a mirage. Whatever ceiling color you choose will be reflected in the silver foil squares.

MATERIALS

- "Turquoise" flat latex paint (Sherwin-Williams), or a color of your choice for the ceiling
- SetCoat: Dark Brown and Metallic Bronze
- Satin Durasheen
- Silver Metallic Foil
- Wunda Size
- Several wide foam brushes
- 2-inch (51mm) low-tack tape

- Robert Rubber
- Chalk box and chalk
- Terrycloth towels
- Level
- Sharpie marker
- Calculator and paper
- Whizz Rollers
- Polystyrene or stiff cardboard

>> PRO TIPS

1. SetCoat Mixture for Squares
Mix one part Dark Brown SetCoat to one part Metallic Bronze SetCoat for the brown squares. One total quart (.95 liter) will be enough for an average size room.

2. How Much Silver Foil is Needed?
The silver foil comes in roll sizes of 1 foot x 100 feet (30.5cm x 30.5m), 2 feet x 100 feet (61cm x 30.5m) and 2 feet x 200 feet (61cm x 61m). Using the 2-foot (61cm) wide rolls will make the work go faster. Measure the entire wall space to determine how many rolls you need.

3. This is a Distressed Finish
When filling in the template with the Setcoat mix, avoid perfection. If you tape the template in a couple of spots, just hold it tight with one hand and paint three or four strokes from top to bottom with the foam brush and move on. Don't use a spray adhesive. Have a damp rag handy to repair a goof if needed.

4. Perfect Over Wallpaper
To prepare a wallpapered surface, peel off any loose pieces then prime with two coats of oil-based primer, tinted brown to get closer to the SetCoat color. Let dry overnight.

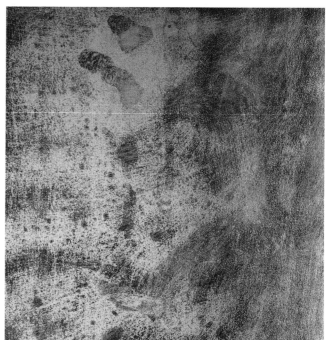

>> **STEP 1:** Tape off the ceiling and baseboards with low-tack painter's tape. Completely cover the floor and any other objects in the room with plastic. Roll the ceiling with two coats or more of the Turquoise paint (or a color of your choice) to ensure solid coverage. Roll the walls with two coats of Dark Brown SetCoat. Let dry overnight.

Carefully read the application directions that come with the Wunda Size. Then roll on one coat of the size. Let it tack up according to the instructions, about 15 to 30 minutes. The size will stay tacky for 4 to 6 hours. While waiting for the size to set up, unroll the foil and cut into lengths a few inches longer than the height of the wall. Cut enough for the entire project. Loosely roll each piece with the shiny side out and secure with a piece of tape.

>> **STEP 2:** Once the size is set up, move your ladder into the corner where you want to begin. Making sure the shiny side of the foil is facing you, position the top edge of the foil against the top of the wall and into the corner and gently unroll a foot or so, smoothing it down with the palm of your hand. Continue unrolling and smoothing until you reach the bottom of the wall. Go back to the top and, with the Robert Rubber, scrub the foil hard so the clear backing pulls away. Pull the backing away, scrub some more, and roll down in sections until complete. Start again back at the top, overlapping just slightly. Continue until each roll is installed. Let dry completely. Roll one coat of Satin Durasheen over the entire surface of the walls to eliminate the tack as it will never totally dry. Let dry overnight.

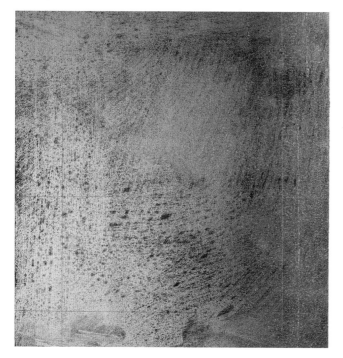

>> **STEP 3:** Examine the scale of the room and decide what size squares you want to use for the checkerboard design. The ones in the photograph are 9 inches. Plan to go around the room and from ceiling to floor with no wrap-around at the corners or partial squares. (Some math and slight adjustments here and there are required!) Double-check your calculations to be sure you don't have two of the same color squares next to each other. With an assistant, go around the room horizontally and vertically and mark your grid. Snap chalk lines. Use your level often to check that your lines are level and plumb.

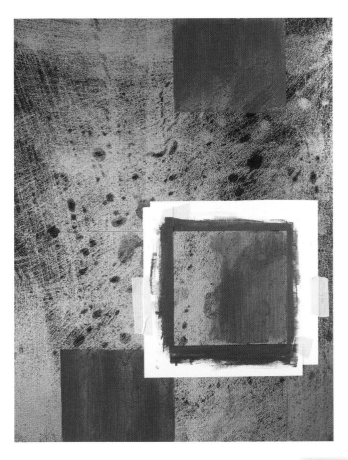

>> **STEP 4:** Make two sets of template guides like those shown in the photo. Use polystyrene or cardboard. They need to be 90° angles, about an inch longer than the size square you want, and about two inches wide. Tape them together as shown, so the opening is the exact size of your square. You will take them apart and cut them shorter to use individually at the ceiling, baseboards and corners.

Beginning at the top of any wall, choose a square and tape the template directly over it. With one hand, hold the template tight to the wall. Dip your foam brush into the Setcoat mixture (see Pro Tip #1) and drag the color through the opening in a few strokes. Work quickly. Do not overwork or try to fill in perfectly. Some imperfection is desirable. Select every other square and continue until complete.

>> **FINISH:** If you like the distressed finish on the squares as shown at the beginning of this project in the powder bathroom, use a stiff brush or terrycloth to remove some of the foil to reveal the paint color underneath.

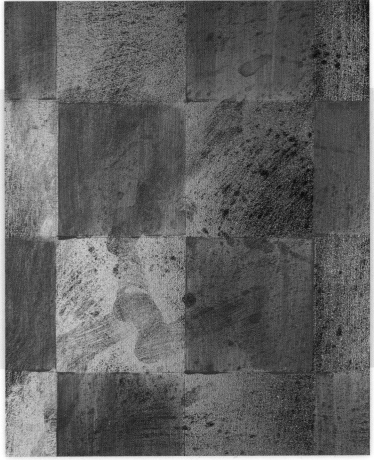

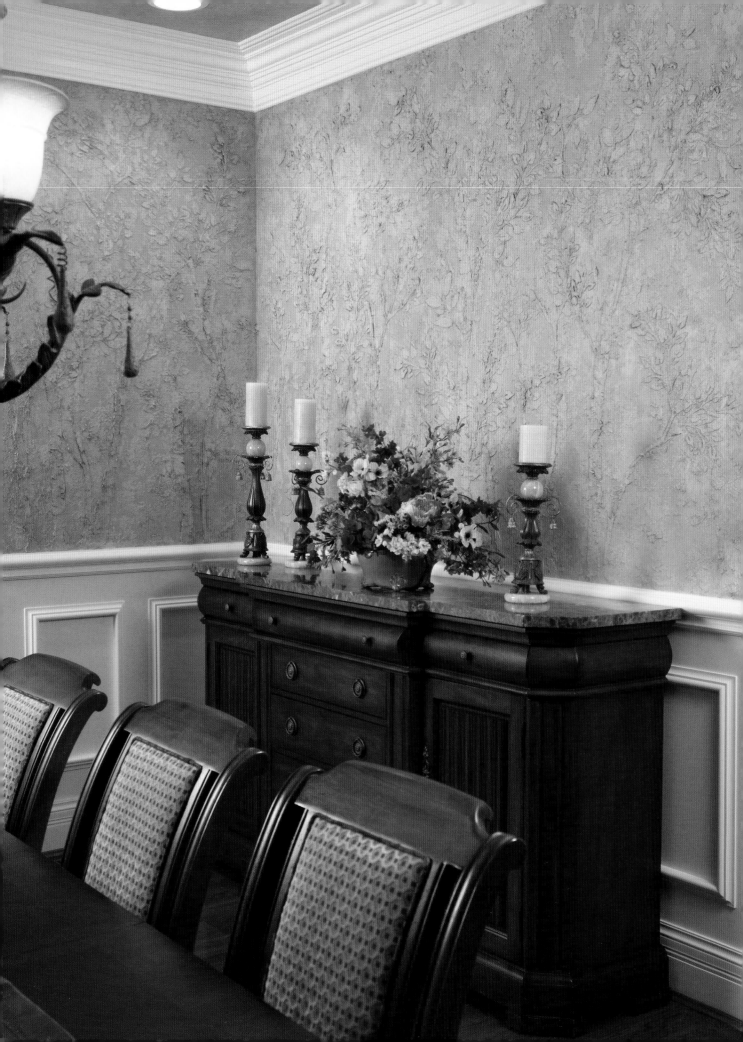

Tree Releaf

KAREN KRATZ-MILLER

This high-relief finish is both organic and elegant. It combines texture, dimension and the glitz and glamour of sparkle stone. It is a dinner party, a powder room, or a family gathering—use it anywhere that you want to incorporate graceful distinction. Using some of the most sought-after products on the market today, you can create an enchanted space of your own, depending on how you arrange the tree stencils and how abundantly you apply the texture. The more texture, the higher the relief, the more dramatic the finish.

MATERIALS

- Basecoat: "Turtle Dove" satin or eggshell latex paint (Pittsburgh/Porter) or an equivalent gray-green color
- LusterStone: Frosted Denim, Sage Green, Silver Taupe
- Rs Sandstone Flake
- Rs Activator
- FauxCrème Clear glaze
- FauxCrème Colors: Earth Brown, Ochre Yellow, Metallic Gold

- Whizz Rollers
- Stainless steel trowel
- "Raised Plaster Aspen Tree" stencil set from www.VictoriaLarsen.com
- Japan scrapers or pieces of styrene
- Kitchen sponge
- Terrycloth towels
- Viva paper towels
- Spray bottle
- Stir sticks
- Paint pans

>> PRO TIPS

1. Working with LusterStone

Try to match your LusterStone color pretty closely to your basecoat color—the LusterStone is somewhat translucent and you'll get a better coverage of this color if they're both close. When rolling on your LusterStone, some variation in sheen and color are acceptable. Don't overwork an area trying to get it as smooth as paint.

2. Stencil Layouts

Establish your tree layout and density by using the trunk stencil first, starting at the bottom and working around the room, taking them to different heights. I always have at least two sets of stencils so I can use both sides to create reverse images of the trees and leaves.

3. Using Terrycloth Towels

I like using terrycloth towels to pat off the glazes. I don't scrunch them up like rags. I fold them neatly into quarters and eighths like a dinner napkin so that I have a flat absorbent surface to work with. As each section becomes saturated, I refold it to a clean section. Terrycloth rags can be found at discount retailers and home improvement centers.

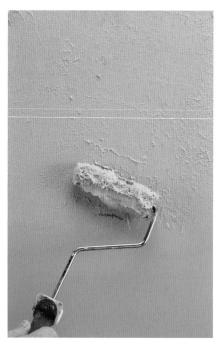

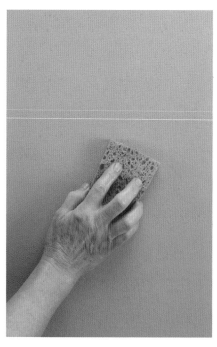

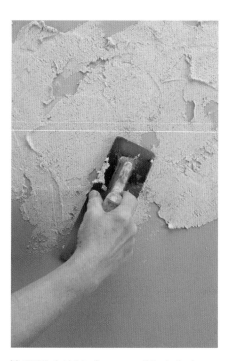

>> **STEP 1:** Basecoat your surface with a medium gray-green latex paint. Let dry. Using a Whizz roller, apply a scratch-coat of Luster-Stone mix of Frosted Denim, Sage Green and Silver Taupe in about equal proportions and diluted with a little water. Roll randomly in different directions to get 100 percent coverage. Let dry.

>> **STEP 2:** Apply Rs Activator with a clean sponge to your surface. Work in about a 1-yard (.91m) square area. The Activator stays open for about 15 minutes.

>> **STEP 3:** Add 1 to 2 ounces of Rs Activator to a gallon bucket of Rs Sandstone Flake and mix it in. Let it set up about 15 minutes before using. Using a stainless steel trowel, apply the mix over the activated surface area. Let some of the basecoat show through in spots and don't smooth it out.

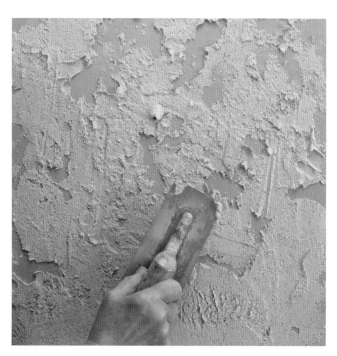

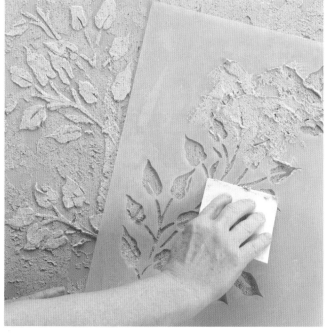

>> **STEP 4:** To get the material to "pop off" the surface here and there, place the flat of your trowel blade against the material, press down, then lift straight off. Chunks of material will come off with the blade. You can use the front edge of the trowel to tear off pieces of material and sculpt it, and Viva paper towels to pull off and move it around to create pleasing organic shapes. Let dry completely, about 24 hours.

>> **STEP 5:** Using the same mix of Rs Sandstone Flake and Rs Activator, hold your tree stencils up against the textured surface and use a square piece of styrene (or a Japan scraper, or a plastic putty knife) to press the material thickly through the stencil openings. Let dry overnight.

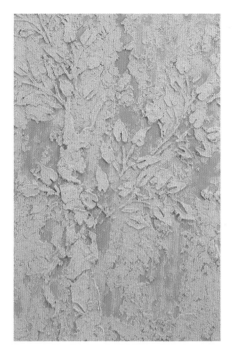 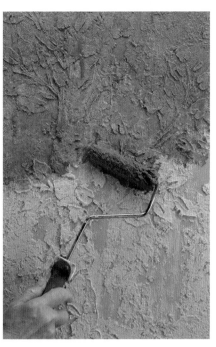 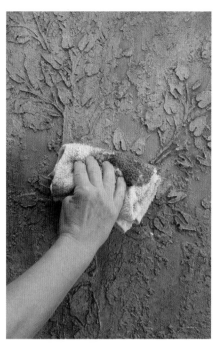

>> **STEP 6:** This is how the tree-shaped relief design looks when dry. The shapes of the leaves and branches are just suggested, not clear-cut and not smooth. Texture is good.

>> **STEP 7:** Before applying the glaze, mist the surface with plain water. Use a Whizz roller and a glaze mixed from FauxCrème Clear, and three colors of FauxCrème Color: 60 percent Earth Brown, 10 percent Ochre Yellow, 30 percent Metallic Gold, or use a golden brown color. Roll on the glaze over the entire working area. Mist the glazed area with water if needed to help the glaze get into all the nooks and crannies of the texture.

>> **STEP 8:** Using a clean terrycloth rag, begin rubbing off the glaze from the high parts of the relief, removing streaks or lines that are left over from the roller. Use a clean rag to pat out excess glaze from the gray-green basecoat areas. Let dry completely.

>> **FINISH:** You can achieve the look of natural growth to the tree reliefs by using your stencils creatively. Turn them to many different angles to mimic the way branches grow out from tree trunks and leaves extend out from twigs and stems. Rather than creating trees that look stiff or calculated, aim for a graceful, natural appearance.

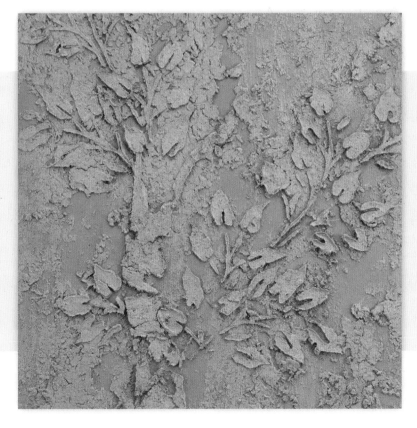

Organic Rust

GARY LORD

If you love the uncontrolled look of a natural organic rusted finish, this may be your dream finish. As the artist, you can only control certain aspects of the technique and then it is up to the beauty of nature to complete the process. Because this finish uses real steel along with a rapid rusting agent, what normally takes years to create you can watch happen overnight.

MATERIALS

- Basecoat: "Sensational Sand" eggshell latex paint (Sherwin-Williams) or an equivalent medium brown color
- LusterStone: Charred Olive and Royal Jade
- Stainless steel trowel
- Whizz Roller
- Magic Metallics Steel Metallic
- Magic Metallics Rapid Rust
- Pump sprayer or plant mister
- Large natural sea sponge

>> PRO TIPS

1. Using Steel Metallic
The Steel Metallic material will settle at the bottom of its container. Make sure you agitate it and mix it continuously throughout your application process. This process is messy, so protect all surrounding surface areas by masking them out with plastic first, then putting something absorbent on top of the plastic to absorb the run-off.

2. Rust in Transition Areas
If the rust is stronger than you want in your transition areas, re-skim LusterStone over the rust to set it back or in some cases remove it entirely by burying it under a new layer of LusterStone.

3. Altering the Look of the Rust
If the rust ends up being too even in color and you want to have more character in the finish, you can re-spray the surface with Rapid Rust even after 24 hours or more and it will alter the look of the rust. Sometimes I will be selective with my next day's spraying and will spray only in certain areas with a very heavy concentration of Rapid Rust. Very cool things happen when I do this, with varying colors of rust and movement.

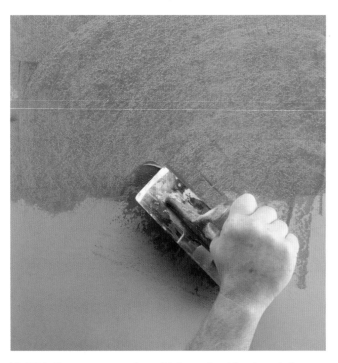

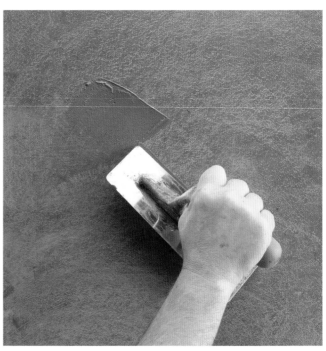

>> **STEP 1:** Basecoat your surface with Sensational Sand eggshell latex or an equivalent color. Let dry. Load a stainless steel trowel with Charred Olive LusterStone, apply a skim coat, then remove most of it by holding the blade at an angle between 45° and 90°.

>> **STEP 2:** Wipe off your trowel and load it with Royal Jade LusterStone. Apply another skim coat, then remove most of it as you did in Step 1.

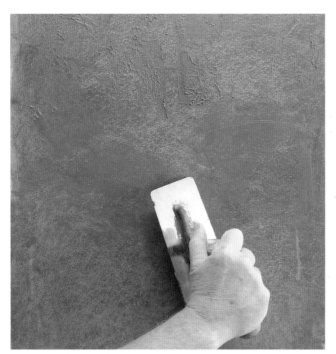

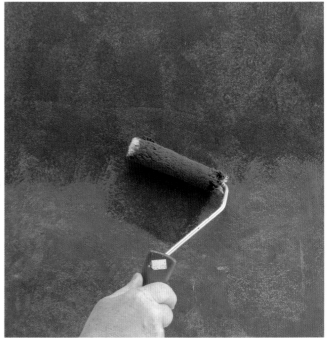

>> **STEP 3:** When loading your trowel blade for a knock-down finish, butter the bottom of the blade with an even, thin amount of material. Pat the Royal Jade LusterStone on your surface randomly, then come back with the blade at an angle and knock it down using curving motions like "S" shapes and "C" shapes. Let dry completely.

>> **STEP 4:** Pour some Steel Metallic into your paint pan and load your Whizz Roller into it. Roll it onto your surface for 100 percent coverage at the top one-third of your area.

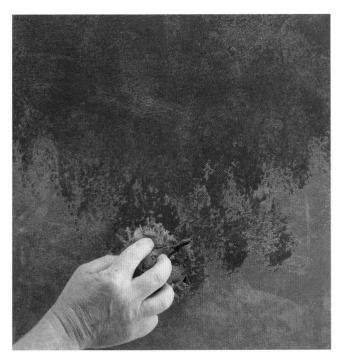

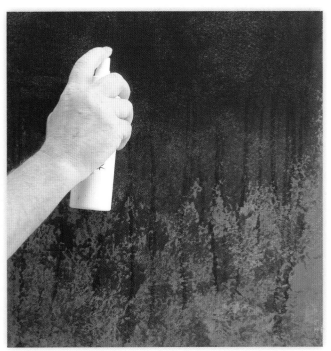

>> **STEP 5:** In the middle third of your area, using a damp, rung-out sponge, pick up a little Steel Metallic and tap it onto the surface with a heavier concentration on the outer edges of your transitional zone. As you move into the bottom third of your project area, use a lighter, more broken amount of the Steel Metallic material. A little of the steel goes a long way and will rust far more than you can imagine. I will often use a damp rag to push out the steel very hard into my open areas to soften the transition from my edges into the field of the project. It is far better to have a hint of the rust versus a strong edge.

>> **STEP 6:** Using Rapid Rust in a disposable pump sprayer from the paint store or a plant mister, spray along the top, allowing the liquid to run down the surface creating drips. (Wear a respirator. Also, any steel or iron surface this spray touches will rust!) Heaviest concentration is at the top, but you do want to have a mist of the Rapid Rust over everything. Let it react. It usually takes 24 hours for full reaction to take place. After 12-16 hours, if you wish to have some areas rust more, re-spray with Rapid Rust, and vice versa: if you wish to have more of the steel color showing, apply more Steel Metallic. Let dry.

>> **FINISH:** The steel paint will start to rust within 4 hours of spraying on the Rapid Rust, but it will not look like this finished section for at least 16-24 hours. So be patient and let nature make your organic rust finish beautiful.

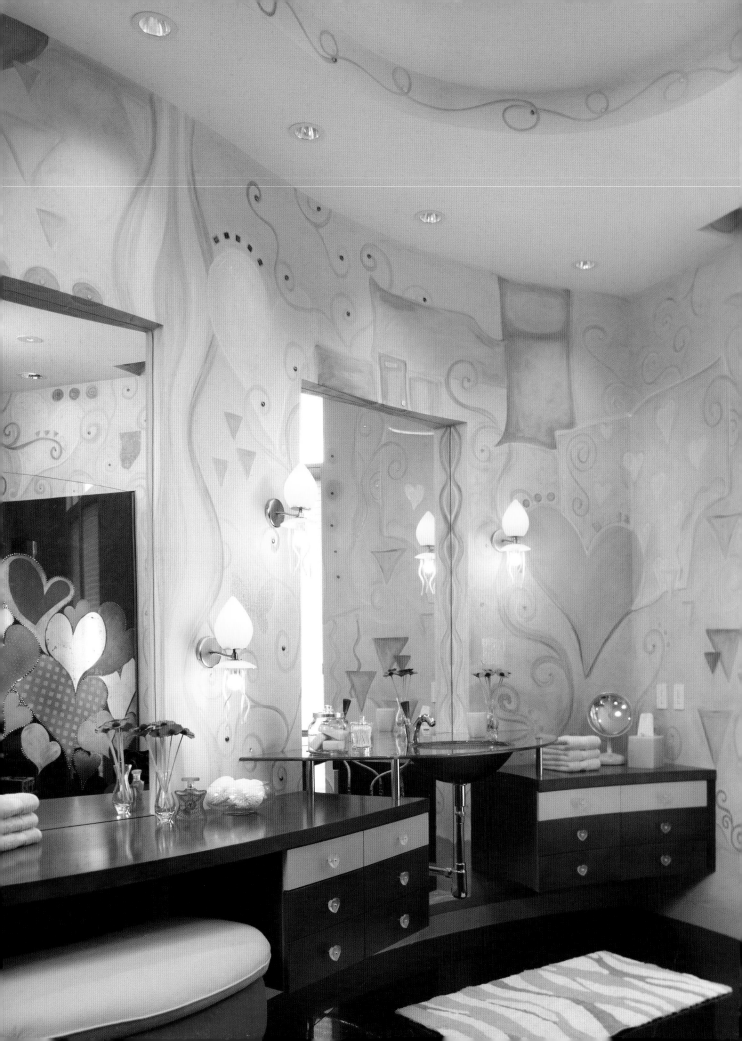

Krazy Klimt

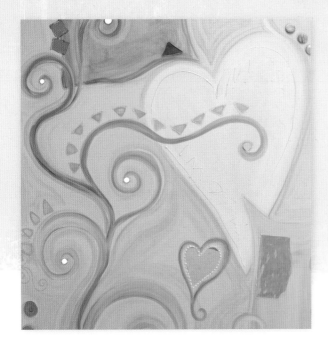

JEANNINE DOSTAL

This design was inspired by my favorite artist, Gustav Klimt, and also by my client who has a whimsical, fun style throughout her home. This technique is totally freehand, and you can't make a mistake. It can be adjusted for any size space. There's so much movement and freedom to it—you'll love the process of creating it as much as you love the final result.

MATERIALS

- Basecoat: A light lavender eggshell latex paint, any brand you prefer
- Artist's brushes, flats and rounds, in several sizes
- Acrylic craft paints in several bright colors, including lavender, lime green, purple, turquoise, orange, yellow, magenta and white
- Terrycloth rags

- Pearlized White dimensional acrylic paint
- Shaped mirrors (circles)
- Yes! Paste
- Glitter Glue paint
- Opalescent papers in different colors
- Various decorative gems and beads from the craft store

>> PRO TIPS

1. Go Crazy with Colors
Double load your flat brushes with two or three compatible colors so the painting goes faster and you get more variation of color in each of your strokes. You can't go wrong, as long as your colors are all compatible. More is more!

2. Fingerpainting with Glazes
I use a damp terrycloth towel wrapped around my index finger to do the glazes—I can control the shapes better and it gives freer movement to the glaze lines.

3. Recycle Your Paints and Craft Supplies
You can use almost anything to embellish a design like this—pieces of wallpaper, scrap papers, napkins, old greeting cards. Adhere these papers with Yes! Paste and burnish them down with a dry, not damp, terrycloth rag. This is a great way to recycle any extra paints, glazes, and craft supplies you have around the house, even old jewelry, etc.

4. Keep an Open Mind
This is not your typical faux finish. Approach it with an open mind and an open heart.

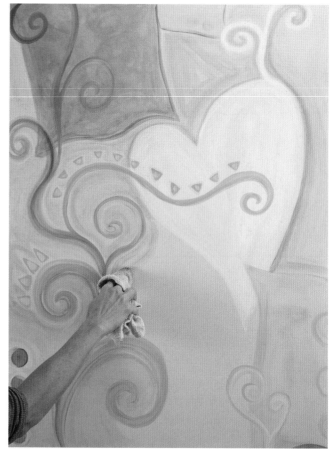

>> **STEP 1:** Basecoat your wall with a satin or eggshell latex paint in a light lavender. Let dry. Load a 1-inch (25mm) flat brush with a white acrylic craft paint and use large, loose strokes to create a freehand heart shape. The "dancing square" in the lower right corner is a mix of light yellow, golden yellow, and tangerine acrylics. The green scrolls are citron (a bright lime green) side-loaded into a turquoise blue on a 1/2-inch (13mm) flat brush. Pick up a little light yellow for variation of color. The four pink circles at the lower left are a bright magenta double-loaded with white on a 3/4-inch (19mm) flat. The Gustav Klimt-inspired heart shape at lower right is light yellow shaded with turquoise and green, and the half circles along the far right edge are orange.

For the wavy purple shape at the top, don't use a brush, just use a slightly damp terrycloth towel and a purple glaze to scumble in the shape. Let dry before going on.

>> **STEP 2:** Add a second coat of purple glaze to the wavy shape at the upper left, then outline it with a border of a green-blue color. Continue painting the green scrolls, bringing them up further into the design and overlapping the larger shapes you placed in Step 1. Add triangles along the top edges of two of the green scrolls. Paint them first with lemon yellow, then come back with bright orange and fill in the centers. Dab the centers with lemon yellow. Wrap a damp terrycloth rag around your finger, pick up purple glaze and add movement lines to the lavender background between and among the other shapes. Draw these lines loosely, like finger-painting, outlining the shapes with a darker purple line. Go with the flow of the shapes and don't overblend.

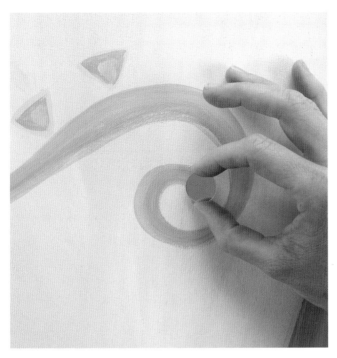

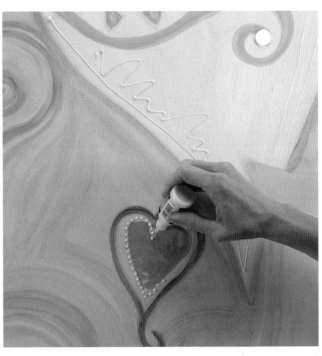

>> **STEP 3:** When all your painting and glazing is finished and dry, begin adding as many embellishments as you like. Here I'm adding little mirrors that have been cut into circle shapes. I use Yes! Paste to adhere the backs of the mirrors to the painting. You can find bags of these little mirror shapes at the craft store.

>> **STEP 4:** Here's a heart shape I cut out of opalescent blue shiny paper and pasted on with Yes! Paste, using a dry soft cloth to burnish it down. I outlined my blue paper heart with a freehand purple heart shape, then I used pearlized white dimensional paint to add dots around the blue paper heart, and freehand lines and squiggles inside the big white heart above it.

>> **STEP 5:** I finished with a pineapple-colored glitter glue to outline the orange triangles and draw some freehand curlicues, and some orange and blue opalescent squares, lime green beads, and a piece of blue mosaic stained glass.

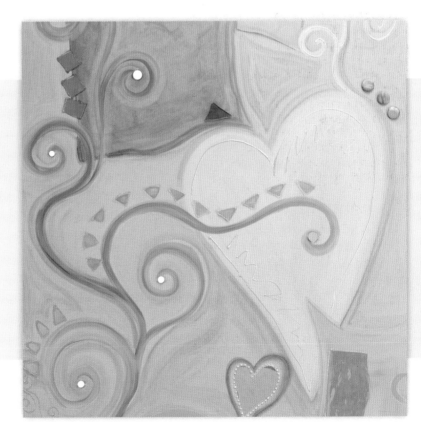

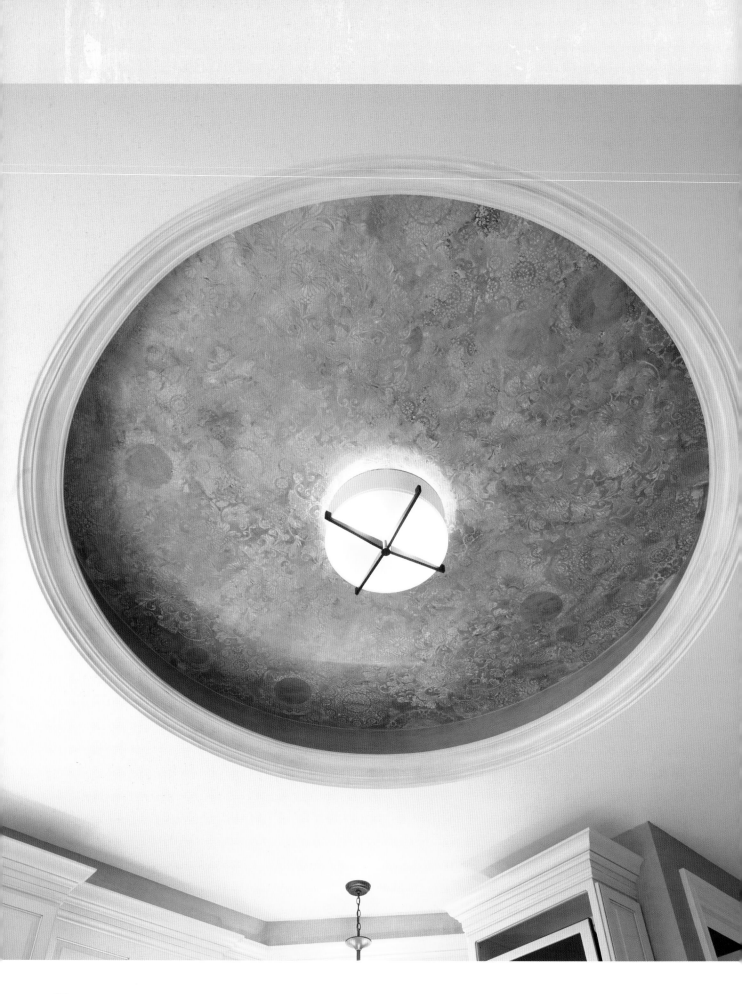

Doily Dome Ceiling

LIZ HERRMANN

You can be very creative with this ceiling design—think outside the box. It's a collage and the different design elements can be anything you want. This design can be done on panels under chair rails, on furniture, on any indoor surface except floors. You can use any color glazes you like and if you want a little sparkle, embellish it with crystals, fine glitter, granite flakes, whatever is appropriate for the space.

MATERIALS

- "Classic Brown" eggshell latex (Porter Paints) or an equivalent brown shade
- Faux Effects Venetian Gem "White on White"
- "Chrysanthemum" stencil, 2-feet (61cm) square, from Helen Morris Stencil Library
- Paper doilies in various sizes and shapes from craft or baking supply stores
- Modern Masters Metallics: Pearl White, Brass, Champagne
- AquaGlaze
- Whizz Roller with Fab cover
- Japan scrapers
- Chip brushes
- Cotton rags
- Low-tack painter's tape
- Optional: Stencil adhesive spray

>> PRO TIPS

1. Working on a Ceiling
To work on a ceiling, you'll need scaffolding to get up to your work surface and have a place for your tools and products. For this ceiling project I stood on the top board of the scaffolding and worked overhead. It can be tiring so having a helper is great.

2. Remove Light Fixtures
Before starting any ceiling project, take down all the light fixtures and pull down any recessed lighting cans. Don't use these as your light source, they get too hot.

3. Start with a Sealed Surface
Make sure you apply this finish to a sealed surface—one that has been basecoated or painted with something other than builder's flat paint. My basecoat for this project was a brown eggshell latex paint.

4. Have Duplicate Stencils
It's nice to have more than one large clear acetate stencil so that one can be cleaned while you're using the other. These stencils clean up well with any biodegradable cleaner like Simple Green.

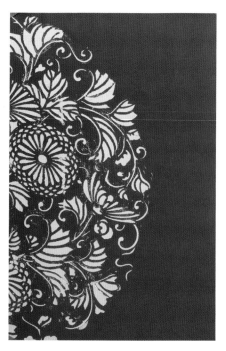

>> **STEP 1:** Using a Whizz roller, apply a base-coat of Classic Brown (or any dark brown) latex in an eggshell finish to your surface. Let dry overnight. You may need 2 coats, letting the first coat dry before applying the second.

>> **STEP 2:** Position the "Chrysanthemum" stencil on your surface and adhere it with low-tack painter's tape or stencil adhesive spray. Using a Japan scraper with the bottom edge buttered with a little Venetian Gem White on White, skim over the stencil; the paste will be pressed through the openings in the stencil. Remove the stencil carefully.

>> **STEP 3:** This is how the design looks after the large stencil is removed. Let dry before going on, usually about 30 minutes.

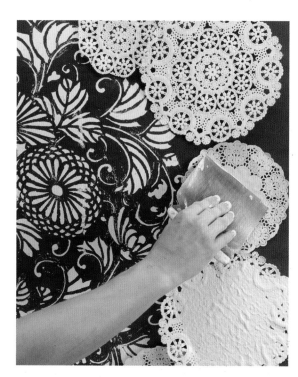

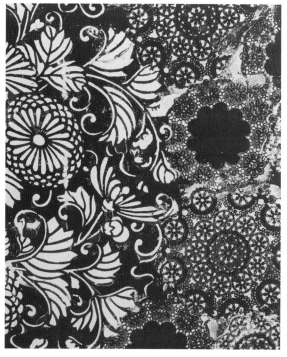

>> **STEP 4:** Arrange your different paper doilies around the large stenciled area and adhere with tape or stencil adhesive spray. Apply the Venetian Gem to the doilies using a Japan scraper. When you're finished with the doilies, discard them—they are one-time use only.

>> **STEP 5:** This is how the completed design looks at this point. If you like a bold, high-contrast look, stop here. The glazing to come will soften it considerably.

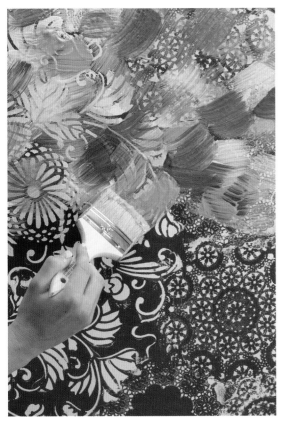

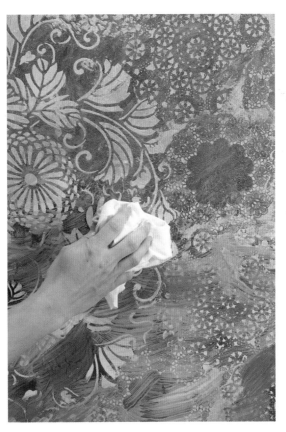

>> **STEP 6:** Using chip brushes and the three colors of glazes—Pearl White, Brass and Champagne—randomly apply the glazes with short strokes of the brush, applying all three colors at the same time, but not on top of each other.

>> **STEP 7:** With a cotton rag, "powder puff" it to soften and blend the glazes and move them around. As they dry, the different glaze colors will become more apparent. Be careful not to overblend or you'll end up with one muddy color.

>> **FINISH:** When the glazes have dried, you will be able to see the different colors coming through.

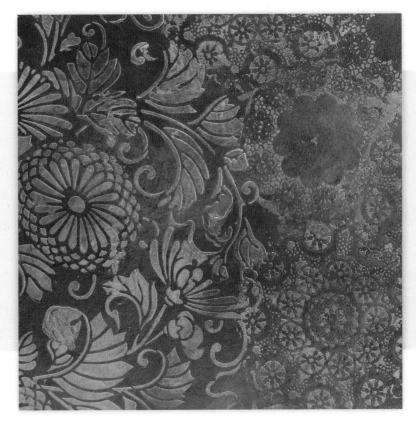

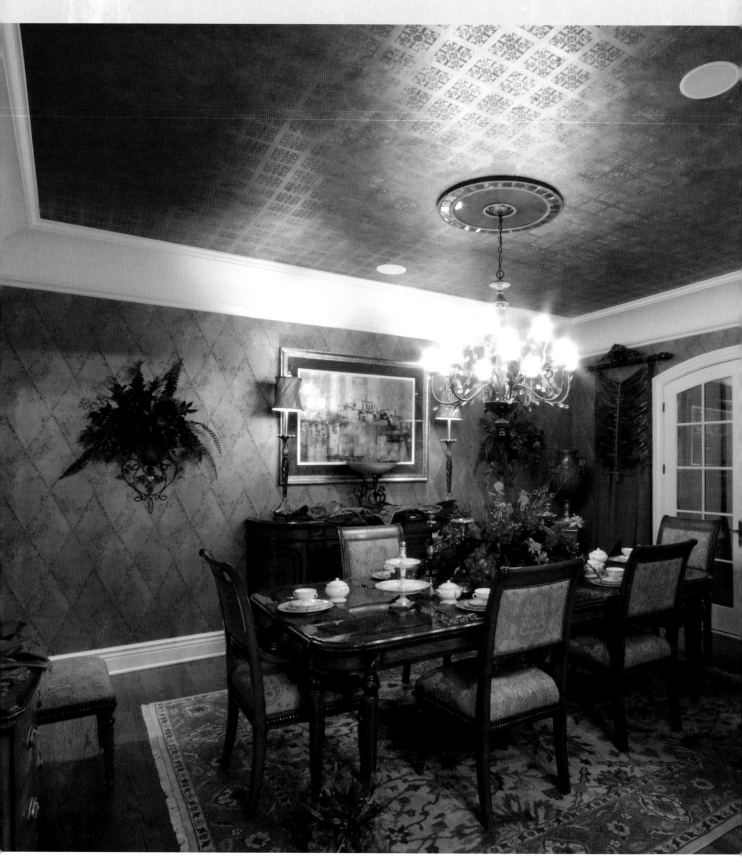

Photo courtesy of Ron Kolb.

Faux Tile Ceiling

GARY LORD

This is a wonderful way to create the look of an old-fashioned tin ceiling but with a modern, updated style to it. I have done this finish in bar areas, studies, dining rooms, media rooms, hallways and libraries, and with each one I created a very dramatic design theme. By using this concept but changing out the materials and colors, the design options become unlimited. So go ahead and make the "fifth wall" in your room something special!

MATERIALS

- "Blue Daisy" latex paint (Benjamin Moore) or an equivalent shade of blue
- Royal Design Studio's Renaissance Tile Series #2, Stencil 710
- LusterStone: Cantaloupe
- Behr Silver Metallic paint
- Chip brushes
- Stain & Seal: Antique Cherry
- FX Thinner
- Denatured alcohol
- Rags
- Japan scrapers
- Misting bottle

>> PRO TIPS

1. Laying Up Straight Lines
Lay up your horizontal and vertical guidelines using a level and a pencil (please see the "Crackle Foil" project on pages 34-37 for tips on drawing guidelines). Align the corners of the stencil on the vertical lines.

2. Loading a Japan Scraper
To load your Japan scraper with the LusterStone, use a wooden craft stick to dip into the LusterStone, then transfer it to the edge of the scraper blade.

3. Washing Off the Stencils
Wash the backs of the stencils about every two applications to prevent bleed-through. It's okay to have a few bleeds here and there (even on your sample board) for a more handpainted look.

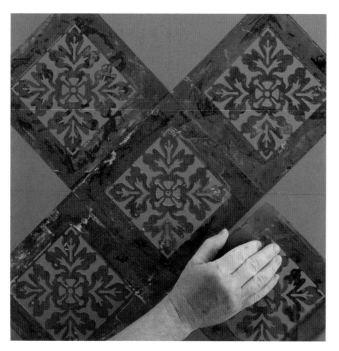

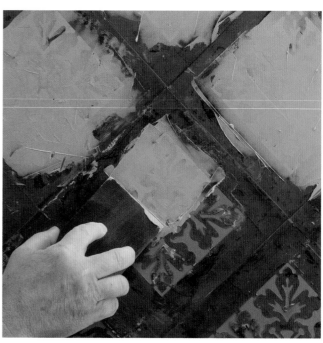

>> **STEP 1:** Apply a solid basecoat of "Blue Daisy" latex paint to your surface and let dry. Use a pencil and a level to draw your horizontal and vertical guidelines for placement of the stencils (see Pro Tip #1). Mist the backs of your stencils with water; this will act as suction to hold your stencils in place.

>> **STEP 2:** Load the top edge of a Japan scraper with LusterStone "Cantaloupe" and apply the LusterStone over each stencil, leaving it slightly raised off the stencil.

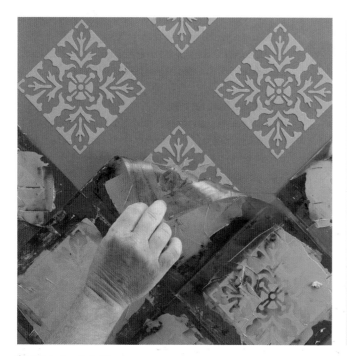

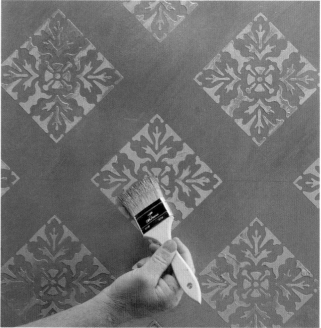

>> **STEP 3:** Carefully lift each stencil straight up so not to disturb the raised pattern. Let dry completely.

>> **STEP 4:** Use a chip brush to scumble on the Behr Silver Metallic paint in a varying depth of opacity over 70-80 percent of the surface. Keep your brushstrokes going in the same general direction. Don't cross-hatch them. You should still be able to see the blue basecoat here and there. Let dry.

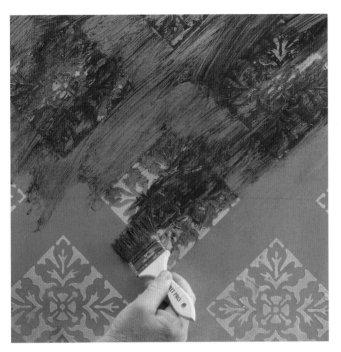

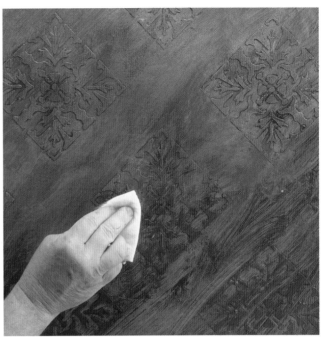

>> **STEP 5:** Dilute the Antique Cherry Stain & Seal 10-20 percent with FX Thinner and brush it over the surface using a chip brush. Keep your strokes going in the same general direction as the metallic silver strokes in the previous step. Work in a fairly small area so the Stain & Seal doesn't dry before you go to the next step.

>> **STEP 6:** Take a cotton rag and remove as much of the Antique Cherry color as desired. A damp rag will remove even more color. Another option is to mist your surface with water before using the Stain & Seal.

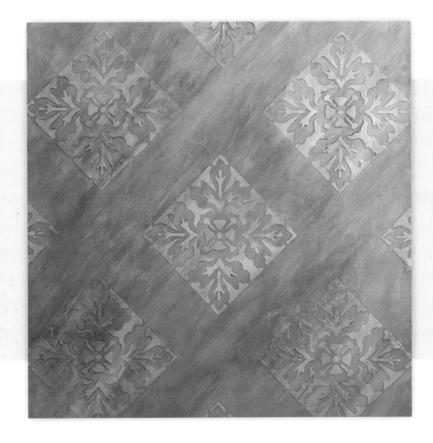

>> **FINISH:** If you wish to cut through the color even more, allow it to dry and then use denatured alcohol on a rag and randomly remove the color by rubbing it gently until you achieve your desired effect.

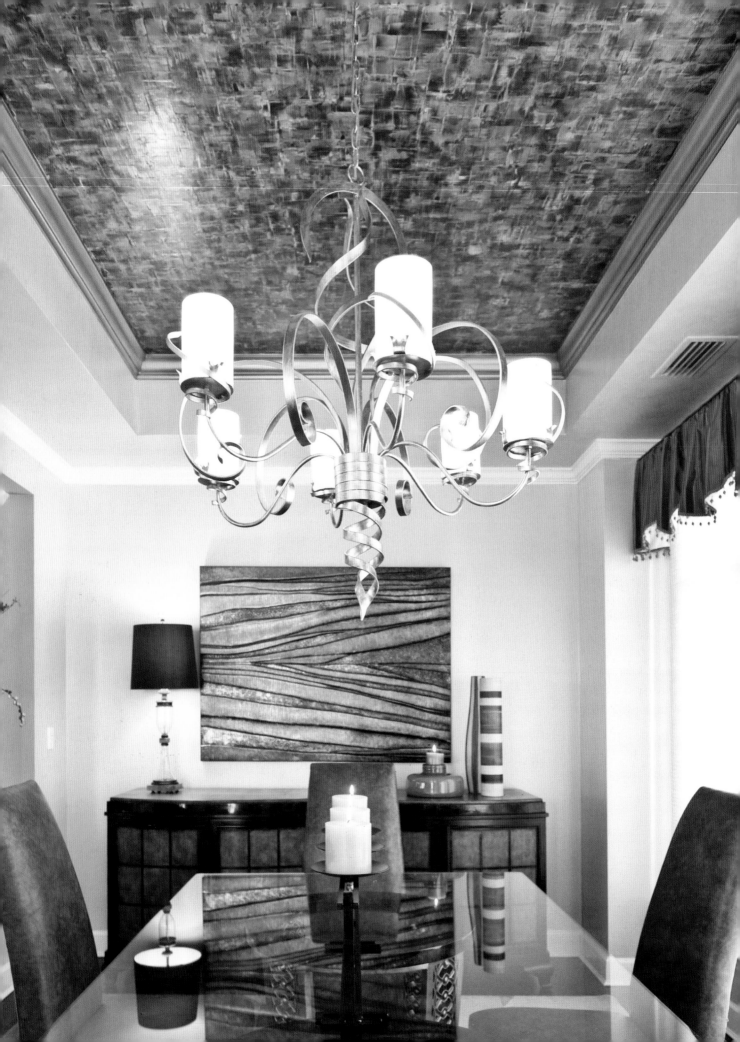

Abstract Ceiling

KRISTA VIND

For this waterfront home in Destin, Florida, the designer and homeowner wanted an eclectic mix of traditional and contemporary, focusing on metallics, green, coral and brown colors. The abundant natural light in the room brings out the vibrant colors and makes the glossy metallics shine. The homeowner tells me that people often comment on the beauty of the ceiling as it is visible from the street. I used no brushes in the application, just Japan scrapers and a trowel to achieve the layered texture and movement I wanted.

MATERIALS

- Basecoat: SetCoat Black or an equivalent color of 100% acrylic paint
- Venetian Gem: Black Onyx
- AquaWax
- Benjamin Moore colorants
- Modern Masters Metallic Paint: Rich Gold and Champagne
- Stain & Seal: Rich Brown
- FauxCrème Color: White
- Stainless steel trowel
- Japan scrapers in various sizes

>> PRO TIPS

1. Painting on a Ceiling
When working on a ceiling, I prefer using a scaffold over a ladder. Instead of constantly going up and down to move the ladder to the working area, you will be able to reach a much larger area with a scaffold. Scaffolding is affordable to rent and is also safer. It can be disorienting to stare up at the ceiling and then refocus downward. A scaffold safety rail to hold onto helps you remain steady.

2. Support Your Neck
I learned this trick from fellow decorative artist, Kathy Carroll: Roll up a towel and put rubber bands on each end. Then wrap the towel around your neck and secure in front with another rubber band. This will help support your head and neck as you look up to apply your material.

3. How to Hold your Japan Scrapers
For this finish it's important that you hold your Japan scraper properly. Hold the sides with your thumb and middle finger, with your index finger in the middle using a very low angle. If you hold it with your thumb underneath and fingers on the top side, you will scrape off too much material and not leave the texture which is important to the final finish.

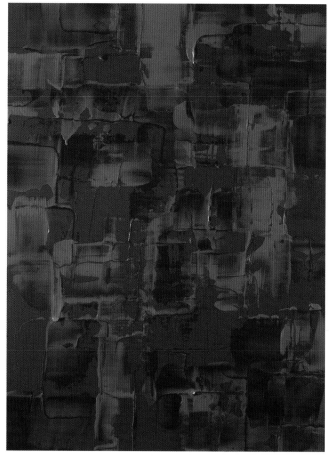

>> **STEP 1:** Basecoat your surface with Black SetCoat. Apply two coats if needed, letting it dry between coats. Or use a 100 percent acrylic paint in black if you prefer. Let dry.

Using a stainless steel trowel, apply an even layer of Venetian Gem Black Onyx to get 100 percent coverage. When using a stainless steel trowel, always apply the Venetian Gem to one side of the trowel. If you are right handed, apply to the right side of the trowel. If left handed, apply to the left side of the trowel. Always trowel the surface with that *one* side of the trowel. If you need to switch directions, turn the trowel upside down. Never trowel with both sides of the trowel. When you do this, material dries on the side that is used least and this can cause dragging as those dried bits pass through the material.

While the Venetian Gem Black Onyx is wet, use a 2½-inch (6.4cm) Japan scraper loaded with a bit of the Venetian Gem to add and subtract material from the surface while scraping in a random vertical and horizontal pattern. Make sure the shapes vary in size and overlap. Do not create a regular checkerboard pattern, keep it very random. Make sure you have created ridges at the edges of some of the shapes. Let dry completely before going on.

>> **STEP 2:** Mix 2 colors of tinted AquaWax in separate containers. The first color is a green mixed from 1 cup (230ml) of AquaWax + 1½ teaspoons of the colorant used for Benjamin Moore's "Fernwood Green" paint, #2145-40. ("Colorants" are just the tint used to color Benjamin Moore paints. They are available at any Benjamin Moore retailer nationwide. Ask for only the colorants for the paint colors listed.) The second color is a red mixed from 1 cup (230ml) of AquaWax + 1 teaspoon of the colorant used for Benjamin Moore's "Wild Flower" paint, #2090-40.

Burnish the Venetian Gem lightly with the edge of the stainless steel trowel. Use a 2½-inch (6.4cm) Japan scraper to apply the green color first in both vertical and horizontal random rectangles. Apply the red color in the same fashion, overlapping in some areas. Aim for a total coverage in this step of 85 percent. Let dry.

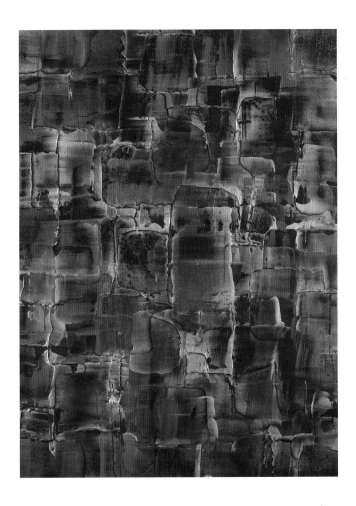

>> STEP 3: When the red and green are both dry, in a third container, mix 1 cup (230ml) of AquaWax + 2 teaspoons of Modern Masters Metallic Paint in "Rich Gold." Use a Japan scraper to apply the gold color in the same way as you did the red and green colors. Now your coverage should be 95 percent of the surface. You can still see small areas of the original black basecoat. Let dry.

>> FINISH: Mix 1 cup (230ml) AquaWax + 1 teaspoon "Rich Brown" Stain & Seal. Mix 1 cup (230ml) AquaWax + 1½ teaspoons Modern Masters Metallic Paint in "Champagne." To the green mix you made in Step 2, add enough FauxCrème Color in "White" to make a half-value of the original green (i.e., a lighter green). Apply the Rich Brown mix to 100 percent of the surface using a stainless steel trowel. While it's wet, use a Japan scraper to add highlights here and there with both the Champagne mix and the lighter green mix. Let dry.

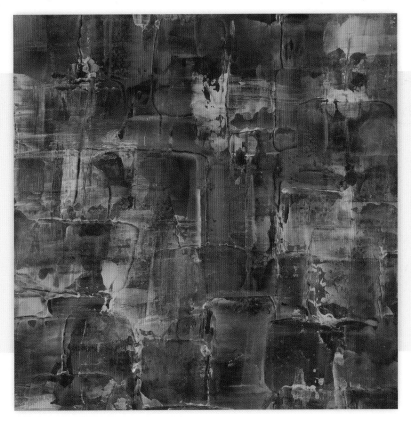

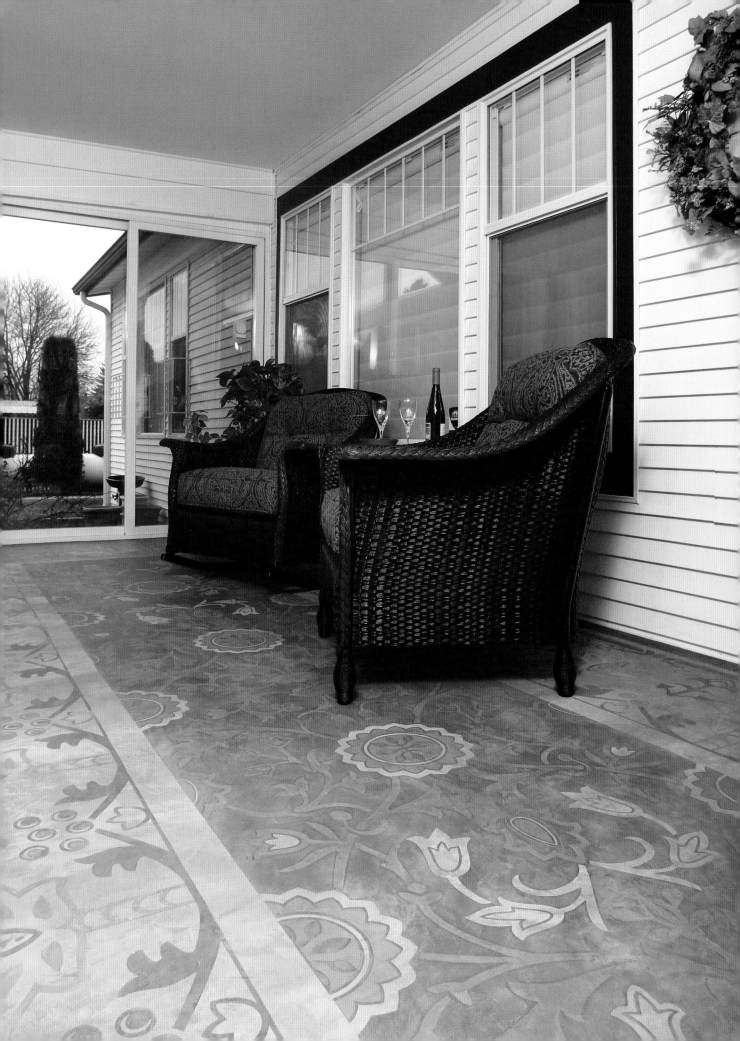

Stained Concrete Carpet

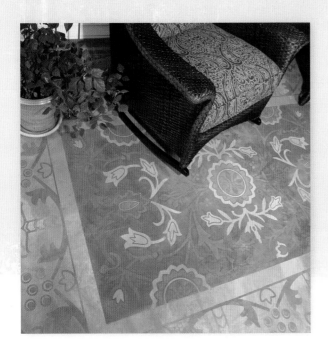

NANCY JONES

Skimming the surface with a decorative concrete overlay incorporating pattern and dimension gives this front porch new life. In keeping with the early 1900's arts and crafts style of this home, a William Morris pattern from Dover Publications was chosen and then adapted to the size and scale of the surface. Notwithstanding the creativity of this project, the ease of application, durability and simple damp mopping maintenance makes decorative concrete on floors a terrific application for decorative artists.

MATERIALS

- SkimStone™ Decorative Concrete Overlay System: Bonding primer, acrylic solution, hybridized Portland cement, acrylic colorants, Nanotech protective sealer
- SkimStone™ ColorPaks: Oystershell, Toasted Pecan, Winter Olive, Sedona Clay, Minoan Red, Mocha
- Modello Designs decorative masking pattern adapted from a William Morris design
- Stainless steel trowels
- Japan scrapers
- Chip brushes
- Paint pad applicator
- Paint tray
- 3M Sandblaster pads: 80, 120 & 180 grit
- 2-inch (51mm) low-tack painter's tape
- 24-inch (61cm) painter's masking film
- Stucco tape
- Calibrated plastic mixing containers
- 32-oz plastic drinking cups
- Plastic spoons or stir sticks
- Rubber spatulas
- Plastic measuring cups and spoons

>> PRO TIPS

1. About SkimStone

The SkimStone™ concrete overlay system has three primary components: the Acrylic Solution, a proprietary blend of acrylic resins; the Powder, a mixture of dry ingredients, including white Portland cement; and the ColorPak, a thick but pourable industrial strength colorant. The artist controls the color and the color strength by adding the desired amount of ColorPak(s) to the Acrylic Solution. The tinted Acrylic Solution is then mixed with the Powder and applied by pouring a small amount onto the surface and spreading it very thinly using a stainless steel trowel. A standard application is three coats of SkimStone followed by up to four coats of Nanotech Protective Sealer. Wet tools clean up with soap and water.

2. Applying SkimStone

Prior to application, the surface must be clean and sound. SkimStone will not adhere to silicone sealer, paint remover or acid stains. SkimStone requires troweling on three coats. Each coat must dry thoroughly before moving on to the next. Then a protective sealant should be applied. Exterior Nanotech sealer is used outdoors to allow the concrete to remain breathable while expanding and contracting with the weather conditions as well as providing UV resistance.

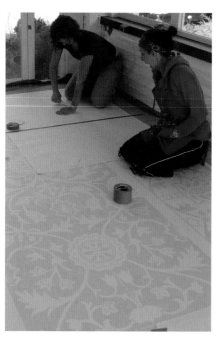

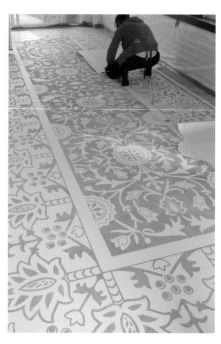

>> **STEP 1:** Tape off surrounding areas with painter's tape, then 24-inch (61cm) masking film. Mix layer #1 of SkimStone: 1 part acrylic solution : 2 oz tint strength of Oystershell + Toasted Pecan : 1.5 parts powder : 1 part silica sand. Apply and let dry. Mix Layer #2 of SkimStone adding silica sand in the same values and proportions as layer #1. Apply in the opposite direction from the first coat. Let dry.

>> **STEP 2:** Place the Modello decorative masking film on the floor and measure carefully to make sure it's centered in all directions. Once the Modello is applied, it cannot be moved.

>> **STEP 3:** When the entire Modello is placed, follow the manufacturer's instructions to expose the pattern.

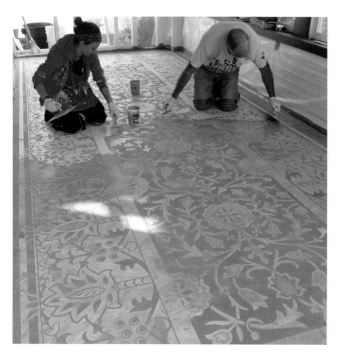

>> **STEP 4:** Seal the Modello with a thin mix of SkimStone consisting of 1 part acrylic to 1 part powder tinted to the color of the basecoat. This will prevent bleeding color under the stencil while applying thin trowel coats. Trowel on SkimStone with a tight skim coat application using a stainless steel trowel.

>> **STEP 5:** Mask off areas you wish to protect during the application of the SkimStone to create the multi-color design.

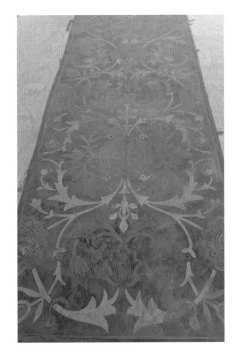

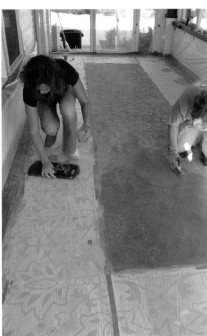

>> **STEP 6:** Create the center of the "carpet" with a "negative" impression, meaning the background receives the SkimStone while the motif remains covered.

>> **STEP 7:** Apply several concrete layers to the center of the design, embedding colors into various parts of the motif as the parts of the pattern are removed and more concrete is applied over the entire surface.

>> **STEP 8:** Finally, remove all parts of the Modello to expose the basecoat in some areas. The Modello is picked out in pieces which are then discarded. It cannot be used again.

>> **FINISH:** Add a touch of Mocha colorant to the first layer of sealer to harmonize the entire floor. After applying two additional layers of sealer, your stained concrete floor is finished!

The SkimStone Nanotech Protective Sealer is pervious, meaning that water and other liquids can be absorbed into the finish during the curing phase to allow the concrete to cure. As the liquids evaporate, the surface will recover. Total cure time is 28 days. Maintain the floor with a damp mop as you would a hardwood floor.

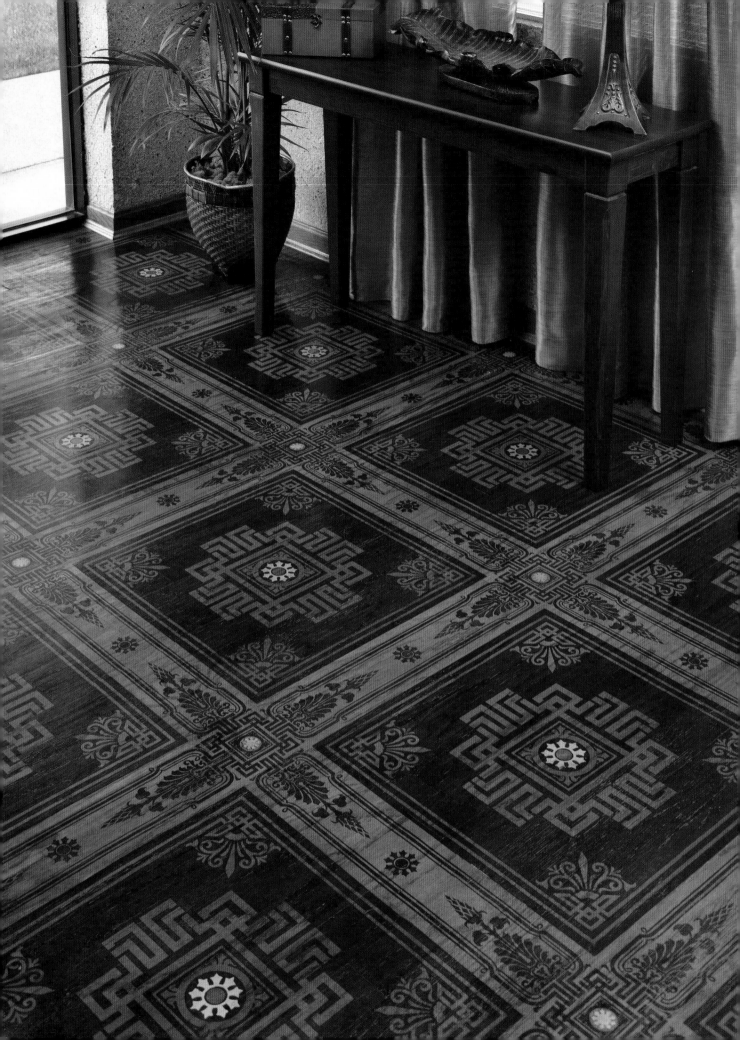

Stained Wood Modello Floor

GARY LORD

The classic custom look of inlaid wood has been around for centuries. Originally it was all hand cut and inlaid pieces of varieties of wood stained with different colors to create the pattern. Today with the use of a Modello (which is a design masking film) you can simulate the look of a hand inlaid floor at a fraction of the cost. The designs are unlimited and are custom made to fit your exact floor space. This is a fantastic option to dress up a floor or any other large wooden surface that can be stained.

MATERIALS

- 2-foot (61cm) square Modello (ORN Tile 124 Negative) by Modello Designs
- Burnishing tool
- Stain & Seal: Van Dyke Brown and Antique Mahogany
- Lambskin staining pad
- Pick-out tool
- Rolco Waterbased Size
- Clear acetate
- Stencil brush
- 22k Gold Leaf
- AquaGard sealer
- Faux Effects C-500 Urethane (gloss)

>> PRO TIPS

1. Removing the Transfer Paper
Wetting the face of your Modello's transfer paper with a damp sponge allows easier removal of the transfer paper.

2. Removing the Backing Paper
Be careful when removing the backing paper of the Modello so the design does not stick to itself because it is almost impossible to fix if it does. Now why do you think I might know that?

3. Check Your Design Placement
Make sure you have your placement just right before you press it down onto the surface because, once again, when it is pressed in place there is very little chance to change it.

4. Fixing a Mistake
If you do make an error, lay tape or Contact paper in the space that needs correction and use an X-acto knife to cut the design you need, then remove the excess material.

5. For More Information...
Need more information on Modellos? Visit www.modello designs.com (or see the Resources section on page 142).

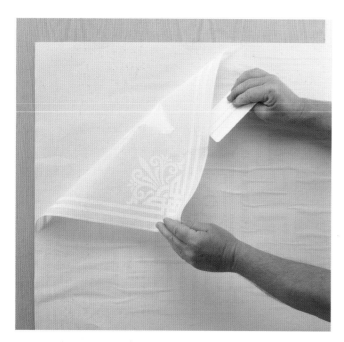

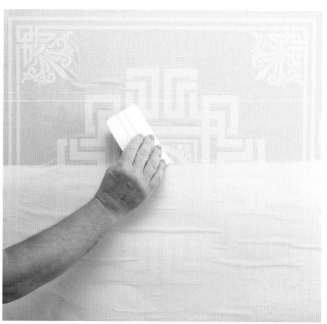

>> **STEP 1:** Using your burnishing tool, burnish both sides of the Modello. This helps ensure that the Modello adheres to your transfer paper and does not remain on the backing paper. Then while removing the Modello, always watch to ensure the design is adhered to the transfer paper; you may have to re-burnish some areas periodically to make this happen.

>> **STEP 2:** If your Modello is large, remove just one-half of the backing paper, being careful not to let the transfer paper stick to anything. (The transfer paper is sticky but the backing paper has no adhesive on it.) Then carefully align the transfer paper to the surface. Gently tack it in place with your fingers; once the Modello is pressed down, there is no adjustment possible. Now that the Modello is placed, use the burnishing tool to press the transfer paper and the Modello down onto your surface. Lift up the loose side that has the backing paper and remove the backing paper; carefully lay down the transfer paper and burnish it in place.

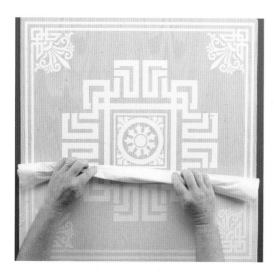

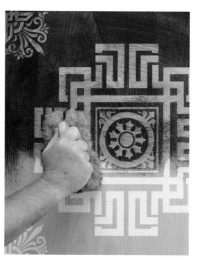

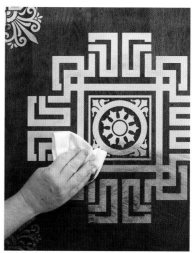

>> **STEP 3:** Remove the transfer paper, making sure the Modello stays onto the surface and doesn't lift with the transfer paper. Roll it back at a 180° angle. As you remove it, roll it into itself. It's very sticky and this helps keep it from tearing off any pieces of the design.

>> **STEP 4:** Using a lambskin staining pad, apply the Van Dyke Brown Stain & Seal to the surface. Rub hard and firm to make sure the stain gets into all the grain of the wood.

>> **STEP 5:** Take a clean rag and wipe away excess stain from the entire surface. Let it dry for about 2 hours or longer.

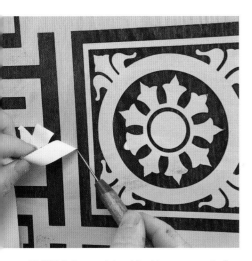

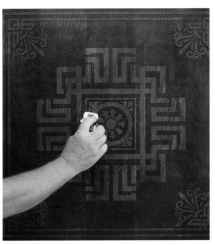

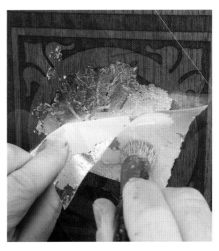

>> **STEP 6:** Use a pick-out tool to remove all of the Modello from the surface. If you don't have a pick-out tool, use a pocket knife or X-Acto knife. Depending on the design, the Modello comes up in pieces. Throw them away—they can't usually be reused.

>> **STEP 7:** Using a lambskin staining pad, apply Antique Mahogany Stain & Seal, cut with about 10 percent FX Thinner, to the entire design. Then use a clean rag to wipe off the excess stain, rubbing hard over the entire design.

>> **STEP 8:** Cut an acetate stencil for the center flower petal design. Cut a circle stencil for the center of the flower to act as a shield over the center circle. Using tape, place them on the center of the design. Using a stencil brush and Rolco Waterbased Size, tap sizing onto the wooden surface and let it set up about 25 minutes until tacky. Apply 22k Gold Leaf onto the flower petals using a soft stencil brush. Carefully brush off the excess gold leaf.

>> **FINISH:** Before applying the sealer, let the surface dry overnight. To protect the design, apply a waterbased clear polyurethane for your finish. The sheen level can be your choice. I used one coat of high gloss Aqua-Gard and let it thoroughly dry, and one finish coat of Faux Effects C-500 Urethane gloss. I used my lambskin staining pad to apply the Sealer and the finish coat.

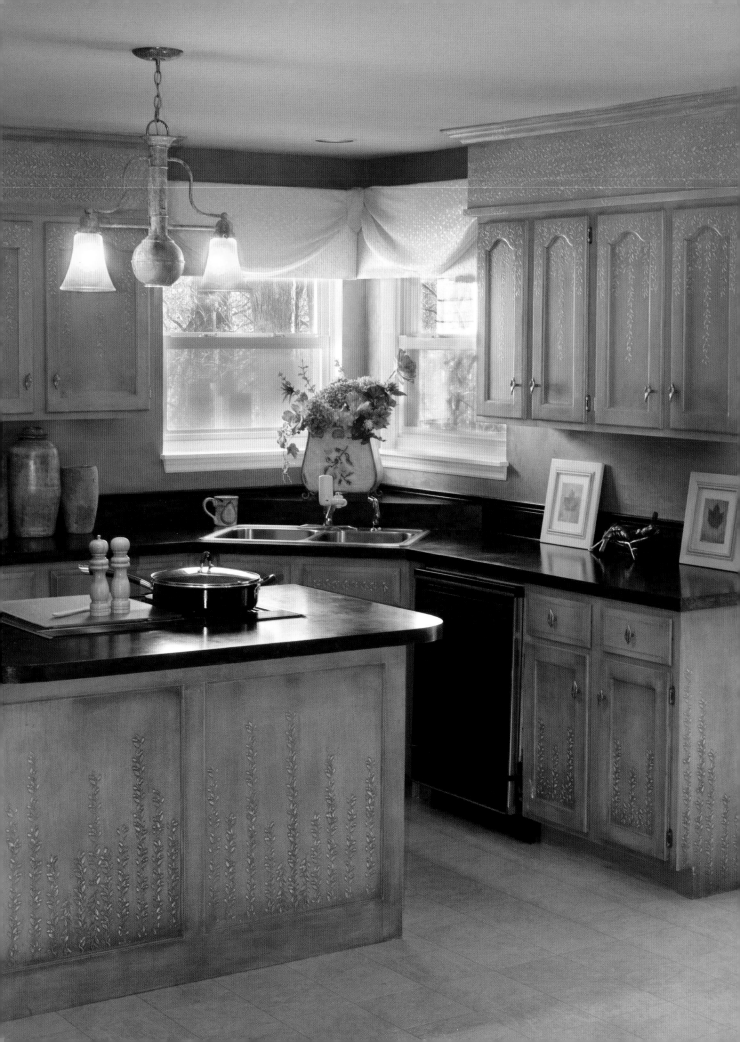

Raised Vines on Kitchen Cabinets

ROSE WILDE

The raised rosebuds-and-vines finish on these kitchen cabinets was created with the durable Wood Icing product, Textura Paste, because once dry it looks and feels like wood. The rosebud stencils create a design that add texture and interest, but are not too dominating or too busy a finish. The goal was a soft elegant look for this bright and stylish kitchen.

MATERIALS

- Cleaning agent like Dawn liquid detergent or TSP
- Sanding block (medium to coarse grit)
- Black Sharpie pen
- Masking tape or low-tack painter's tape
- Water bucket
- Vacuum or Shop-Vac
- White bonding primer
- Off-white (warm tone) satin latex paint
- 6 or 8-inch (15-20cm) medium density roller
- Chip brushes in various sizes

- Badger brush
- Soft absorbent rags or cloth for wiping glaze
- Wood Icing: Textura Paste, offset palette knife (for spreading Textura Paste), Rosebud All-Over Pattern Stencil (single layer), Rosebud Vertical Border Stencil (optional)
- AquaColors: Yellow Ochre, Dark Brown, French Red
- AquaCreme Glaze
- AquaSeal
- C-500 Urethane (satin)

>> PRO TIPS

1. Clean and Prepare the Kitchen Cabinets

Clean the cabinets with a de-greasing agent such as TSP (trisodium phosphate) or Dawn liquid detergent. Rinse thoroughly and allow to dry. Rough up the surface with medium or coarse sandpaper. This chore can be done more quickly with an orbital sander. Vacuum away the dust thoroughly.

2. Mark Doors and Hinges As You Remove Them

Marking your doors and hinges as you remove them will save time and prevent confusion when you re-attach the cabinet doors once the finish is complete. Assign one number to the following items as you remove the hinges from each door:
1. Cabinet door
2. Base cabinet for that door
3. Hinges (hinges are made with a die cut and do not vary much, so if they are all the same hinge it won't matter if you don't mark them)

Mark on the door and the cabinet with a black Sharpie pen in the exact place the hinge once was. Then cover over the writing with a piece of masking tape. Once the finish is complete, remove the tape to reveal the marking. The marking will then be covered again once you reattach the hinge.

>> **BEFORE:** The 16-year-old oak cabinets in the kitchen were solid and in good condition but needed to be brought up to date. In order to give the illusion of more modern, taller cabinets as seen in today's kitchens, crown molding was added to the existing soffits and then the raised rosebud-and-vine finish was extended to include these areas (see the "After" photo on the facing page).

>> **STEP 1:** After the cabinets have been cleaned and sanded and the doors and hinges removed, apply a white bonding primer using a medium density roller. This will prevent brush marks and give a light texture to the surface. Then apply an off-white satin latex paint in a warm tone, using a medium density roller. Let dry.

>> **STEP 2:** Tape off parts of the vines in the All-Over Rosebud Stencil with blue painter's tape to create a hanging vine design with varying lengths of vines. Spread the Textura Paste over the design with an offset palette knife. Remove the stencil immediately and allow to dry.

>> **STEP 3:** Gently sand over the top of the raised vine design with medium grit sandpaper, then vacuum away the dust. Paint over the raised design with the same off-white, satin latex paint you used in Step 1 above. Let dry.

>> **STEP 4:** Prepare a medium caramel brown glaze from AquaColor Dark Brown (1 tbsp), Yellow Ochre (1 tbsp) and French Red (1/3 tsp) mixed with 1 quart of AquaCreme Glaze. Apply the glaze with a chip brush all over the surface, working the glaze into the crevices around the raised design.

>> **STEP 5:** Using a soft cloth, wipe away 50 percent of the glaze (cheesecloth is not recommended because it will snag on the raised design). A badger brush will help even it out and remove brush marks. Let dry.

>> **STEP 6:** Use a sanding block to gently sand over the top of the raised vines to highlight the rosebud and vine pattern. (Optional: Apply one coat of AquaSeal and allow it to dry before sanding to prevent the dust from sticking in the crevices around the raised design.)

>> **AFTER:** Seal and protect the cabinets with one coat of AquaSeal and three coats of C-500 Urethane in a satin finish. Let dry and re-attach the doors. Compare the final result shown here with the "Before" photo on the facing page. You would never know that these were at one time those dark, old, outdated cabinets. Now they look clean, new and beautiful for a fraction of the price of new cabinets.

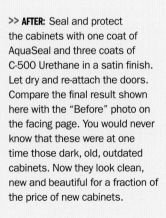

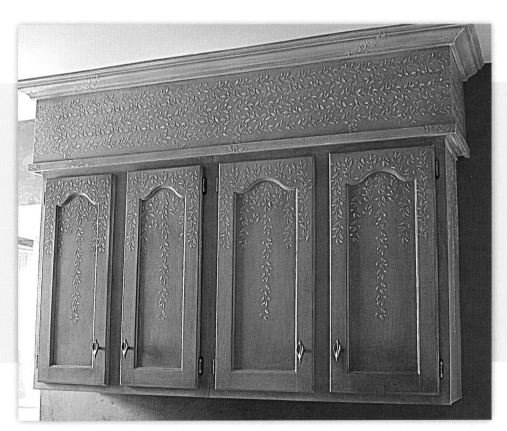

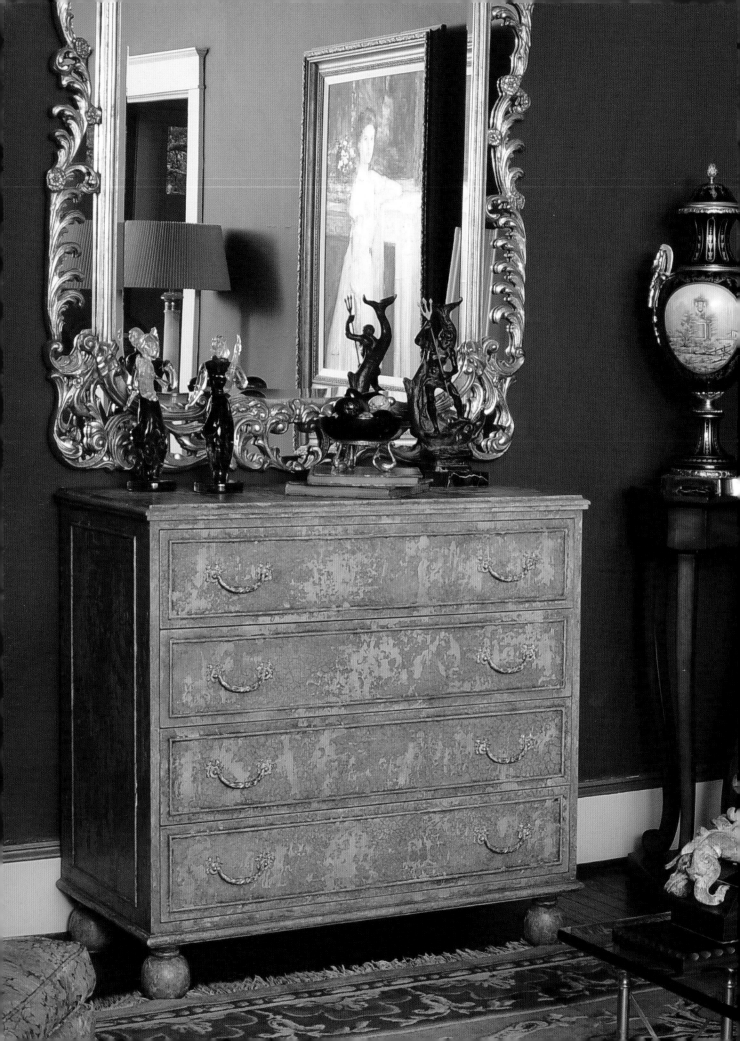

English Plaster Chest

ANN SNIPES

Through my interior design business I have been exposed to the most eloquently designed showrooms in the Southeast. These showrooms have incredibly elaborate faux-finished walls, wainscoting and trim. The showrooms themselves encompass a wow-factor that traditionally finished furniture cannot. My vision was to create the same ambience with unique finishes on furniture by using non-traditional tools such as trowels, rollers, stamps, and brushes.

MATERIALS

- Primer: Satin latex paint in a brown-gold color
- KSK Platinum Series Glazing Cream Colors: Raw Sienna, Van Dyke Brown, Natural Brown
- Platinum Series Furniture and Cabinetry Glazing Cream
- Platinum Series Zero VOC Basecoat color CB-150
- Shizen-Kyoto Untinted Plaster
- Modern Masters Decorative Painters Satin Varnish

- Wood Icing: Fissure
- Steel wool
- Water bottle
- Chip brush
- 4-inch Whizz Roller with ½-inch (13mm) nap poly-amide fabric
- Stainless steel trowel
- Tack cloth
- Cheesecloth
- Sandpaper 220 grit

>> PRO TIPS

1. Preparing and Painting Your Chest of Drawers
Sand furniture inside and out with a low grit sandpaper. Use tack cloths to remove all dust particles left behind from sanding. Using a 4-inch (10cm) Whizz roller, apply a layer of latex wood primer, 100 percent coverage, of a brown-gold satin latex paint on all surfaces that will be seen, including the insides of the drawers. Let dry completely and lightly sand, then use a tack cloth. The piece should feel smooth.

2. Using Glazing Products
When using Platinum Series Furniture and Cabinetry Glazing Cream, you must have the Platinum Series Zero VOC Basecoat underneath the glaze or it will flash. These products are made to be durable and with each layer you are building strength. Use the chip brush for applying the glaze. This will help the glaze move between the layers of the plaster.

3. Making the Crackle Finish
The Fissure determines the scale of the crackle. To make a large deep crack, put the Fissure on thick, and vice versa to make a thin crack. When the Fissure is dry to the touch, it's ready for Platinum Series Zero VOC Basecoat CB-150.

>> STEP 1: Follow the instructions in Pro Tip #1 (see previous page) for preparing and painting your chest of drawers. Using a dry Whizz roller, apply a thick layer of Fissure size on all surfaces that will be seen. Do not put Fissure on the insides of the drawers. Let dry for an hour or two until it is dry to the touch. The drying time will depend on your climate and humidity.

>> STEP 2: Using a clean 4-inch (10cm) Whizz roller, apply a thick layer of Platinum Series Zero VOC Basecoat CB-150 all over the surface. Do not paint the insides of the drawers. Let dry overnight.

>> STEP 3: After the CB-150 has crackled, apply a clear coat, 100 percent coverage, of Decorative Painters Satin Varnish on all surfaces including the insides of the drawers.

>> STEP 4: To 4 ounces of the Furniture and Cabinetry Glazing Cream, add ½ oz. Glazing Color in Raw Sienna and ¼ oz. Glazing Color in Van Dyke Brown. Apply a thick coat with a 4-inch (10cm) chip brush over the crackled area. Soften by lightly patting in a circular motion with cheesecloth to remove brushstrokes. Let dry overnight. Using a Whizz roller, add another layer of Satin Varnish and let dry overnight.

>> **STEP 5:** Load Shizen-Kyoto Untinted Plaster about 3/8-inch (10mm) thick on a stainless steel trowel. Place the trowel vertically on the surface and pat in a random motion, picking up and putting the trowel down. Rake the trowel downward to remove high places in the plaster. Strategically place the plaster leaving open areas and covering about 45-60 percent of the piece. This is a decorative detail so plan your pattern. Let dry completely about two hours or so.

>> **STEP 6:** To 2 ounces of Furniture and Cabinetry Glazing Cream, add 1/4 oz. Glazing Color in Van Dyke Brown and 1/16 oz. Glazing Color in Natural Brown. Spritz area with water, and using a clean 4-inch (10cm) chip brush, apply the glaze mixture on the furniture starting on the plaster areas. Soften the brush lines with cheesecloth. Let the glaze dry overnight.

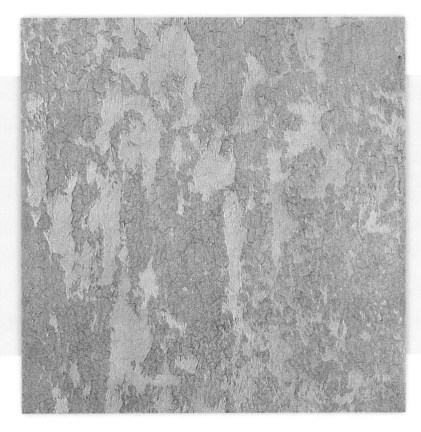

>> **FINISH:** Using a clean 4-inch (10cm) Whizz roller, apply a clear coat of satin varnish, 100 percent coverage, on all surfaces including the insides of the drawers. Let dry overnight and enjoy your piece of furniture art!

Abalone Crackle

CONNIE & RANDY COTITA

Abalone Crackle is one of our organic iridescent finishes. It works best as a furniture finish. It could also be used on small walls such as in a powder room or an accent wall. Here, we've used a small, wooden, barrel-shaped garden seat for this finish and added some upholstering tacks for detailing. The garden seat looks very eye-catching outdoors where the sunlight brings out all the colors of the iridescent finish.

MATERIALS

- Primer: AquaBond Black or an equivalent color of 100% acrylic paint
- Basecoat: Modern Masters Metallic Paint: Silver
- Golden Acrylics: Interference Blue (fine), Interference Green (fine), Fluid Interference Oxide Green (BS), Fluid Interference Oxide Violet
- Blue Pearl metallic water-based glaze: Verdi Bordeaux
- Plaid FolkArt Metallic Peridot acrylic paint

- Plaid FolkArt Floating Medium
- FauxCrème Clear glaze
- FauxCrème Color: Black
- Zinsser Bull's Eye 1-2-3 clear shellac
- C-500 Urethane (gloss)
- AquaGard
- 4-inch (10cm) foam roller
- Chip brushes (small)
- 4-inch (10cm) badger brush
- Round stippler brush
- Terrycloth rag
- Textured plastic trash bags, cut up and crumpled

>> PRO TIPS

1. Preparation
Make sure that the surface, especially furniture, is clean and free from dust, wax or oils. Prime the piece with black AquaBond or a 100 percent acrylic paint, then paint the Metallic Silver basecoat and let dry completely. Most metallic colors look better with a black basecoat under them.

2. Color and Brand Selection
For this finish, particular iridescent colors and products were used, but you may use any iridescent and/or metallic glazes or paints you desire.

3. Top Coats
Using a clear glossy top coat enhances iridescent colors.

4. Using Chip Brushes
If bristles release from your chip brush during application, remove them immediately or they will hamper the badger brush softening process.

5. Blending Colors with Plastic Bags
Rotate and frequently replace the plastic bags you are blending with in order to avoid muddying the colors.

>> **STEP 1:** After your prepared surface has been primed with black acrylic paint, then basecoated with metallic silver (see Pro Tip #1) and allowed to dry, apply iridescent glaze colors to the surface in a loose wave-like pattern using a different 2-inch (51mm) chip brush for each color. Use the Interference Green and Blue first, to form the structure of the finish, followed by the Verdi Bordeaux, then the Metallic Peridot thinned with floating medium. With a 1-inch (25mm) chip brush, apply sparingly the Interference Oxide Green and the Interference Oxide Violet. Continue on to the next step while these colors are still wet.

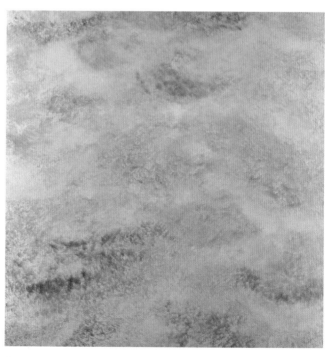

>> **STEP 2:** While the iridescent colors are still wet, use crumpled-up pieces of textured plastic bags to pounce the edges of the colors into one another, slightly blending but still maintaining the individual characteristic of each color, so as not to become muddy.

>> **STEP 3:** Let the colors sit for a short while (until they start to look "waxy"), then use a 4-inch (10cm) badger brush to lightly soften, creating a strata-like appearance. Let dry thoroughly (overnight if you don't have drying room). Using a brush of your preference, coat with 2 layers of clear shellac and let dry for 2 hours. Do not permit to dry very much longer as it will lessen the crackle effect.

>> STEP 4: Using FauxCrème Clear glaze, mix it with FauxCrème Color in Black to create two colors: a medium-to-dark gray and a darker, almost black, gray. With a chip brush, apply the almost-black glaze randomly to add areas of more contrasting interest. Using the 4-inch (10cm) roller, immediately roll over the entire piece with the lighter gray glaze, being careful not to overwork. Using a stippler brush, lightly remove any application and/or tool marks and expose some of the iridescent colors underneath. Use a dry terrycloth rag to delicately pick up some of the glaze to reveal the more interesting patterns underneath.

>> FINISH: Let dry thoroughly and the crackle will appear. Seal with an isolation layer of AquaGard and let dry. Apply several thin coats of C-500 Urethane gloss. Do not overwork the C-500. Let dry.

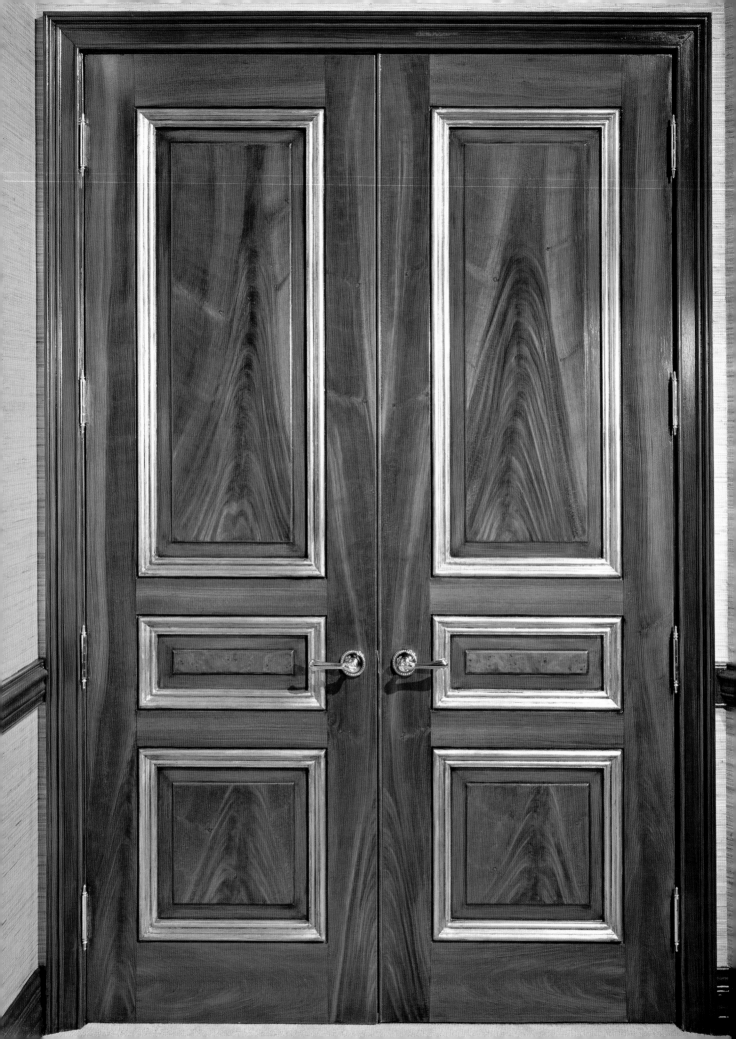

Book-matched Mahogany Doors

ERIC SPIEGEL

Faux wood-graining has been around for a long time, but in recent years has become easier because of the wood-graining tools available everywhere. Book-matching takes it a step further. Genuine book-matched wood is very expensive, requiring precise sawing to open up the wood to expose interesting graining patterns that are mirror images of each other. These double doors had nice inset panels but the wood was rather ordinary. A bit of glazing and some tools brought them to another level and made them extraordinary.

MATERIALS

- SetCoat: Camel, or an equivalent color of 100% acrylic paint
- FauxCrème Color: Dark Brown and Van Dyke Brown
- FauxCrème Clear glaze
- 2-inch (51mm) brush
- 3-inch (76mm) wavy mottler brush
- Badger hair softener brush
- Cotton cloth
- Satin varnish

>> PRO TIPS

1. Wet Sanding
Faux Effects SetCoat can be wet-sanded before graining to achieve a furniture finish outcome.

2. Gold Leaf
If you want an even more elegant look to your faux-mahogany doors, apply gold leaf to the raised molding around each panel. This acts almost like a picture frame and focuses the viewer's attention on the book-matched graining.

3. Working with Glazes
For this finish it's important that you work quickly while the glazes remain wet. Therefore, work on only one panel at a time, completing all the steps and letting the panel dry before applying a satin varnish.

Photo © Randall Perry Photography.

>> **STEP 1:** Begin by mixing two different glaze colors in separate containers. Glaze no. 1 is FauxCrème Color: Dark Brown mixed into some FauxCrème Clear. Glaze no. 2 is FauxCrème Color: Van Dyke Brown mixed into some FauxCrème Clear. Apply glaze no. 1 to the door panel with a 2-inch (51mm) brush in a vertical direction. While this glaze is still wet, apply glaze no. 2, starting at the bottom of the panel and brushing it on in a cone-shaped vertical pattern, then narrowing towards the top of the panel.

>> **STEP 2:** Starting in the center of the panel, begin softening with a badger hair softening brush. Soften perpendicular to the path of glaze no. 2, brushing horizontally then vertically. Continue softening the entire panel. Do not oversoften! Just remove obvious brushstroke marks.

>> **STEP 3:** Using a 3-inch wavy mottler brush held vertically in hand and parallel to the surface, begin laying in the heart grain. Starting at the center base of glaze no. 2, begin cutting into the glaze, making an inverted rounded "V"-shaped pattern. Continue climbing and narrowing this pattern towards the top of the panel. While the glaze is still wet, lightly soften with the badger hair brush.

Taking a crumpled cotton rag in hand, drag down along both outer edges of the heart grain, creating a lighter band of grain. Then take the wavy mottler brush and drag downward through the lighter bands created with the rag. Continue this movement from top to bottom through the entire panel, eventually working out to the edge of the panel. Repeat this same procedure on the panel with the opposite side of the heart grain.

>> **FINISH:** Take the wavy mottler brush in hand, bristles pointing up at a 45° angle. Starting at the top of the panel, drag downward approximately a third of the way in a sudden stop-start motion, curving the brush outwards to the edge of the panel. Place the brush back down at your stopping point and continue again downward along the side of the heart grain. Repeat this technique on the opposite side of the heart grain. With the wavy mottler, lightly go over all straight grain pushing the brush up and down over the grain. This will create the medullary rays often found in mahogany wood. When dry, apply a satin varnish for a finished look.

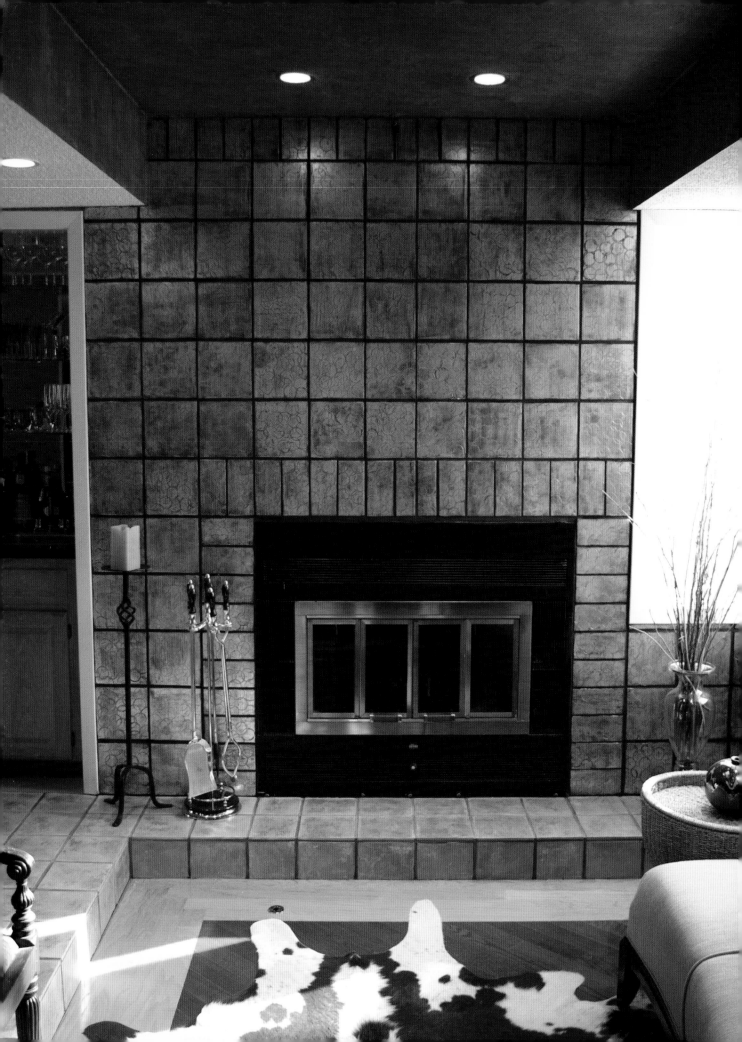

Chrome Contemp-O Tile

REBECCA SLATON

Move over, walls. Faux finishing gives us an opportunity to dramatically change the appearance of many nontraditional surfaces. This easy finish transforms common builder's grade tile into a high-end contemporary look. Household items become clever tools for creating whimsical patterns. Here is a hip, retro style that is cost-effective, involves no construction, and recycles an existing resource in the home—a truly modern makeover.

MATERIALS

- 150-grit sandpaper
- TSP (tri-sodium phosphate) degreaser and deglosser
- Cotton rags
- PrimEtch clear primer
- SetCoat: Dark Brown
- 1-inch (25mm) low-tack painter's tape
- Venetian Gem Plaster: Tiger's Eye
- Soda can or a small round container such as a baby food jar or plastic cup
- Pewter Metallic Foil
- Wunda Size
- Robert Rubber or kitchen scrub brush
- Palette Deco: Metallic Gold
- Stain & Seal: American Walnut and Rich Brown
- FX Thinner
- Varnish Plus (gloss)
- Japan scrapers or small flexible trowels
- Small foam paint rollers
- Brush

>> PRO TIPS

1. Preparing the Tile

It is important to scuff and clean your tile before applying the faux finishing materials. Use a rough sandpaper such as 150 grit to sand the tiles. This creates some "tooth" for your future layers. Pre-mixed, liquid, no-rinse TSP should be wiped across the surface to clean off dust and any other materials such as oils or waxes. TSP will also clean the grout. Follow the manufacturer's directions for cleaning tile. Use a foam roller to apply a thin even layer of PrimEtch, a sticky, clear primer for non-porous surfaces. In this application the grout color is darkened to match the finish so the PrimEtch is rolled over both the tile and grout. Let the PrimEtch dry overnight to bond with the tile surface before applying your Dark Brown SetCoat base color.

2. Variations on a Theme

To create an Asian-inspired version of this finish, follow the steps but use Ruby Venetian Gem plaster instead of Tiger's Eye, Bright Gold metallic foil instead of Pewter, and Palette Deco Metallic Bronze instead of Metallic Gold.

3. Shapes Other than Circles

Try other shapes for this finish, such as diamond or star-shaped cookie cutters, or a grid made by a potato masher.

>> **STEP 1:** Use a foam roller to apply a thin, even coat of PrimEtch clear primer to the sanded and cleaned tiles. Also roll it over the grout. The PrimEtch should dry overnight and will not be tacky the next day.

>> **STEP 2:** Apply 2 coats of Dark Brown SetCoat with a foam roller to the tile and the grout. Let dry 2 hours between coats. Mask off every other tile by applying 1-inch (25mm) low-tack tape to the grout surrounding all 4 sides of the tile. This will keep your plaster from coloring your grout lines. Use tape to mark the remaining tiles with an "X" to show which tiles are not ready for plaster.

>> **STEP 3:** Use a Japan scraper to apply "Tiger's Eye" Venetian Gem plaster evenly to the tile. Then use your selected circle tool (such as a soda can, baby food jar or plastic cup) to stamp circles into the wet plaster. Vary the number, make them random, and allow some of the circle shapes to overlap. Clean your circle tool with a damp cloth between pushing into the plaster to keep the shapes clean.

>> **STEP 4:** When the stamped plaster is dry, roll on Wunda Size over the tiles that are ready for foiling and let it tack up. Stick a piece of Pewter foil to the size with the shiny side facing you. Apply the foil with pressure using a Robert Rubber in a scrubbing motion. The circle shapes will show through the foil if you are pressing hard enough. Pull the foil. Repeat the foil process to all the tiles that are taped off.

>> **STEP 5:** Apply the Palette Deco Metallic Gold with a Japan scraper. Use a small amount and pull it tightly across the surface allowing the Palette Deco to catch in the circle shapes. This will also scrape off some of the foil, revealing areas of the dark Venetian Gem plaster layer. Soften the Palette Deco with a damp cotton cloth. Repeat this process to all tiles that are taped off.

>> **STEP 6:** Mix 1 part FX Thinner to one-half part Rich Brown Stain & Seal. Do the same with American Walnut Stain & Seal. Brush the Rich Brown glaze over the tile and rub into the finish with a cotton cloth to tone the tile and remove some areas of foil. Apply the American Walnut glaze over the wet Rich Brown layer and soften with a cotton cloth. When all the taped off tiles are glazed, remove the tape. Repeat Steps 2 through 6 until all tiles are completed. Let dry overnight.

>> **FINISH:** To finish and seal the tiles and grout lines, apply a topcoat of Varnish Plus gloss with a foam roller in a thin even layer over all the tiles and grout lines. Apply a second coat within 4 hours. If you cannot apply the second coat within 4 hours, you must wait 48 hours to apply an additional layer of Varnish Plus.

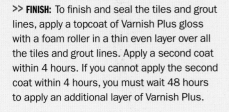

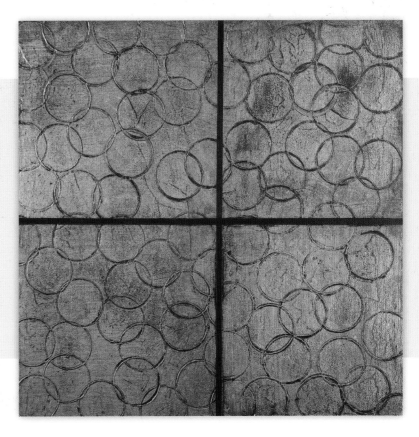

Urban Rust Panels

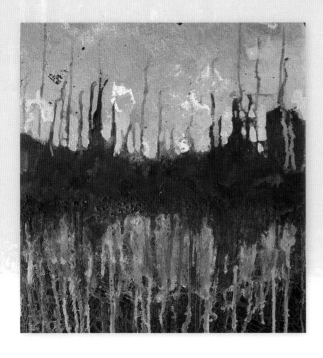

ALEXANDRA KRANYAK

This is a great way for a non-painter to create an original piece of art. These canvas panels can add intense color and texture to a room without overwhelming it and can be customized for any color scheme. If you don't have room for these very vertical panels, adjust the design to fit smaller canvases that can be found at any art and craft supply store. Use the canvases that wrap all the way around the sides so you don't have to purchase frames, and make sure they're pre-primed.

MATERIALS

- Three 12 x 30-inch (30 x 76cm) pre-primed, wrapped canvases
- Satin or semigloss latex paint in golden brown, brown and deep red
- Purple acrylic craft paint
- Rolco Water-based Gold Size
- Gold composition leaf
- AquaSize
- Faux Effects Black Crackle

- Modern Masters Metal Effects: Iron Paint, Rust Activator, Baroque Paint, Baroque Activator
- 4 plastic spray bottles
- Clear spray paint
- Rubbing alcohol
- Silver holographic foil
- 2-inch (51mm) chip brush
- Small plastic containers
- Small wedge-shaped makeup sponge

>> PRO TIPS

1. Personalizing Colors
All paint colors can be changed to match your décor and your own personal taste. My base colors were golden brown, brown, and deep red. I like how they look with the gold leaf and the color of the rust.

2. Use Leftover Paint
To save money, you can use leftover latex paint you have around the house, or ask for mis-tints from the paint store.

3. No Straight Lines
Uneven, organic, ragged edges are desired when applying the colors, gold leaf and rust. Work freehand and let the products do what they may.

4. Let Everything Dry
It's important that even though this is an organic project, you need to let each step dry completely before going on to the next step. There are many layers to these panels, and you'll get the best results if you don't rush it.

>> **STEP 1:** On all three canvas panels, using a 2-inch (51mm) chip brush with a crosshatch motion, paint golden brown latex paint along the upper edge, blending into brown latex in the middle, and deep red latex along the bottom. Let dry completely.

>> **STEP 2:** Mix a small amount of deep red latex and purple craft paint with about 40 percent water to make a wash. With a chip brush, wash this mix over the top of each canvas (approximately one-third of canvas). While it's still wet, spritz rubbing alcohol over the wash. Let dry.

>> **STEP 3:** With a chip brush, apply a thin layer of Rolco water-based gold size on the upper one-quarter to one-third of each canvas. An organic random edge is best. When dry but still tacky (about 15-20 minutes), apply composition gold leaf over the gold size. Lightly spray with clear spray paint.

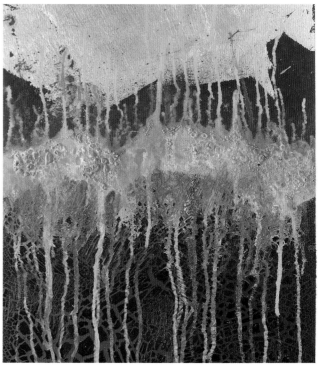

>> **STEP 4:** With a chip brush, apply AquaSize in a random crosshatch pattern on the lower two-thirds of the canvases. Let dry overnight. With a chip brush, apply Black Crackle in a random pattern over the Aqua-Size. Let dry completely and then spray with a clear spray paint.

>> **STEP 5:** Along the top of the black crackle edge, paint a thin (but generous) band of Baroque paint, spritz with water, then lift the canvas vertically so the paint runs down through crackle. Add more Baroque paint, spritz with water and lift the bottom of the canvas, letting it run up the canvas. When completely dry, spray with Baroque activator.

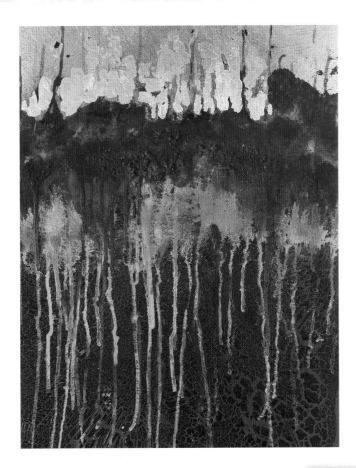

>> **STEP 6:** Just above the Baroque paint band, repeat Step 5, this time using the Iron paint followed by the Rust activator. You can spray activator again to achieve your desired level of rust. When dry, lightly spray with clear spray paint.

>> **FINISH:** With a small makeup sponge, dab a few random spots of Rolco water-based gold size on the gold leaf area of each canvas. When the size is dry, apply silver holographic foil (shiny side up) and rub until it transfers to the painting.

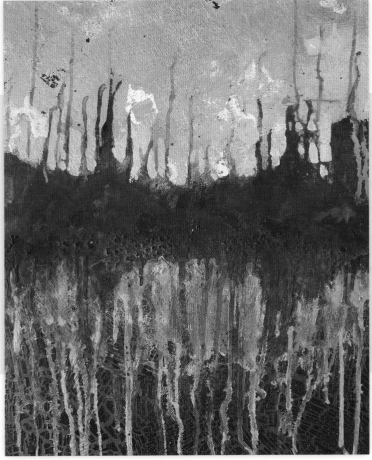

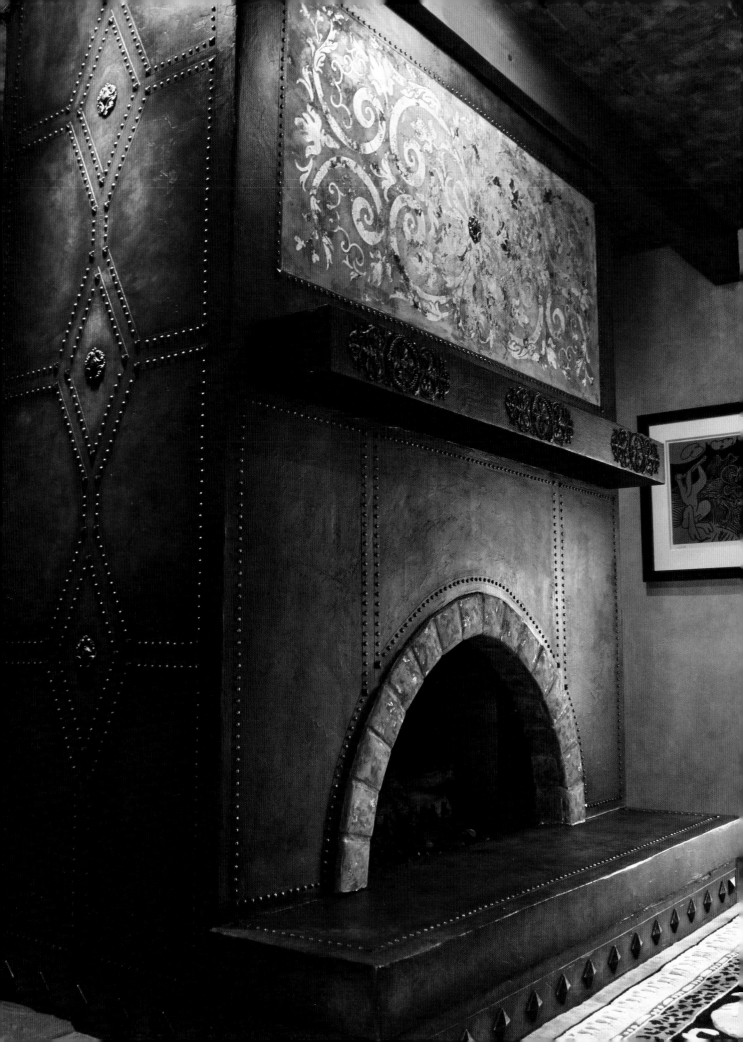

Faux Leather Fireplace Surround

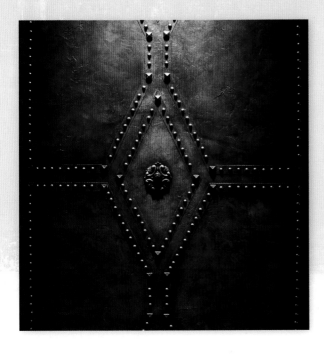

SUSAN ANSPACH

This massive fireplace took center stage in a Mediterranean-style home complete with wooden beams and terra cotta tile floor. The homeowner wanted a strong, masculine statement, which was achieved with faux leather accented with bronze-toned decorative nail heads and center medallions. Faux leather ("Finte Pelli") begins with a textured base to mimic the look of hide, and ends with dark-colored stains and glossy sealers for a smooth finish.

MATERIALS

- AquaBond: Off-White and Dark Brown
- Aqua Extender
- Venetian Gem Base Coat
- Stain & Seal: Natural Cherry
- AquaGard Gloss
- Decorative nail heads
- Paint tray
- Whizz Roller

- Chip brush
- 220-grit sandpaper
- Stainless steel trowel
- Japan scrapers
- See-through quilting ruler
- Hot glue gun
- Nail clippers
- Viva paper towels
- Staining pad
- Cheesecloth

>> PRO TIPS

1. Working on Large Surfaces
When working on large surfaces, use a 9-inch (23cm) roller to speed up the application of the basecoat color.

2. Substituting Acrylic Paint
You can use any good 100 percent acrylic paint from a home center for your wall prep and basecoat. Use an off-white that matches the color shown in Step 1.

3. Try Using a Quilting Ruler
See-through quilting rulers are clear plastic with the measurement lines and grids printed on one side. You can see your work through the ruler, which makes it so much easier to measure and mark accurately.

4. Finding Decorative Nail Heads
You can find these items at stores that sell upholstery materials, or search for them online. They come with a nail attached so you can hammer them into any wooden or drywall surface. However, if your surface is concrete, as this fireplace was, you will need to clip off the nail portion and use a hot glue gun to attach the head.

>> **STEP 1:** Basecoat your surface with two full coats of Off-White Aqua-Bond. Using a stainless steel trowel, apply a medium thickness layer of Venetian Gem Base Coat. Allow folds and trowel marks to show. Let dry, gently sand with 220-grit sandpaper, and repeat to add more depth. Measure and lightly pencil in the design using a see-through ruler. Our design has 1-inch (25mm) raised "straps" with a 1-inch (25mm) recessed area between.

>> **STEP 2:** Use 1-inch (25mm) blue painter's tape and mask to the outside of your straplines. Continue masking to protect all areas that are not straps. Here I've used masking paper just to speed up the process in the larger areas, or you can continue to use blue painter's tape as shown in Step 3.

>> **STEP 3:** Once all your masking is complete, use the trowel or a Japan scraper to apply an additional layer of Venetian Gem Base Coat to the exposed straps. Let this layer dry and apply one last layer to build the appearance of raised straps on your surface.

>> **STEP 4:** Once the Venetian Gem Base Coat is dry, carefully remove all your blue masking tape to reveal the design. Lightly sand with 220-grit sandpaper.

>> **STEP 5:** Use the see-through ruler to apply light pencil dots evenly spaced down the center of each raised strap (as shown in the lower left quadrant). Attach the decorative nail heads and corner pyramids with hot glue if your surface is concrete, or by hammering them in if your surface is wood or drywall (see Pro Tip #4).

>> **STEP 6:** Create a mix of Dark Brown AquaBond with 25 percent Aqua Extender added. Roll this on in small sections using a Whizz roller. Immediately blot the area with a damp staining pad, feathering the edges of the mix. While the area is still wet, use a large wad of Viva paper towels and press into the wet paint. This creates more texture and pattern. Follow this process covering the entire area and working section by section. Let dry.

>> **FINISH:** Use a chip brush or Whizz roller and apply Natural Cherry Stain & Seal to small workable areas. Make sure to cover the decorative nail heads and use a chip brush to scumble the stain up to the edges of each nail head. While the Stain & Seal is still wet, rub it softly with a piece of cheese-cloth, keeping a feathered edge. Repeat this process over the entire area, working in small sections. When complete, let dry. Finally, apply AquaGard Gloss as a final, protective sealer and topcoat.

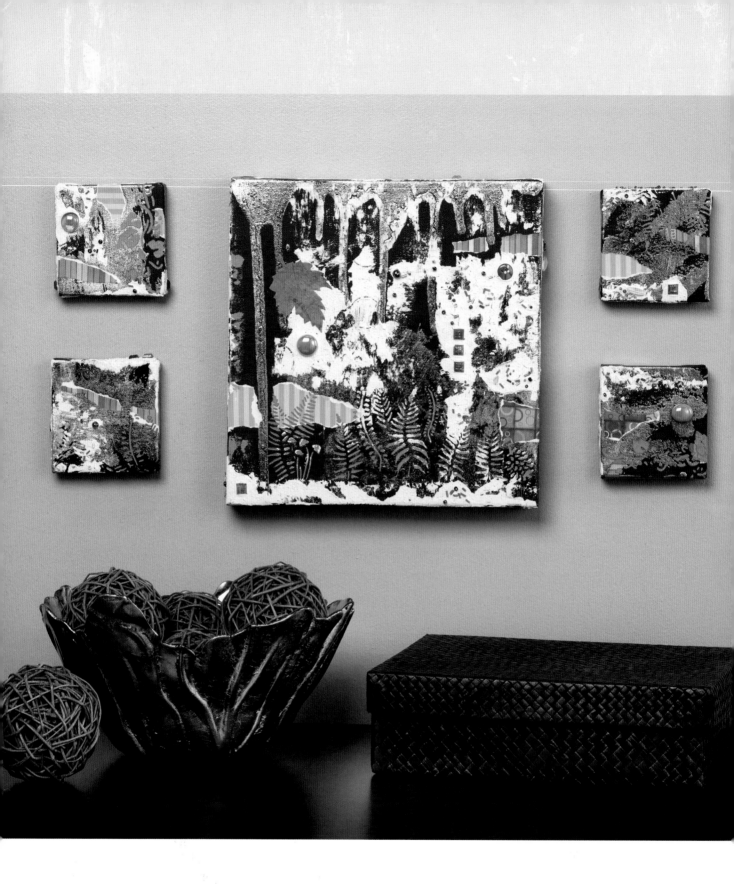

Spring Collageables

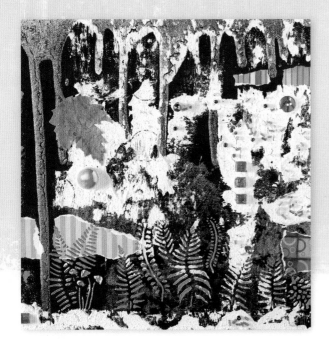

DEB DRAGER

"Collageables" combines not only faux finish applications of paints, plasters and stencils but also includes a scrapbooking feel with decoupage papers, mixed trinkets, beads, buttons and various dimensional accents. I wanted a more faux-to-go product so my creations could be hung in any environment and clients could take the canvases with them. Shown here is "Spring," a time of new growth, snow melting into water, baby ferns creeping up from dark soil and graphic elements that dance a spring-y step across the canvas.

MATERIALS

- 12-inch (30cm) square pre-stretched artist's canvas
- Four 4-inch (10cm) square Fredrix Creative Edge Gallery Style canvases
- SetCoat: Black
- Wunda Size
- Metallic Foils: Celadon Green, Caribbean Blue and Holographic Silver
- PlasterTex: White
- LusterStone: Medallion Gold, Shamrock Green tinted with Yellow, and Earth Green, all mixed together to make a lime-green plaster
- Mosaic Mercantile: Italian Glass, Vitreous Opalescents and Smalto Tiles
- Miscellaneous beads, buttons, charms, jewelry findings, scrapbook papers, and nature-motif stencils
- 4-inch (10cm) Whizz Rollers
- Elmer's craft glue
- Paint rollers
- Chip brushes
- Low-tack painter's tape
- Plastic trowel

>> PRO TIPS

1. For Inspiration...
Pick out your scrapbook papers or look through a drawer of miscellaneous gift-wrap, tissue paper or even greeting cards, photos, calendars and magazines for ideas for decoupaging. Clean out drawers for buttons, broken jewelry and miscellaneous objects for embellishments to embed into the plasters.

2. Tearing Decorative Papers
When you tear decorative papers, ripping in one direction exposes the white backing paper. For a white "deckle edge," tearing the other direction creates a hard edge on your paper patterns. Use this as an accent to your designs. Break up paper patterns but continue stripes in vertical or horizontal layouts to continue a pattern across the canvas.

3. Applying Colored Foils
When applying colored foils with stiff brushes, the directions you push and how hard, will change the amount of foil that sticks to the glue. I also use pre-used sheets of foil that have off-loaded patterns to create more patterns—look at the negative positive shapes on used foil. Or, create crosshatch patterns by transferring foils with a brush in both horizontal and vertical directions.

>> **STEP 1:** On the pre-stretched canvas sizes you've selected, paint a solid coat of Black SetCoat or a rich satin-finish black latex paint. Make sure to paint all four sides of each canvas where it wraps around the stretcher bars, and wrap a bit of paint onto the back side too. Prop up the canvases on wooden blocks so airflow can dry them completely.

>> **STEP 2:** This layer represents melting winter snow, spring rains and running water. Using a Whizz roller, roll Wunda Size along the top edge of the canvas. Hold the canvas upright and let the size run down in a drip pattern. Lay it flat to let the size tack up. Apply the blue and green foils with a stiff brush. Whichever color you start with will become the dominant color. For this project, I used blue as the dominant color with celadon green and holographic silver for highlight colors.

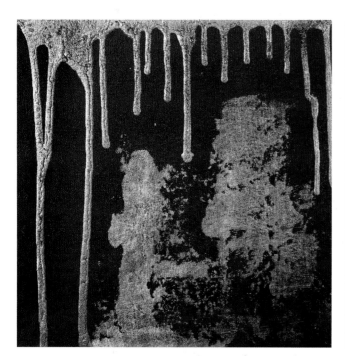

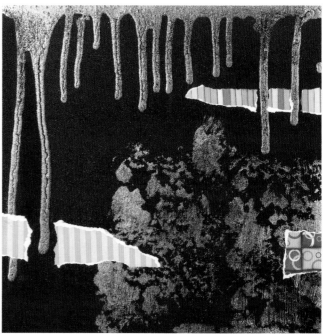

>> **STEP 3:** This layer of foil creates a more organic pattern of shine and light. Load a 4-inch (10cm) Whizz roller with Wunda Size. Roll with a light touch in negative areas among the drips and along one edge. Let it tack up. Apply blue and green foils with a stiff brush.

>> **STEP 4:** Tear selected papers in random shapes and apply with craft glue. Chip-brush the glue to areas on the canvas and on the back sides of the papers, then position them and squeegee across with a plastic trowel. The excess glue will squish out on the sides. Pat it up with a rag or pounce it in with a chip brush.

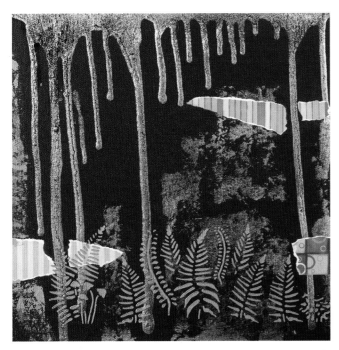

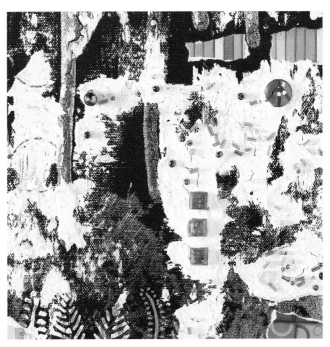

>> **STEP 5:** Select stencils in leaves, flowers, mushroom or scroll motifs and tape into position. Apply the lime green LusterStone with a plastic trowel over the stencils, like frosting a cake. Don't worry if your stencils bleed or spot color off the edges of your pattern. Clean off your trowel along one edge of the canvas for a graphic color splash. Pull off the stencils and let the LusterStone dry.

>> **STEP 6:** Add dimensional white PlasterTex in various areas and, while still wet, embed the embellishments of your choice, such as glass beads, mosaic tiles, buttons, etc. While the plaster is curing you can take bottle-caps or empty tape rings to press into the plaster for graphic circle shapes. And just tipping the plaster across the stencil designs can make the leaves look like they have light or morning dew on them.

>> **FINISH:** Decoupage paper leaves or any additional design elements you like that will add texture and interest. The four small canvases shown on either side of the main canvas (see page 138) were created using the same materials and colors, with repeating motifs to pull all the canvases together into one cohesive design.

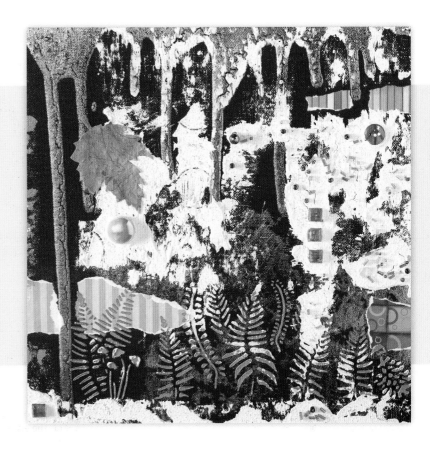

RESOURCES

Faux Effects
3435 Aviation Boulevard
Vero Beach, FL 32960
www.fauxfx.com
Ph. 1-800-270-8871
Manufacturer of Faux Effects products (see list of products below under Prismatic Painting Studio).

Prismatic Painting Studio
11126 Deerfield Rd.
Cincinnati, OH 45242
www.PrismaticPainting.com
Ph. 513-931-5520
Authorized distributor of all Faux Effects products, including SetCoat, FauxCrème Colors, AquaCreme, AquaGard, Aqua-Glaze, AquaSize, AquaStone, MetalGlow, Palette Deco, PlasterTex, Stain & Seal, C-500 Urethane, and SoSlow Super Extender. Also other products such as Magic Metallics Steel Paint and Rapid Rust, Wood Icing, and fluorescent paints. All brushes (badger brush, chip brush, Leon Neon stippling brush, sponge roller, Robert Rubber nylon scrub brush), trowels (float trowel, rubber trowel, stainless steel trowel, stainless steel Japan Scrapers), metallic and holographic foils, Wunda Size, and rollers (including Whizz rollers) can also be found on the website.
　　Instructional packets and videos are also available, as well as a listing of upcoming workshop classes taught nationally.
　　See our newest website: www.ItsFauxEasy.com for instructional videos, free techniques, tools and supplies.

Royal Design Studio
3517 Main St.
Suite 302
Chula Vista, CA 91911
www.royaldesignstudio.com
Ph. 1-800-747-9767
Stencils

Modello Designs, Inc.
Royal Design Studio
3517 Main St.
Suite 301
Chula Vista, CA 91911
www.ModelloDesigns.com
Ph. 1-800-663-3860
Modellos and instructional material

Worktools International, Inc.
12397 Belcher Road, Suite 230
Largo, FL 33773
whizz@whizzrollers.com
www.whizzrollers.com
Ph. 800-767-7038
Whizz rollers and other specialty paint tools. These products are also available in many paint stores nationwide.

Wood Icing
info@woodicing.com
www.woodicing.com
Ph. 1-866-966-3423

ARTIST CONTACT INFORMATION

Susan Anspach
Faux FX by Susan Anspach
www.fauxfxca.com

Tammy Burgess
Art & Texture
www.artandtexture.com

Connie & Randy Cotita
Studio Abbelliré
www.studioabbellire.com

Cynthia Davis
Cynthia Designs / Wallovers™
www.cynthiadesigns.com
www.wallovers.com

Jeannine Dostal
www.jeanninedostal.com

Deb Drager
Drager Design Studio
www.ddrager.com

Mindy Giglio
dmgiglio@yahoo.com
info@prismaticpainting.com

Debbie Hayes
Faux Design Studio, Inc.
www.faux-design-studio.com

Liz Herrmann
Elizabeth Designs
www.lizfaux.com

Sue Hon
Faux the Home
wgas@kc.rr.com

Nancy Jones
Artworks!...Spokane Inc
www.artworksspokane.com

Alexandra Kranyak
Kranyak Designs
AlexandraKranyak@kranyak designs.com

Karen Kratz-Miller
Broad Spectrum
www.broadspectrumpainting.com

Rik Lazenby
Lazenby's Decorative Arts Studio, Inc.
www.lazenbystudio.com

Gary Lord
Gary Lord Wall Options, Inc.
www.prismaticpainting.com
www.itsfauxeasy.com

Kim Metheny & Sue Weir
Metheny Weir Painted Finishes
www.methenyweir.com

Donna Phelps
Sarasota School of Faux & Architectural Finishing
www.sarasotafauxfx.com

Gina Rath
Defined Illusions
www.definedillusions.com

Rebecca Slaton & Ashley Reuter
Surfaces Decorative Arts Studio
www.surfacesfinepaint.com

Ann Snipes
Anne H. Snipes Interiors & Academy of Decorative Finishes
www.annsnipes.com

Eric Spiegel
Spiegel's Decorative Finishes, Inc.
www.spiegelsdecorativefinishes.com

Krista Vind
Ufauxrea
www.ufauxrea.com

Rose Wilde
Wood Icing
www.woodicing.com

Zebo Ludvicek
Zebo Studio
www.zebostudio.com

Index

Ideas. Instruction. Inspiration.

>> These and other fine North Light products are available at your local art & craft retailer, bookstore or online supplier. Visit our Websites at www.artistsnetwork.com and www.artistsnetwork.tv.

Mural Painting Secrets for Success by Gary Lord. ISBN 978-1-58180-980-0. Paperback, 160 pages. #Z0816.

Naturescapes with Terrence Lun Tse. ISBN 978-1-60061-998-4. DVD running time: 61 mins. #Z6464.

The Artist's Magazine. Find the latest issue on newsstands or visit www.artistsnetwork.com.

Visit www.artistsnetwork.com and get Jen's North Light Picks! Get free step-by-step demonstrations along with reviews of the latest books, videos and downloads from Jennifer Lepore, Senior Editor at North Light Books.